DESIGNING
BUSINESS AND MANAGEMENT

DESIGNING
BUSINESS AND MANAGEMENT

EDITED BY
SABINE JUNGINGER
AND JÜRGEN FAUST

Bloomsbury Academic
An Imprint of Bloomsbury Publishing Plc

BLOOMSBURY
LONDON · OXFORD · NEW YORK · NEW DELHI · SYDNEY

Bloomsbury Academic

An imprint of Bloomsbury Publishing Plc

50 Bedford Square	1385 Broadway
London	New York
WC1B 3DP	NY 10018
UK	USA

www.bloomsbury.com

BLOOMSBURY and the Diana logo
are trademarks of Bloomsbury Publishing Plc

First published 2016

British Library Cataloguing-in-Publication Data

A catalogue record for this book is available from the British Library.

ISBN:	HB:	978-0-8578-5553-4
	PB:	978-0-8578-5624-1
	ePDF:	978-0-8578-5568-8
	ePub:	978-0-8578-5770-5

Library of Congress Cataloging-in-Publication Data

Designing business and management / edited by Sabine Junginger and Jurgen Faust.
pages cm
Includes index.
ISBN 978-0-85785-553-4 (hardback) — ISBN 978-0-85785-624-1 (paperback)
1. Design services—Management. 2. Design—Practice—Social aspects.
I. Junginger, Sabine, editor. II. Faust, Jürgen, editor.
NK1173.D47 2016
745.4—dc23
2015016247

Typeset by RefineCatch Limited, Bungay, Suffolk
Printed and bound in India

CONTENTS

v

LIST OF FIGURES AND TABLES

FIGURES

TABLES

LIST OF CONTRIBUTORS

Daved Barry, PhD, is Professor of Creative Organization Studies in the Department of Management, Politics, and Philosophy at the Copenhagen Business School. He is also Adjunct Professor of Creative Organization Studies at Universidade Nova de Lisboa and at RMIT, Melbourne. Previously, he was the Banco BPI Chair of Creative Organization Studies, School of Business and Economics, Universidade Nova de Lisboa. He received his PhD in Management from the University of Maryland focusing on Strategic Management and Organizational Behavior. Daved has published intensively in Organizational Development and Design. He has a great interest in design, arts, and humanities-based approaches to management and organization. He researches how such design processes can be applied to innovation, creativity, change, strategy, leadership, entrepreneurship, and workplace development.

Massimo Bianchini is Research Associate and PhD Candidate at the Department of Management, Economics, and Industrial Engineering at Politecnico di Milano. His research broadly focuses on the relationship between design and "micro-production." He explores new design processes between advanced fabrication, open and distributed manufacturing, and the emerging makers' culture. Previously, he was part of the coordination group at Sistema Design Italia (SDI), a network of academic design research agencies. He also participated in Design Research Maps, a national research project studying academic design research activities in Italy (2008–2010) that received the ADI's (Associazione per il Disegno Industriale) XXI° Compasso D'Oro Prize for design research (2011). His most recent work centers on design-driven innovation for the Italian design system and how new forms of design entrepreneurship link to new emerging production models in urban contexts, local productive systems, and schools and universities.

Richard J. Boland, Jr., PhD, is the Elizabeth M. and William C. Treuhaft Professor of Management and Professor in Design and Innovation at the

Weatherhead School of Management at Case Western University in Cleveland, Ohio. He conducts qualitative studies of individuals as they design and use information. His interest is in how people make meaning as they interpret situations in an organization, or as they interpret data in a report. He has studied this hermeneutic process in a wide range of settings and professions with a primary focus on how managers and consultants turn an ambiguous situation into a problem statement and declare a particular course of action to be rational. He has approached this in a variety of ways and from different perspectives, including symbolic interaction, metaphor, cause mapping, frame shifting, language games, and exegesis. Most recently, Richard has become fascinated with narratives and designs as modes of cognition, which he believes are systematically undervalued, yet dominate our meaning-making. He is the co-author of the book *Managing as Designing* (Stanford University Press 2004) and has been involved in all Designing Business Conferences. Richard enjoys visiting at the Judge School of Business at the University of Cambridge for several weeks each semester, where he is a research director, as well as a visiting fellow at Sidney Sussex College.

Richard Buchanan, PhD, is Department Chair and Professor of Design and Innovation at the Weatherhead School of Management at Case Western University in Cleveland, Ohio. Before joining the Weatherhead faculty in 2008, he served as head of the School of Design and then as director of doctoral studies in design at Carnegie Mellon University. While at Carnegie Mellon, he inaugurated interaction design programs at the master's and doctoral level. He is well known for extending the application of design into new areas of theory and practice, writing and teaching as well as practicing the concepts and methods of interaction design. He argues that interaction design does not stop at the flatland of the computer screen, but extends into the personal and social life of human beings and into the emerging area of service design, as well as into organizational and management design. In keeping with this conviction, Richard has worked on the redesign of the Australian Taxation System, the restructuring of service products and information for the US Postal Service, and other consulting activities. Since joining Weatherhead School of Management, he has pursued research into "collective interactions," focusing on problems of organizational change and the development of management education around the concept of Managing by Designing. His most recent projects involve strategy and service design, including patient experience, information services, and public sector design. He received his AB and PhD from a prestigious interdisciplinary program at the University of Chicago: the Committee on the Analysis of Ideas and the Study of Methods ("I & M"). He has supported and contributed to the Designing Business Conferences from their inception.

Charles Burnette, PhD, received his BArch, MArch, and PhD from the University of Pennsylvania where he was also Research Associate at the Institute for Environmental Studies. Positions he held include Director of the Philadelphia Chapter of the American Institute of Architects, Founding Director of the Interdisciplinary Center for Planning Design and Construction, and Dean of the School of Architecture at the University of Texas, Austin. In recognition of his research and service, he has been named Fellow of the American Institute of Architects. Charles also taught and directed the Industrial Design Department and the Graduate Program in Industrial Design at the University of the Arts in Philadelphia, where he directed many industry- and government-sponsored projects, among them the Advanced Driver Interface Design/Assessment project. In 1994, he was recognized by *I.D. Magazine* as one of five "design mentors" who make a difference in design. He is a recipient of the prestigious Pew Fellowship in the Arts and has published widely on topics such as design management, design thinking, and design education. His Role Oriented Approach to Group Problem Solving has been taught in many schools and at several corporations. He is a frequent speaker in European design schools and at the European Union's Cumulus Program on Design Education. He was a member of the Design Leadership Advisory Board at UIAH, Finland for 10 years, initiated a program to introduce design thinking into basic education, and later co-directed Design Link for Art and Science, a state-funded project teaching art and science through design. While developing curricula in design thinking for children in Korea, he authored the website, idesignthinking.com as a resource for teaching design thinking. He is deeply committed to understanding the neuroscience underlying design thinking.

Jürgen Faust, PhD, is currently the President of Macromedia University, the biggest private university within the media sector in Germany where he is also Professor for Design and Theory. He studied chemical engineering, art and has recently finished his PhD in Design Theory at the University of Plymouth as a member of the Planetary Collegium. He worked in four different countries as a professor and as a dean at universities and was the co-founder of a private university in Germany. For several years Jürgen worked as a Consultant for Strategy and Development at the IED Group in Milan, Italy. In Mexico he was a Professor at Monterrey Tecnologico, Monterrey. Between 1999 and 2006 he worked as a Professor for Digital Media, as Chair and founder of the TIME department, and Dean of Integrated Media Environment at the Cleveland Institute of Art, USA. Jürgen designed several graduate and undergraduate programs in digital media and as well in strategic new important fields in design. Jürgen's research focuses on the transfer of art and design methodologies

into various fields, especially the field of management to enhance management models and capabilities. He has contributed to many international conferences, has published several books and contributed papers about business, design, and management, and has contributed over the years to theory-building in the design sector. Jürgen was the architect, organizer, and co-chair of several conferences in the field of business design and management, including the Designing Business conference in Barcelona, which was the foundation for this book. As an international artist, his artwork has been shown in galleries and museums in Europe and North America.

Ken Friedman, PhD, is Chair and Professor of Design Innovation Studies at the Tongji University College of Design and Innovation in Shanghai, China. He is also a University Distinguished Professor at Swinburne University of Technology in Melbourne, Australia, where he headed the Faculty of Design from 2008 to 2013 and was named Distinguished Professor of Design in 2012.

Ken has worked with national design policy in Australia, Estonia, Latvia, Lithuania, Norway, and Wales, and state design policy for Victoria. He was Advisor to the Federal Interdepartmental Committee for the Design Policy Scoping Process for the Office of the Arts in the Department of Prime Minister and Cabinet, and served as Co-Chair of the International Advisory Group of the pilot project for DesignGov, the Australian Centre for Excellence in Public Sector Design. His work is situated at the intersection of three fields: design, management, and art. He works with theory construction and research methodology for design, focusing on strategic design for value creation and economic innovation. He is Adjunct Professor at the James Cook University School of Creative Arts in Townsville, Australia.

Matthew Hollern is Professor of Art and Design at the Cleveland Institute of Art where he has taught jewelry, CAD/CAM/RP, and business since 1989. He served as Dean of Faculty (2007–2011), Chair of the Craft Disciplines, and Dean of Design and Material Culture (1997–2005). He is co-founder of Cadlaboration (www.cadlaboration.com), an inter-institutional collaboration established to contribute to the on-going evolution of the field of art and design by fostering education and substantive collaboration among artists working with digital technologies. He earned a Bachelor of Science degree in Art and French at the University of Wisconsin-Madison. In his junior year, he lived in Aix-en-Provence, France where he attended the Université Aix-Marseille, and studied art at the École des Beaux-Arts, Aix-en-Provence. In 1989, he earned a Master of Fine Arts degree in Jewelry-Metals-CAD/CAM from Tyler School of Art, Temple University. Since then, he has received research and professional development grants from the Society of North

American Goldsmiths, the Lilly Foundation, the John and Maxeen Flower Fund, the Cleveland Institute of Art, the Community Partnership for Arts and Culture-Creative Workforce Fellowship, and two Individual Artist Fellowships from the Ohio Arts Council. His work has been exhibited throughout the United States and Europe, and is included in the collections of the Renwick Gallery of the Smithsonian American Art Museum, The Vatican, the Ohio Crafts Museum, the Cleveland Art Association, Alcatel-Sprint, and in many other places around the world.

Wolfgang Jonas, PhD, studied Naval Architecture at the Technical University Berlin, earned his PhD in 1984 and his teaching qualification (Habilitation) for Design Theory in 1994. He has worked for 20 years on theory and practice in design and has invested heavily in teaching in design. Wolfgang has researched and published about knowledge production in design besides the natural sciences and liberal arts. A further interest is a methodology to develop instruments for social and economic innovations and to apply them to transportation design. He has held professorships in Halle, Bremen, and Kassel, and since 2010 he has been Professor for Designwissenschaft at the Institute for Transportation Design/Braunschweig University of Art. His current interests are design methodology, systemic and scenario approaches, and the development of the concept Research Through Design.

Sabine Junginger, PhD, is currently Visiting Professor at Macromedia University of Applied Sciences and Fellow at the Hertie School of Governance, an international university that prepares graduate students for leadership positions in government, business, and civil society. She is a founding member of ImaginationLancaster at Lancaster University in the UK, where she co-developed the "Master in Design: Management and Policy." From 2012 to 2014, she was Associate Professor at the School of Design Kolding in Denmark. Her research explores the activities, methods, principles, and practices of a human-centered approach to designing in the contexts of public and private organizations. She is particularly interested in the relationships of designing, changing, organizing, and managing. Sabine received a Master in Design (Communication Planning and Information Design) and a PhD in Design from Carnegie Mellon University. She has been involved in several Designing Business Conferences and is co-editor of this book.

Castulus Kolo, PhD, first studied physics at the Ludwig-Maximilians-University in Munich, Germany and completed his studies with a PhD at CERN, Geneva (Switzerland). Later he gained an additional PhD in social and cultural anthropology. Castulus gathered professional experience in consulting

and applied research with one of the leading top management consultancies and the German Fraunhofer Society. In 2001, he became a member of the board of directors of the corporate venture management of a large German publishing house for four years, being responsible for business development and innovation. Throughout his management career, Castulus has continued his academic activities as a lecturer at several universities on innovation management, media, and ICT. In 2007 he became Professor and in 2008 Chair of Media Management at Macromedia University of Applied Sciences, Munich (Germany), where since 2013 he has been Vice President for Academic Affairs and Dean. He has published in leading international journals and is focused on the preconditions, the diffusion, as well as the effects of (media) innovations at the intersection of economy, society, and technology. Besides his academic activities, Castulus still works as a business consultant for major companies and is founder of the foresight institute Future Directions (ck@future-directions.com).

Stefano Maffei, PhD, is an architect and Associate Professor at the School of Design, Politecnico di Milano where he teaches Service Design, Product/Production Systems Innovation, and Design Phenomenology. He is also the Director of the Master in Service Design. His current research and work interests are focused on service design innovation, design-driven innovation in local productive systems, new production-distribution models, and advanced-distributed-micro manufacturing systems. He was the Coordinator (2005–2010) of Sistema Design Italia (SDI) and he directed Design Research Maps, a national research project studying academic design research activities in Italy (2008–2010) that received the ADI's (Associazione per il Disegno Industriale) XXII° Compasso D'Oro Prize for Design Research (2011). He is a design curator for Subalterno1 design gallery, one of the most important Italian galleries for the self-production design scene.

Stefan Meisiek, PhD, is Associate Professor in the Department of Management, Politics and Philosophy at Copenhagen Business School, and a Visiting Professor at the University of Hong Kong. He received his PhD in Management Science from the Stockholm School of Economics, and his MA from the Free University, Berlin. Over the years, he has been a visiting scholar at NYU Stern, ESADE, Stanford University, MIT Sloan, Nova SBE, Osaka City University, and Macquarie GSM. His research interests concern leadership of creative teams and business innovation. He has also worked with a number of companies and government organizations on process innovation, and has helped raise start-up capital for high-tech ventures. Recently, Stefan created the Studio at CBS, an innovative learning concept and environment for management inquiry and leadership development.

Christoph Merdes is a user experience designer with a focus on information architecture, information design, service design, and design thinking. He completed his Master's degree in Media and Design with a specialization in strategic design at the Macromedia University of Applied Sciences in Munich, Germany. During his studies, he started a media company and was a conference speaker (e.g., on service design). Since 2012, Christoph has been working as a User Experience Architect for one of the leading digital agencies in Europe. He also has a Bachelor degree from the DHBW University in Baden-Wuerttemberg and has studied life science at the University of Konstanz.

Nadja Ruby and **Elisa Steltner** completed their study of product and system design at the University of Kassel in 2012. Their diploma thesis explored "design as a success factor for startups." In their research, they drew on the experiences of starting a business two years earlier, "Ruby & Steltner GbR." From the start, they were intrigued by the challenges of aging. Initially, they explored age in the context of social media but in 2012, they developed an age-simulating suit, "adit," with which the anatomic restrictions of aging can be experienced and explored. Today this suit is at the center of their business, around which they have begun to develop coaching programs for national customers interested in demographic change.

Michele Rusk is an experienced academic, government adviser, and management consultant. A member of the Design Management Institute and Fellow of the Chartered Institute of Marketing, she holds a primary degree in Design and an MBA. Her expertise includes strategic design management for enterprise and innovation development. Her experience spans new product and international market development; government strategy and policy development; and international development work in Poland, Russia, Armenia, and Ukraine. Michele leads the development of Design Management at Belfast School of Art. Prior to this she was Head of Consultancy at the University of Ulster's Office of Innovation. A former member of staff at the Ulster Business School, Michele re-joined the university after a break of 14 years when she was Director at Paradigm Shift Ltd, the management consultancy company she founded in 1994. She was adviser to the Northern Ireland government as Deputy Director of the Design Directorate and Vice-chair of Belfast's European Capital of Culture Bid. Michele is a frequent contributor at international design and business conferences, most notably the Helsinki Global Design Lab.

Oliver Szasz is professor at MHMK Macromedia University for Media and Communication in Munich, Germany. In his current position, Oliver

teaches design theory, interactive media, design ethics, and experience design in the Media and Communication Design Faculty and the Media and Design Master School. He has been with MHMK for three years. His primary research areas of interest include design thinking, human-centered design, design ethics, ethnographic research, experience design, service design, sustainable development, cultural studies, philosophy and design theory. Before joining MHMK, Oliver held positions as a design lecturer in Cape Town, as an art director in various design agencies in diverse places, such as London, the Cayman Islands, and Barcelona, before establishing his own interdisciplinary design studio in London in 2001. Oliver studied sociology, philosophy, and political science at Augsburg University prior to his studies in communication design (Dipl.-Des. FH) at the University of Applied Sciences in Augsburg. He received his Master of Arts degree (MA Design Studies, with distinction) from Central Saint Martins University of the Arts (CSM), London.

Teal Triggs is Professor of Graphic Design and Associate Dean, School of Communication, Royal College of Art, London. She is also Adjunct Professor in the School of Media and Communication at RMIT, Australia. As a graphic design historian, critic, and educator, she has lectured and broadcast widely and her writings have appeared in numerous edited books and international design publications. Her research has focused primarily on design pedagogy, self-publishing, and feminism. Her books include: *Fanzines* and *The Typographic Experiment: Radical Innovations in Contemporary Type Design*, both published by Thames & Hudson. Her forthcoming book, *The Graphic Design Reader* (Bloomsbury), is co-edited with Leslie Atzmon. Teal is also Editor-in-Chief of the *Journal of Communication Design* (Bloomsbury) and co-editor of *Visual Communication* (Sage) and Associate Editor of *Design Issues* (MIT Press). She is a Fellow of the International Society of Typographic Designers, the Royal College of Art, and the Royal Society of Arts.

Amy Zidulka joined the core faculty at Royal Roads in 2003 after two years serving as an Associate Faculty Member. Her primary research interest is in workplace creativity, which she combines with her interests in critical thinking, communication, and management education. Amy holds an MA in English from the University of Victoria, a BA in English and Writing from Concordia University, and a BSc in Architecture from McGill University. She is currently working towards a Doctorate of Education through the University of Calgary which she anticipates completing in 2015. Her dissertation topic focuses on organizational learning, creativity, and innovation. Prior to working

at Royal Roads, she made her living as a professional artist, specializing in commissioned portraits of Alaskan fishing boats. She is also a certified life coach (International Coaching Academy) and a recipient of the Royal Roads MBA Professionalism and Dedication award in recognition of her teaching excellence.

ACKNOWLEDGMENTS

There is a growing community of researchers and practitioners whose continued efforts have informed this book and on whose shoulders we stand. We got to know many of them in person over the past years. As always, one book cannot do justice to all the great work that is going on in the field. There are limits and we recognize that. In an evolving domain, despite our best efforts, we will remain incomplete. We are grateful to everyone who invests time in thinking about designing business or applies these ideas in practice, thereby contributing to an ongoing and much needed discourse this book seeks to advance. Particular thanks go to Richard Boland, Richard Buchanan, and Ken Friedman, all of whom took an active role in these efforts from the start. Xin Xiangyang from the School of Design at Jiangang University in China has also provided active support. Without the initial engagement of the Istituto Europeo di Design (IED) and the current backing from Macromedia University of Applied Sciences, this book would not have come together. Finally, we want to thank Rebecca Barden and Abbie Sharman from Bloomsbury Publishers, whose patience and encouragement have been much appreciated along the way. Thank you all.

AN INTRODUCTION TO DESIGNING BUSINESS

Jürgen Faust and
Sabine Junginger

Business in many segments is no longer sustainable. Many managers today must revisit and restate what business they and their organizations are in. Increasingly, business models that have worked for years, sometimes decades, are cracking under the weight of social, technological, economic, and environmental changes. In the search for new ways forward, many of the traditional tools are ill-suited to develop the way forward. How should one go about solving a problem when one does not yet know the problem? How should one go about making a decision when the criteria for the decision have yet to be understood? How do we conceive of radically new forms of business, come up with new business models, envision new products and new services, identify, discover or generate new resources?

Recently, design, or more specifically design thinking and other new domains of designing, such as service design, have attracted attention among business managers and many types of organizations. It is hoped a design approach will improve service provisions and develop innovative services and products. However, few of these design-driven projects inquire into how design relates or contributes to core issues and problems of business and management. Nonetheless, we can trace the origins of "designing business" to earlier work that looked at organizational or social problems as issues of design. These include, among others, *The Sciences of the Artificial* by Herbert Simon (1969 [1996]).

Simon adamantly positions both social planning and organizational problems as urgent issues of design to which design thinking and design methods apply and, more importantly, for which a design approach is necessary to arrive at alternative solutions. Designing in Simon's view, however, merely means to configure, to assemble and reassemble existing parts; that is, to

choose from given alternatives to achieve outcomes as they "ought" to be, not as they might be. This focus on discovery implicitly accepts organizational structures and business as given, with little space for re-envisioning, re-imagining, and re-inventing organizational systems.

In hindsight, Simon overlooks much of the creative and emergent characteristics of design—the very aspects of design required for designing business. However, he does point to gaps between design thinking and design doing and laments that the decision criteria recommended by business professionals seldom find application or implementation in everyday organizational life. Moreover, Simon recognizes that designing is an activity many different people engage in. Even "members of an organization or a society for whom plans are made are not passive instruments, but are themselves designers who are seeking to use the system to further their own goals," he observes (Simon, 1969 [1996], p. 153). Curiously, human experience and human interaction do not seem to factor into a design challenge. Instead, Simon sees the challenge simply as one of resolving misfits between interacting components and moving parts. Succeeding in resolving these misfits means to arrive at a configuration that satisfices as a solution.

Simon's foray into organizational design and organizational behavior remains relevant to designing business. And although he merely looked to "configure" organizations, he nonetheless highlighted the configuration of organizations "whether business corporations, governmental organizations, voluntary societies or others" to be "one of society's most important design tasks" (Simon, 1969 [1996], p. 154). Designing business acknowledges the importance of these design tasks while offering different views on the nature of design, the purpose and the tasks involved in designing.

Designing business as an idea owes much to Richard Boland and Fred Collopy who, as scholars at the Weatherhead School of Management, initiated conversations around managing as designing when they found management as a profession to be "in a difficult situation" (Boland and Collopy, 2004, p. 7). Picking up both the strengths and the weaknesses of Simon's design understanding, they identify the need for a design attitude in management practice and in the management profession. Their 2002 conference *Managing as Designing* marks a key event for research into designing business. The resulting book *Managing as Designing* (2004) critically engages with what Boland refers to as the dominant "decision attitude toward problem solving" in management practice and management education (p. 6). Both the book and the initial conference have successfully brought together researchers and practitioners from different disciplines interested in exploring issues of designing in business and management.[1] It has also spawned new and important research into what a design attitude implies (Michlewski, 2015).

Among those whose thinking has strongly influenced research into designing business and management from its inception is Richard Buchanan. The former head of the School of Design at Carnegie Mellon University has since joined the Weatherhead School of Management. His writings on "Wicked Problems of Design Thinking" (1992), "Rhetoric, Humanism and Design" (1995), and "Management and Design: Interaction Pathways in Organizational Life" (2004) count among the key literature, as does the special issue of *Design Issues* on Organizational Change (2008), which he co-edited. Buchanan, too, expands on the notion of design across different domains of professional practice. But he also reminds us that designing is about enhancing the human experience. Designing business therefore acknowledges that both business and design are concerned with "the" social, and that managing and designing are activities that are social at heart (Faust and Auricchio 2011).

As much as the concept of designing business has begun to take shape, there remain many questions as to what changes in thinking and doing "designing business" imply and require. This book presents critical reflections on concepts, methods, and practices relevant to designing business in an effort to find answers to these questions. There are two main reasons why we considered this book worthwhile. First, we felt encouraged by the depth and growing sophistication of the discussions that we are having. Much of the thinking that informed our initial conversations on designing business has now matured and become more theoretically grounded and illustrated through practical application by case studies. We want to make this knowledge accessible to a wider group of readers and anyone interested in the topic and issues. Secondly, design is now approached from different academic and professional angles. Yet, what or where design is or what constitutes a business in these different explorations is not always clearly articulated.

Indicative of these developments is current research in the field of gaming and simulation, where design questions now center on whether it is possible to calculate risks by simulating business situations through game applications (e.g., Thavikulwat and Pillutla, 2008). Other developments include research into and around business model design (e.g., Ostenwalder *et al.*, 2005; Youngwook *et al.*, 2008). Numerous efforts to establish design thinking in business and management (e.g., Rogers, 2005; Brown, 2008; Liedtka and Ogilvie, 2011) have to be considered part of this just as much as research that looks into the role of design in policy, public management, and public organizations (e.g., Briggs, 2011; Eppel *et al.*, 2011; Bason, 2014). The above is complemented by other work, such as that on design and management information systems (Garud *et al.*, 2008), design and entrepreneurship (Sarasvathy, 2008), and design in innovation (Boddington *et al.*, 2011).

We could offer endless more examples—which in itself is a sign that design and business have more in common than we generally acknowledge. At the same time, these collective works indicate the emergence of designing business as a field of research and practice. From an academic perspective, this immense curiosity about design and designing in and across different disciplines begins to beg for a search for commonalities in these design explorations. What are the key questions here? How do we frame this discourse? What is being addressed, what not? What are we overlooking? Not least because of this curiosity, we see a need as well as an opportunity for critical reflections and inquiries that can help us understand more fully the foundations and implications of designing business. Furthermore, in order to have a sense of the evolving discourse about designing business, we have to consider that discontinuity (Foucault, 1972) dominates a field of research, ensuring pre-eminent gaps in our analysis of the field.

Simultaneously, we are volunteering our view of designing business. For us, designing business involves inquiries into what a business is, does or stands for, how it goes about producing some "thing" and how it creates value. Designing business therefore depends on an understanding of what "the business" of an organization is: What is it the organization cares about, that it is troubled by? One of the obvious troubles of many businesses today is the need to re-orient itself to serve people and their communities better. It is troubling because it involves changes in organizational culture, organizational structures, and, from a designing business perspective, a change in design attitudes (Michlewski, 2008) and organizational values. If anything, this illustrates a deep connection between designing business and human-centered design. Moreover, it concerns matters of sustainability and efficiency.

Our view on designing business follows the idea that conducting business, like management, is at its heart a human and social activity (Falk, 1961; Yunus, 2011). Designing business acknowledges the presence of design activities and design practices in organizations, by management and by many others that often go unnoticed (Gorb and Dumas, 1987; Junginger, 2015), and are therefore taken for granted and escape reflection (Schön, 1983). Designing business seeks to make accessible how designing works in business, management, and organizations.

Designing business encourages us to reflect on doing business, on being in business, and on the purpose of business from a design perspective. Like our views of design, business definitions have also changed over time and like design, there is no one view of business to which everyone agrees or can agree. As a result, for some, business merely refers to the reality of being busy and occupied (Weber, 1927 [2012]); for others, it is a social act that expresses care (Dewey, 1948); some people think of business purely in the sense of a machine

to make money or achieve the highest possible return on investment; yet others consider going into business as an opportunity to be entrepreneurial and independent. These different views sometimes blur what we understand to be the purpose of business. Not long ago, it was as simple as producing material goods or services (Barnard, 1968). For Peter Drucker (cf. Watson, 2002), the purpose of a business is to generate and maintain customers. In Drucker's view, businesses (i.e., enterprises) are paid by people to create wealth for people. Creating wealth, though, goes beyond making money and monetary wealth. Money, in Drucker's view, is secondary in that it merely is an affirmation that the products developed and delivered by a business provide a value that customers are willing to buy. What Drucker highlights is that money is important to business but not its product and not its purpose. This view is echoed in the work of Nobel Laureate Mohammed Yunus, for whom profit-making is a business need but not a business purpose. The business purpose, in Yunus's view, is to add to social wealth.[2]

Regardless of which view of business we agree with, or whatever we consider to be the purpose of business, the purpose we value the most will drive our findings, our design. It is for this reason that designing business concerns itself with how we are performing our tasks; the ways we go about designing our organizations as well as all parts and aspects of what we comprehend when talking about business models.

We take these conversations and developments as starting points for our reflection on design as a discipline highly relevant for business. It is our hope that this book can serve as a platform for this reflection and contribute to the development of theories and practice in this new area.

THE BOOK CHAPTER BY CHAPTER

We hope this book contributes to the rapidly growing area of cross-disciplinary research at the boundaries of social business, social entrepreneurship, innovation studies, design management, social design, organizational design, and design research. Selected contributions by leading design and management scholars clarify the relevance and implications of designing in the business context. Taken together, the chapters sketch important issues, concepts, and principles, which apply when the purpose of doing business shifts to enhance human living. Moreover, the book offers insights into practices of designing and managing, their commonalities as well as their distinctions, and thereby begins to point to boundaries and limitations of design in business, too. Because we are limited in what we can include in a book, the full set of provocations remains accessible online.[3] What follows is a chapter-by-chapter overview.

We have grouped the chapters into four parts. Part 1 presents shifts in design that have helped establish designing business. Part 2 captures organizational and managerial developments in designing business. In Part 3, approaches to design thinking are scrutinized for their relevance and contribution to designing business. Finally, Part 4 considers the implications for design education and the teaching challenges designing business presents for Business, Management, and Design Schools.

Part 1: Design Shifts

Designing business marks a major shift in design, one that embraces management as a design discipline, business design as a meta-discipline, and that challenges us to clarify our understanding of techniques, methods, and arts in design.

In Chapter 1, "Design on New Ground: The turn to action, services, and management," Richard Buchanan discusses the relationship between design and management, which, in his view, is one of the "most important hotspots in design thinking and design practice." He explains how the turn to action, services, and management positions management itself as a design discipline and is an indication for "another radical transformation of design." Design is not foreign to management and management is not foreign to design, although, as Buchanan observes, the rise of strategy consultancies in the 1960s distorted the purpose of business and introduced a chasm between design and management. Their self-serving emphasis on analytics and profit, notes Buchanan, had a wide-ranging impact on management education and business practice that removed managers ever further from the actual products and services of their organizations. To correct and address some of these distortions that have also left their marks on design and designers, Buchanan suggests moving "students from a disciplinary understanding of their area of professional specialization toward a design understanding of the discipline." The remainder of the chapter lays out how this may be done by looking at plural meanings of design thinking and fundamental relations of design, as well as analysis of the object of design and design of the business model.

We are shown that there are different approaches to bridge and integrate design into management. Not just because every business needs a product, these traditional domains of design make clear that technical knowledge is needed to design. The same is true of management, which explains the rise of specializations in management and business schools around issues of finance, marketing, operations, accounting, and organizational behavior.

Design thinking is all the hype within those management schools that realize that the "objects" in management are not a given, they are created. But

this highly ambiguous concept has quite a wide range of features: cognitive processes, imagination, innovation and culture, as well as mind and forethought. And if such a concept is the solution to everything, then it is a quite difficult framework to work with. Design thinking enables us to view the "business model" as the prototype of an object of design.

In Chapter 2, Jürgen Faust explains why "Designing Business Matters Means Designing Business Models." He argues that there is no such object of business that is "a fact" because everything in business is an artifact: made up and negotiated by the people engaged in setting up business. Designing in the context of business, therefore, concerns business model designing for a variety of assignments. But in order to design business models, design has to undergo a transformation just as business has to change along with the metaphors we apply. Faust shows that our behaviors and actions change the moment we think of organizations as machines, for example, instead of organizations as (living) organisms. Because the metaphors we apply shape the outcomes we produce, business models and how we talk about them is imperative to designing business. Faust surmises the absence of a singular rational that can explain or capture what a business model is, what it contains, and what it does; he proposes to lean on different business model theories to extract common aspects and characteristics. This chapter establishes business design as a meta-discipline that is responsible for designing how these various domains come together.

In Chapter 3, "Thoughts on Design as a Strategic Art," Sabine Junginger draws attention to design techniques, design methods, and design as an art. Techniques, methods and arts, she states, are related but not the same. They each deserve careful attention when we seek to understand designing business. At present, however, confusion abounds and design techniques are often referred to as design methods and vice versa. To illustrate the differences between techniques, methods, and arts, she presents two stories where people apply techniques, engage other people through methods, and make use of techniques and methods as a strategic art to inquire into indeterminate situations. In her view, design as a strategic art has particular relevance for designing business. However, as she points out, understanding how design can be used as a technique, a method, or a strategic art also holds the key for design education to move from seeing business as a place for design to recognizing the opportunities of designing business: business as a place full of design activities and design opportunities.

Part 2: Organizational Developments

Business is inseparable from its organizational environment. Organizations are the places where managers struggle with failures, uncertainties, and choices

in their decisions and actions. Organizations are places with long traditions and histories of design. For these reasons, designing business has to consider organizational developments.

This section of the book opens with a chapter by Richard Boland, who takes a close look at struggles in designing and in managing. In "Struggle in Designing and in Managing," he argues that struggle as a description of process does not receive enough attention and is not recognized for its value in arriving at innovation. One of the reasons, he proposes, is a misconception about managers and artists that is rooted in a simplistic view of both: managers are only focused on decision-making and, if they have enough information, then decisions are easy to make; artists, on the other hand, have a single moment of inspiration that presents them with a complete solution. Yet, as Boland shows, the struggles involved in designing are as evident in architectural buildings as they are in historic writings about artistic endeavors. The same goes for management projects: managers hope to innovate by going beyond familiar boundaries without offending, while designers seek to surprise their public without shocking them, breaking expected patterns while presenting something desirable. For Boland, the current efforts by business schools to offer a more design-oriented education is an indication that struggle is beginning to be recognized as a value. He concludes that shifts in our educational practices start with shifts in our research to help us understand the struggle of organizing as a struggle of creating true art.

In Chapter 5, Ken Friedman presents the historical context of "Three Thousand Years of Designing Business." For Friedman, the history of designing business includes the first five books of the Bible, since they contain extensive instructions on how to organize public life, conduct legal trials, perform worship, and organize the social systems that make these activities possible. These were later manifested in the organizations of early churches that required a way to maintain common bonds and standard procedures. In similar fashion, he explains, the history of China with its military strategy and a national economy geared to support the army can be viewed as a form of designing business. Other examples he turns our attention to include the military organization of Plato's Greece, the attention to organizational issues articulated in the Islamic religion, and Machiavelli's discussions on how to organize affairs of state for national prosperity. Looking at the basis for design, he reminds us that design has been understood as a process with the purpose of achieving a goal; transferred to organizations this is difficult, since organizations may be only described as organized anarchies or as a loose collection of ideas rather than a coherent structure. Therein also lies a problem, he concludes, cautioning that a certain level of pessimism about the future of design is warranted.

Daved Barry reflects on developments in the field of organizational design in Chapter 6. He points out that early organizational design emphasized analytical aspects of engineering, focusing on business functions, business optimization, and decision-making using principles of efficiency and material science. He suggests that current research in organizational design is less interested in these aspects, positioning itself as a rational endeavor that revolves around problem-solving, contingent decision-making, and optimization. Instead, he points to several new approaches in this field that explore the implications of a broader view on design. He introduces one such approach, Analytic Organization Design (AOD), as an example of practitioners becoming more aware of other design perspectives, design thinking, and designerly methods. In Barry's view, organizational design is heading towards a new chapter of innovation and invention as it opens itself to more designerly approaches. The result may be something along the lines of what he calls "Creative Organization Design" (COD), "Human Organization Design," "Designerly Organization Design," or "Tangible Organization Design." For these approaches to succeed, however, organizational design will have to become more than an opportunity for executives to brainstorm, prototype, or otherwise "get creative." Only systematic testing over time, he concludes, will tell us when and how these innovative designs work and don't work.

Part 3: Design Thinking Approaches

In terms of methodology relevant to designing business, design thinking assumes a particular place that is evident throughout the chapters of this book. Although design thinking is often presented as a singular concept and practice, we find a range of different design thinking approaches relevant to designing business.

In Chapter 7, Charles Burnette explains what business thinking and design thinking have in common and how we can work with this knowledge. His approach to "Bridging Design and Business Thinking" is to focus on how purposeful thinking links to action. He identifies seven different purposes for thought and action, which he describes as: intentional, referential, relational, formative, procedural, evaluative, and reflective thought. Burnette proposes a framework to work with in designing business by implicitly suggesting that it is the mode of thinking as it corresponds to domains addressed by purposeful thought in business thinking, design thinking, and creative design thinking that makes all the difference and that allows us to talk about designing business.

Oliver Szasz discusses "Design Thinking as an Indication of a Paradigm Shift" in Chapter 8. The paradigmatic shift from design to design thinking, he says, is comparable to a previous change when we moved from craft to design.

Historically, design thinking expresses a shift from the creation and production of artifacts to a human-centered approach, which combines design activities with research on human needs with technological and business concerns in order to create knowledge, solve problems, and to innovate. He reflects on the changes that took place when design became separated from art and craft during the industrial revolution to provide a context for the changes that are now underway in design, induced by the shift toward design thinking. Neither of these movements occurred spontaneously but can be explained when broader social, economic, and technical—especially communicational—circumstances are taken into consideration. He goes on to explain why "traditional" design education can no longer suffice to develop design thinking practice. However, he is careful to point out that design thinking should not be considered as inherently superior to "traditional" design practice.

In Chapter 9, Castulus Kolo and Christoph Merdes approach design thinking from the perspective of innovation. In line with the previous two chapters, they also find business thinking to share common intellectual ground with design thinking, while their differences seem to be reflected in their respective practices. They propose that the coming generations of students should be trained and prepared to embrace design and management thinking equally. Combining their complementary strengths rather than polarizing them, they observe, may be achieved by teaching common theoretical foundations that exhibit similarities within the differences. Doing so, in their view, can help create an environment that is favorable to ideation and creation while making use of efficient processes to transform these creations into actual offerings. Kolo and Merdes also refer to this as bridging the gap or as domesticate "a-ha" moments. To develop their argument, they draw on the history of innovation and explore how cybernetics may be useful to differentiate between design thinking and business thinking.

Chapter 10, by Stefano Maffei and Massimo Bianchini, is entitled "Emerging Production Models: A design business perspective", and looks at the implications emerging production models have for businesses. They point out that the systemic transition at the heart of designing business relates to changes in the production model, changes in the market structure, changes in the nature of how we think of products, changes in the design process, changes in the work done by designers and, last but not least, changes in the relationship between designer and enterprise. The consequence of all these changes, according to Maffei and Bianchini, is that an individual designer now forms a company in his or her own right. The task of designing business in such a case has more to do with designing an small-to-medium enterprise or a startup and is less concerned with the highly structured and complex organizations design management has typically focused on. They identify micro-production as one

of the emerging production models that has the potential to create new products for new community-markets and a future "market of ideas." Micro-producers, Maffei and Bianchini conclude, are crafting, equipping, fabbing, and making social innovation.

The section on design thinking approaches closes with Chapter 11 by Nadja Ruby, Elisa Steltner, and Wolfgang Jonas, who take social design as a point of departure for a critique of design thinking and the design profession. In "Handmade by Love: Crochet Work and Social Business Design," they call for a deeper examination of methodological, theoretical, and epistemological aspects of the concept of "the social" that are currently in use, for example, in social design, social business design, and social transformation design. They also call on designers to develop a more nuanced understanding of their own competencies of conceiving and organizing change processes and the competencies that are needed to make moral decisions: decisions that are "preferable and good." One of the problems as they see it, is that designers often retreat to fixed moral positions that are based on personal morals but do not embrace the morals of the system they are working with. To illustrate and explore their critical hypotheses further, they discuss a case study of a social business design project, "Alte Liebe." The chapter and this section end with thoughts on social transformation design in general, its rich origins, its deficits and blind spots, and its perspectives.

Part 4: Educational Challenges

The design shifts, the organizational developments, and the different approaches to design thinking mean that designing business poses new challenges for design education. At this point in time, teaching business design is still not a developed domain within universities or Design Schools. One of the questions we face is how to educate business designers? What are the implications of management being recognized as a design discipline? Does it mean that more and more design professionals will apply their skills to business settings, or does it mean that more and more managers are developing their own design capabilities? These questions are at the center of the final section.

In Chapter 12, our focus turns to the challenges designing business presents for education. Stefan Meisiek's question "A Studio at a Business School?" is aimed at understanding what the studio approach that originated in the art studio implies for business schools and business education. He explains that the idea of a business studio makes more sense than one might think at first glance when we consider that, historically, business schools had more in common with art and design schools than with the natural and social sciences.

There was a time, Meisiek tells us, when managing "was seen as a craft," organizing "as a design task," and leadership "as an art form." In some ways, design thinking has shed new light on the creative and crafty side of management and business. But it has also generated a range of questions, including: "Can design and science co-exist in business schools?" "What should studio pedagogy for management education be like?" "And what alternative sources for studio work are there?" Meisiek challenges the notion that design thinking offers enough of a framework for design pedagogy and studio work at a business school. Instead, he says, we need to look beyond design thinking to discover what other sources and resources might help us bridge academic content and design process to address systemic issues.

Chapter 13 by Teal Triggs deals with the education of graphic designers in the UK in an environment that is more and more shaped around the economic needs of government and the demands of industry. She offers an encouraging prospect for how educators may respond to these challenges and highlights the "malleable nature of graphic design" that can adapt by forming new "subject hybrids." Reporting on a project with Hyundai Motors and postgraduate students in graphic design from the Royal College of Art in London, she describes a possible educational model for knowledge exchange to respond to these needs and demands.

Matthew Hollern shows that designing business also has relevance to how design faculties go about their business of developing curricula. In Chapter 14, he argues "Collaboration Requires Design Thinking." Hollern is puzzled by his experiences in the educational environment where faculty often get together to draw up new plans and new strategies, but often end up shelving them because there is no commitment to their concepts and, more importantly, no link that connects these plans and strategies with the actual daily operations of the department or school. He envisions higher education as a laboratory of design thinking, a "collaborator" that echoes the format of a working conference. In this laboratory, faculty would develop a curriculum catalytic to experiences, strategic to achieve objectives, and ultimately supportive to designing, thinking, and learning. The result would be a new model curriculum for art education, which he describes for us.

Chapter 15 by Michele Rusk points to challenges in design management education and in design management scholarship. "Translational Design: The Evolution of Design Management for the Twenty-first Century" criticizes the continuous focus of design management on the relationship of design and designers with management and takes the "plethora" of different terms that have emerged over the past years as an indication that "design management" no longer aptly describes and captures what is going on in designing business. Rusk sees the need for a new term and suggests "Translational Design" would

better describe the developments concerning management and design. She concludes with calling for a New School of Thought and presents a curriculum for twenty-first-century design management.

Chapter 16 closes the collection. In it Amy Zidulka shares her thoughts and experiences of introducing a design approach into the curriculum of an innovation program. Rather than insisting on introducing design thinking, she and her initially skeptical colleagues developed a new language and a new method. Her chapter reflects on the reasoning behind these steps and on the first experiences with MBA students. Creative Problem Solving, or CPS, she explains shares with design thinking that it is a structured process for navigating complex, open-ended problems, yet builds and embraces analytical thinking, which business students already understand. In addition, CPS, like design thinking, emphasizes user empathy and prototyping. The hybrid CPS-design thinking model, she suggests, may work for students and educational environments where the introduction of design thinking may lead to confusion. In her view, CPS offers the advantage of being more closely aligned with existing managerial approaches to problem-solving.

NOTES

1. "Managing as Designing" took place at the Weatherhead School of Management in Cleveland, Ohio. Subsequent Designing Business Conferences were held in Milan, Italy, 2010; Barcelona, Spain, 2011; and Wuxi, China, 2014.
2. Mohammed Yunus contributed to the first conversations around designing business.
3. http://www.designbusinessconference.com.

REFERENCES

Barnard, C. I. (1968) *The Functions of the Executive*, Cambridge, MA: Harvard University Press.

Bason, C. (2014) *Design for Policy*, Farnham, UK: Ashgate/Gower.

Boddington, A., Grantham, A. and Hobday, M. (2011) "Design and Innovation at the University–Business Interface."

Boland Jr., R. J. and Collopy, F. (eds.) (2004) *Managing as Designing*, Palo Alto, CA: Stanford Business Books.

Briggs, L. (2011) "The Boss in the Yellow Suit or Leading Service Delivery Reform," a Valedictory Address by Lynnelle Briggs on the occasion of her retirement from the Australian Public Service on July 7, 2011, unpublished.

Brown, T. (2008) "Design Thinking," *Harvard Business Review*, 86 (6), 84–92.

Buchanan, R. (1992) "Wicked Problems in Design Thinking," *Design Issues*, 8 (2), 5–21.

Buchanan, R. (1995) "Rhetoric, Humanism, and Design," in R. Buchanan and V. Margolin (eds.), *Discovering Design: Explorations in Design Studies*, Chicago, IL: University of Chicago Press, 23–66.

Buchanan, R. (2004) "Management and Design: Interaction Pathways in Organizational Life," in R. J. Boland Jr. and F. Collopy (eds.), *Managing as Designing*, Palo Alto, CA: Stanford Business Books.

Dewey, J. (1948) "Common Sense & Science: Their Respective Frames of Reference," *Journal of Philosophy*, XLV (8), 197–208.

Eppel, E., Turner, D. and Wolf, A. (2011) "Future State 2," Working Paper 11/04. Institute of Policy Studies, School of Government, Victoria University of Wellington, New Zealand, June.

Falk, R. (1961) *The Business of Management*, London: Penguin Books.

Faust, J. and Auricchio, V. (eds.) (2011) *Design for (Social) Business*, Milan: Lupetti.

Foucault, M. (1972) *The Archeology of Knowledge and the Discourse on Language*, translated by A. M. Sheridan Smith, New York: Pantheon Books.

Garud, R., Sanjay J. and Tuertscher, P. (2008) "Incomplete by Design and Designing for Incompleteness," *Organization Studies*, 29 (3), 351–371.

Gorb, P. and Dumas, A. (1987) "Silent Design," *Design Studies*, July 8 (3), 150–156.

Junginger, S. (2015) "Organizational Design Legacies and Service Design," *The Design Journal*, 18 (2), 209–226.

Liedtka, J. and Ogilvie, T. (2011) *Designing for Growth: A Design Thinking Tool Kit for Managers*, New York: Columbia Business Press.

Michlewski, K. (2008) "Uncovering Design Attitude: Inside the Culture of Designers," *Organization Studies*, 29, 373–392.

Ostenwalder, A., Pigneur, Y. and Tucci, C.L. (2005) "Clarifying Business Models: Origins, Present, and Future of the Concept," *Communications of AIS*, 15 [http://www.softwarepublico.gov.br/file/16723017/Clarifying-Business-Model.pdf; accessed July 29, 2014].

Sarasvathy, S. (2008) *Effectuation – Elements of Entrepreneurial Expertise*, Northampton, MA: Edward Elgar.

Schön, D. (1983) *The Reflective Practitioner: How Professionals Think in Action*, New York: Basic Books.

Simon, H.A. (1969 [1996]) *The Sciences of the Artificial*, 3rd edn., Cambridge, MA: MIT Press.

Thavikulwat, P. and Pillutla, S. (2008) "A Constructivist Approach to Designing Business Simulations for Strategic Management," *Simulation Gaming*, 41 (2), 208–230.

Watson, G. H. (2002) "Peter F. Drucker: Delivering Value to Customers," *Quality Progress*, 35 (5), 55–61.

Weber, M. (1927 [2012]) *General Economic History*, New York: Courier Dover Publications.

Youngwook Kim, Youngho Lee, Gyoungsoo Kong, Hyunjung Yun and Sukgwon Chang (2008) "A New Framework for Designing Business Models in Digital Ecosystem," *Proceedings of the 2nd IEEE International Conference*, 2008, 281–287.

Yunus, M. (2011) "What is Social Business?" Keynote presented at the 2010 Milan Conference "Designing Social Business," in J. Faust and V. Auricchio (eds.), *Design for (Social) Business*, Milan: Lupetti, 20–22.

DESIGN SHIFTS

PART **1**

CHAPTER 1

DESIGN ON NEW GROUND
The turn to action, services, and management
Richard Buchanan

We are at another of the turning points that have marked the evolution of design over the past hundred years. Design is undergoing another radical transformation, a turn toward action, services, and management. My task in these opening remarks is to provide the setting for what we will be discussing. I hope you feel the energy and urgency of what we are pursuing in this meeting. Four years ago, I moved from the School of Design at Carnegie Mellon School to the Weatherhead School of Management at Case Western Reserve University. At the time, I received calls and e-mails from friends and colleagues around the world who were puzzled, wondering why I would leave a leading design school for a school of management. The reason is perhaps evident now that the relationship between design and management has become one of the most important hotspots in design thinking and design practice. This was the theme of our conference, and we explore what the future of design may be now that it is more closely aligned with management than at any time in the past.

This was one in a series of conferences held around the world on the theme of design and management. The conferences have ranged from one on social business organized by the same thought leaders who have organized the 2015 conference to a conference held in Boulder, Colorado in 2014 on human interactions and relationships, where the issue of human beings, design, and

management was a central theme. The 2014 conference held in Copenhagen focused on public sector design, where we learned of the emerging work of MindLab and other European organizations, as well as very interesting work being carried out in Australia at ThinkPlace, Second Road, and elsewhere. But it was at a 2011 conference on service design held in San Francisco that I detected a very puzzling attitude that is most relevant for our present meeting. As several speakers were making their presentations, they took time to apologize for discussing management issues in what, I believe they assumed, was simply a traditional design conference. I found myself wondering why. Why were they apologizing for raising important management issues while discussing service design?

I thought about this throughout the meeting until I finally began to understand what I was observing. The group was wrestling with its understanding of "what had been" and "what will be" in the world of design. Design, itself, is at an important transition point between the object of design as it was understood in the past and what the object of design will have to be in the future. When I gave the closing keynote address for the conference, I made no apology for discussing design and management. Instead, I presented some of the central reasons why it has become important and perhaps essential for designers to consider the relationship between design and organizational life in their work. I was blunt, but the audience responded with surprisingly strong applause. I believe that designers have begun to realize the significance of the new direction that the field is taking, even if we are not entirely sure of the paths that we will follow. My presentation in this chapter will address a few issues that I believe will emerge frequently in the remainder of the book as we, too, wrestle with the relationship of design and management.

The first issue emerges from the history of design and management. It concerns the purpose of organizations and the relationship between design and management. And it also reminds us that design has always been deeply involved in organizations and management, even if from an outsider's perspective. In the first decades of the twentieth century, design played an important role in developing the products of business and industry in Europe and the United States. Indeed, this is a story that has provided identity and definition to the early design disciplines, particularly industrial design but graphic design also. Designers were respected, and they brought vision and disciplinary strength to their work. For the most part, however, designers were outside the core of business decision-making and management.

Despite their outsider status, designers have struggled to find a way to bring their understanding of design in a sensitive, personal or humanistic way into the management context. The struggle has been complicated by a distorted understanding of the purpose of businesses and organizations that emerged in

the 1960s with the rise of strategy consultancies, such as the Boston Consulting Group, and their subsequent impact on the education of MBA students. These consultancies changed the way managers thought about their businesses, marking a turn toward analytics as the central tool of decision-making. The story is told well in *The Lords of Strategy*, a book by Walter Kiechel III (2010), in which he provides an intellectual history of the rise of the strategy consultancies, including BCG, Bain, and others whose names we all know well.

Reading this book from a design perspective, it is clear that the consultancies created "products" that could be sold to businesses. The products involved careful analytical tools that could be used to assess the progress of companies in the marketplace, their competitive position, and so forth. The products of these consultancies required calculation and quantitative analysis. To support these tools, business schools shifted their educational programs toward training programs that prepared a new class of MBAs, the "analysts," skilled in quantitative methods but often without an understanding of the products and services on which a company stood. Analysis was the base of the new curricula and analytics is what got jobs for students, feeding the growing need for "competitive strategy." The consequence was a growing misunderstanding of the purpose of business and organizations in general. Profit became the purpose, rather than "production of material goods, or services" (Barnard, 1968, p. 154). Of course, there is a long history of conflict regarding the true purpose of organizations, a battle over the priority of "profit" or "providing goods and services"—and the proper relationship between the two. But the strategy consultancies tilted the balance toward profit as the purpose of organizations. And it certainly was profitable for the consultancies.

This history is a backdrop for the new engagement of design and management. Design or design thinking returns our understanding to a focus on the quality of products and services. We recognize that profit is one of the factors that make a business sustainable, but purpose is found in the customer, the human user, and his or her experience of what is meaningful in the offerings of organizations. Design offers insights into how we may reform management education and explores the closer relationship of design and management.

Perhaps we ought to begin with recognition that designers and managers are not two separate groups. The history of the rise of management in the twentieth century is the history of a design discipline. Each of the major schools of management represents an effort to improve the quality and strength of organizations so that they may be better designed. Indeed, it is arguable that the most important design products of the twentieth century are neither products of graphic design nor of industrial design but products of management: the design of organizations, without which no other design discipline could

have any impact on society and the lives of human beings. As George Nelson (1979) wrote in *Problems of Design*:

> One of the most significant facts of our time is the predominance of the organization. Quite possibly it is the most significant. It will take time to realize its full effect on the thinking and behavior of individuals. In this conditioning process, few escape its influence.

We have been slow to recognize that management, itself, is a design discipline, but that recognition is emerging today—foreshadowed in the work of individuals such as Herbert Simon (1996), who is well recognized in both design and management as a pioneer of theory and practice.

In my own teaching of MBA students in the capstone course at the Weatherhead School of Management, I have two objectives. Certainly, one is to help young managers-in-the-making understand and appreciate the process of designing and developing products and services. A common complaint about managers is that they have lost touch with the products and services of their organizations, absorbed as managers are with the analytic side of business. Part of my work is to help correct this. My course is organized around a design process, and I attempt to integrate along with design principles and process an understanding of strategy and marketing as they impact the boundaries of the objects of design. My second objective is to teach design as a management practice in itself—not something to be managed but a way of managing. In fact, there are three major areas where "managing as designing" affects organizations, whether those organizations are for-profit businesses or not-for-profit organizations. The areas are vision and strategy, operations, and the development of goods and services. We could add greater refinement to these three, distinguishing in more detail where design can play a role—for example, in corporate governance—but the broad division is adequate for now. I imagine that as our work progresses in the future we will begin to see such refinements.

Comparison among schools of design and schools of management can be useful. For example, I have found that many schools of management are beginning to address the first objective, though with varying degrees of commitment. Our effort at the Weatherhead has probably been the most thorough, with a two-semester course and a variety of sponsors from business and not-for-profit organizations. Most often in other schools, there is a course in product development—usually taught by an adjunct professor or lecturer—and sometimes only a two- or three-week module. Beyond this, however, I have found only a few schools that are involved in the pursuit of the second objective, teaching students how to manage with design principles and practices. This is surely the most challenging area for work, because the projects can become very complex and intangible, challenging the concreteness that

designers appreciate and seek. But it is also the area with the greatest promise for deeply affecting organizational life. Embedding design in the work of managers is a long-term enterprise for the field and for individual organizations. This is something I have encountered in my own work with large public sector agencies. In one case, embedding design was a desirable and explicit goal. In another case, it was not possible and my team had to pursue another approach involving the design of an "evolving system." Regarding such problems, of course, I recommend John P. Kotter's *Leading Change* (2012) as a good place to begin to understand the challenges design faces and the relationship between his "eight-step process" and the design process at this level of work. The bridge across the spectrum of design and management is complicated and not easy, but there is no inherent division except in our prejudices and old learning.

Putting aside the well-trodden ground of product development, there are important issues in the effort to advance design as a practice of management. Every area of design involves some level of technical knowledge that is specific to the problems designers seek to address. In graphic and communication design, for example, there are technical matters relating to the production process, fonts, and hierarchies of information. In industrial design, there are technical issues regarding materials, industrial production processes, and so forth. The same is true for work in the area of management. There are certain kinds of technical knowledge that are valuable and inherent in effective management. Indeed, these kinds of knowledge explain the rise of specializations in management and business schools around issues of finance, marketing, operations, accounting, and organizational behavior. These areas are often silos of learning, and over time they have become remote from each other in the overall enterprise. We train for the technical specialty and neglect educating for their integration in the synthetic work of managing and leading organizations.

I believe it is an urgent challenge for all areas of design to move students from a disciplinary understanding of their area of professional specialization toward a design understanding of the discipline. What I mean by this is that designers (including managers, of course) must, naturally, have grounding in the special features of their area of design, but they must also be able to see over the wall of specialization and understand how to cross disciplines to gain a more holistic perspective. I believe this is why we have begun to talk about "design thinking" in many places.

"Design thinking" is a highly ambiguous term. There are at least four variations that I have seen in the literature and detected in conference presentations (Figure 1.1, overleaf). The first variation is that "design thinking" is a cognitive process related to information processing and decision-making. This is a common view, particularly among a school of design researchers who

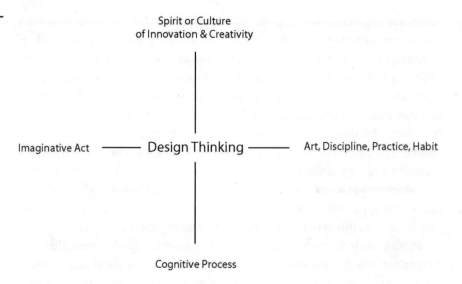

can trace their roots to the work of Herbert Simon. The second variation is that "design thinking" is an act of imagination. This is a common view among some design consultancies and among some design schools that are located within art schools. It prizes the ability of designers to imagine new possibilities of form, function, and style. Some management schools seem to believe that this is also part of the task of teaching: to help MBA students "expand their imaginations." The third variation is that "design thinking" is a spirit of innovation and culture in which some individuals participate and in which some organizations rise through shared values and creative passion. This is a common view among those who emphasize culture and transcendent values in our lives. The fourth variation is that "design thinking" is a discipline of mind and forethought, a practice that can be taught and that can become a habit for the most gifted and dedicated individuals. This, too, is a common view among designers of all professional orientations. It is the humanistic view of design and the work of designers. Indeed, it is close to Peter Drucker's view of entrepreneurship as a practice and a discipline whose principles and processes can be articulated and taught. For this perspective, I recommend Drucker's seminal *Innovation and Entrepreneurship* (2012), a compelling account that has echoes of design throughout.

"Design thinking" is a controversial concept in current discussions of design and innovation. It is controversial because it has taken on divergent meanings in design theory and practice and because the term has often been exploited without a nuanced understanding of the different avenues it opens up for consideration and action. However, the term remains meaningful and useful as long as the different meanings are understood. The preference among

these meanings in my own work is perhaps evident, because I have been intent on building the discipline of design and understanding the many areas of application that have transformed our world over the past century.

One of the reasons that design thinking remains a useful concept in exploring the relationship between design and management is the comparison it makes possible as we think about businesses in particular and organizations in general. The language of design and the language of management do not, at first, seem to be closely related. There is great complexity of terminology in business and it is not easily accessible without some kind of Rosetta Stone. Design thinking provides that Rosetta Stone. Design thinking allows a translation that is both meaningful and useful for students and professionals. For example, it allows us to see the "business model" as the prototype of an object of design (Figure 1.2). In a business model, the value proposition is the equivalent of the function of the product—what the product seeks to deliver to a user or community of use. In turn, the business model requires an understanding of the relationships among the value proposition, resources, people, and the form or structure of the organization that must deliver the value. Form, matter, people, and the manner of design and production— the classic terms of analysis in industrial and communication design. The correspondences are direct and sometimes surprising, once one gets past the "magical" terminology used to exert professional authority.

I also find it useful to get across a designer's understanding of the nature of a product as the synthesis of logos, ethos, and pathos: the technological

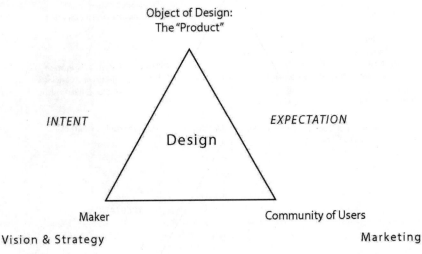

Object of Design:
The "Product"

INTENT

Design

EXPECTATION

Maker

Community of Users

Vision & Strategy

Marketing

ENVIRONMENT:
SOCIAL, CULTURAL, NATURAL

Figure 1.2
Fundamental relations of design
© Richard Buchanan

Figure 1.3
Analysis of the object of design
© *Richard Buchanan*

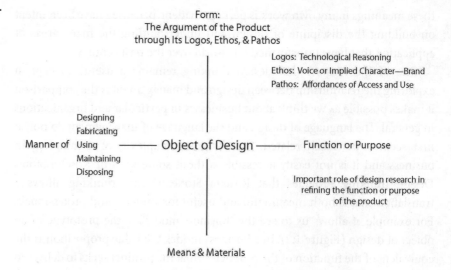

Figure 1.4
Design of the business model
© *Richard Buchanan*

reasoning and logic of form, the character or voice expressed in the product, and concern for the limits and capabilities of the user—the affordances that are gestures of accessibility to the product (Figure 1.3). These terms have a direct application to our understanding of organizations. One looks for the logic of the business—how it will make and deliver goods and services, with a clear understanding of revenue streams and cost structures (Figure 1.4). One looks

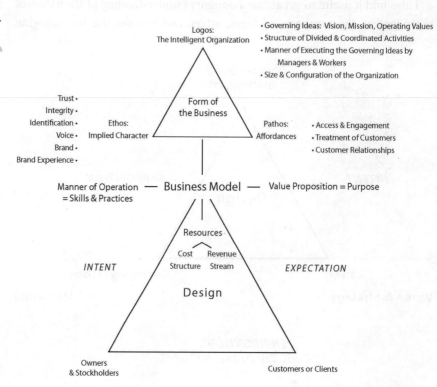

for the ethos or perceived character of the business, often seen in terms of the qualities of brand. And one looks for the affordances offered to customers: access and engagement with customers, treatment of customers, and customer relationships.

I would like to conclude with some observations on the arts by which we explore the relationships between design and management and the arts by which the work of design and management is carried into the world in theory and practice. In the course of the twentieth century, two intellectual arts provided the connections and themes for discussion. Whether in theory or practice, both designers and managers turned to the intellectual arts of logic and grammar for the tools to build the disciplines. To make this concrete, it is appropriate to point out that there were two great accomplishments of the Bauhaus school of design. The first was an exploration of form and function as the logic or poetics of production in graphics and industrial design. As further evidence, we should turn to Moholy-Nagy's "Design Potentialities." Included in *Vision in Motion* (1947), this brief article is a brilliant statement of the logic or poetics of design—certainly one of the best expressions of design thinking in the twentieth century. However, when one studies the materials of the Bauhaus carefully, Gropius also points toward a new grammar of communication as one of the greatest, if not the greatest, accomplishment of the school. Most of the design theories built in the early and middle decades of the twentieth century were constructed around the arts of grammar or logic.

In the last thirty or forty years, however, an important change has occurred in the intellectual arts that has shaped inquiry into design and management. There has been a pivotal move toward rhetoric and dialectic in design—the communicative and social aspects of design as a practice and the objects of design thinking. Whatever the technological changes that we have seen, the more fundamental change in our thinking is the turn toward rhetoric and dialectic. These arts reflect what I call the third and fourth orders of design. Particularly in the fourth order of design, the designer does not possess all of the power to effect new products. The designer becomes a facilitator of the work of others, helping people to come together, organize themselves properly and productively, and encourage the kind of participation that leads to a vibrant and healthy community. If one needs examples of the turn toward dialectic in design practice, it is useful to study the work of MindLab in Copenhagen and the Helsinki Design Lab. Both are examples of fourth-order design and the new uses of dialectic in theory and practice. I could cite examples from the emergence of dialectic in management, as well. The work of Peter Drucker is a prime example, but it is perhaps enough for us to consider the conduct of our conference and how we will work together to explore design and management in a new synthesis.

REFERENCES

Barnard, C. I. (1968) *The Functions of the Executive*, Cambridge, MA: Harvard University Press.

Drucker, P. (2012) *Innovation and Entrepreneurship*, reprint, London: Routledge.

Kiechel III, W. (2010) *The Lords of Strategy*, Boston, MA: Harvard Business Review Press.

Kotter, J. P. (2012) *Leading Change*, Boston, MA: Harvard Business Review Press.

Moholy-Nagy, L. (1947) *Vision in Motion*, Chicago, IL: Paul Theobald.

Nelson, G. (1979) *Problems of Design*, 4th edn., New York: Watson-Guptill Publications.

Simon, H. A. (1996) *The Sciences of the Artificial*, 3rd edn., Cambridge, MA: MIT Press.

DESIGNING BUSINESS MATTERS MEANS DESIGNING BUSINESS MODELS

Jürgen Faust

Following contemporary design theory, it is clear that design is moving into new domains, into new fields, into new orders as Buchanan called it (Buchanan, 2001), or into artificiality as Krippendorff framed it in his statement on the "trajectory of artificiality" (Krippendorff, 2006). Within such a context it's no surprise that the field of business is becoming a well of interest for designers and managers who are pushing to apply design and design thinking to business (Boland and Collopy, 2004). More or less all disciplines, everything that we do, where we change something, is designing, but not necessarily conscious designing. But if it is a purposeful creation, then we could call it "design."

Thus, under such circumstances design can itself be seen as being designed; it is also a matter of designing, if design is purposefully adjusted to fit a new frame (Faust, 2015). Therefore, we can say that design is not a given and it is moving into a new field of designing—designing business—which requires that we look carefully at what design means in this context. Meaning changes in the new context, in other words how we have to redesign design, so that we don't mislead and confuse the reader coming from a more traditional understanding of design, for instance that design is problem-solving. As a result, designing business requires looking at designing and its possible understandings, reframing those understandings if necessary to adjust to the needs of designing business. It is an investigation into design as well as an investigation into business and elaborating what design can provide in this context, how design can be conceptualized by designing business. Therefore, we start with the issue of business, since it might

frame the requirements of designing and provide a better means of looking into designing, narrowing down the possible understandings.

WHAT IS BUSINESS?

A common view of business is an organization involved in goods or services, interfacing with customers, and for profit. A more radical understanding, in the sense of the etymology of business, stems from the state of being busy, and being busy can be understood as commercially viable and profitable work. But business can be understood also as a particular organization, a market sector, for instance the media, transportation, trade. But it can indicate as well an organization ... a certain company, a certain business. Or in a more general understanding, it can mean all activities by all the suppliers of goods and services, the business.

All these definitions and understandings are references to an activity in the sense as outlined above, so we talk not activity business, we are talking in words, we are talking in language, metaphors to grasp what is out there, the activities mentioned. We are not talking business; we are talking about "business" using metaphors and models, what we think the activities mean and indicate. An exception would be if we talk about the activity, being busy (business) of talking, here the difference between the activity and language would collapse into one.

The same construct—or frame—applies when we speak about business organizations, business processes, business structures, and business models. Doing so we end up with metaphors and models, language constructs, of what we call business. We end up with a language reference, what we think the activity of business is, and we continuously adjust these models in light of the experiences we have so that our metaphors and the models we use fit. But the reverse is also true, since the "reality" of business changes with the metaphors we apply. A bold example is thinking about business as a mechanical construct, where each part of the business has a fixed and defined link to the other parts. For instance, the strategy is a fixed part of the business plan and the business processes are systematically fixed within the creation of value.

With such a metaphor we come to realize that our conception of business follows the metaphorical models. A quite different conception arises with the more fluid business metaphor, thinking of business as a biological entity, a being that lives. Such a being processes food, creates value through digestion and grows, breathes, and moves along. Gareth Morgan (2006) applied a set of successful metaphors to business organizations but also highlighted the limitations: Organizations as Machines, Organizations as Organisms, Organizations as Brains,

Organizations as Cultures, Organizations as Political Systems, Organizations as Psychic Prisons, Organizations as Flux and Transformations, and Organizations as Instruments of Domination. Reading and Organization is authoring an organization (Morgan, 2006).

The metaphors we apply to conceptualize the kind of metaphors are responsible for the outcome produced. Therefore, talking about business is inextricably linked to the underlying model applied, as it is a language statement to be constructed in attempting to provide an answer. That brings us very close to Krippendorff's claim that design must continuously redesign its discourse and itself (Krippendorff, 1995, p. 12). And that applies to business also, which brings us to the problem of redesigning its discourse and itself, since it is in redesigning the metaphors (models) we apply that we get better insights.

Thus we cannot answer the question of "what is a business?" without addressing the question of modeling and the issue of a definition of a metaphor. Summarizing the first thoughts we can legitimately, without any concern of inadequacy, expand the question of a business to that of "what is a business model?," since we are modeling business when we are asking "what is a business?" Applying metaphors to business, to such an activity of being business, is therefore a basic designing act, since it generates what we see as business. But stating such modeling is designing introduces us into a vicious cycle, since what we are trying to understand is a result of a designing act, applying metaphorical language. Therefore, to exit this cycle is to look at the understanding of business models, of existing model theories.

Some answers as regards modeling can be found in the work of Stachowiak, who speaks about the characteristics of a model:

a. representation: a model is always an image of something
b. simplification: a model reduces the number of parts to the original by only capturing relevant parts
c. pragmatism: any model is created for a special purpose, and this purpose is specified for certain users within a certain period of time.
 (Stachowiak, 1973, p. 131, my translation)

Therefore, in speaking about a business, or a business model, we are implicitly discussing an image of a business, which is a simplification of the real business, with a limited number of parts. It is a pragmatic approach, as we want to use it for a certain purpose (use of the model) and need to change the model as the purpose changes. "Therefore a metaphor or model is paradoxical. We can create insights, but it is in the same time a distortion, as the way of seeing created through metaphor and models, becomes a way of not seeing" (Morgan, 2006, p. 5).

Another perspective can clarify the "not seeing" aspect further. For instance,

> a business (the author: model) can also be seen as a complex system, therefore some system thinking and theory might help us here as well. For instance, a complex system implies (not always) the following attributes:
>
> (1) a complex phenomenon consists of many parts (or items, or units, or individuals);
> (2) there are many relationships/interactions among the parts; and
> (3) the parts produce combined effects (synergies) that are not easily predicted and may often be novel, unexpected, even surprising.
>
> (Corning, 1998, p. 200)

Every company, as a system, acts within a larger system, whereby the market and a business model always ignore some parts of the larger system, or ignore other systems that participate within the market system. It may also ignore the interdependence of different systems (competitors for instance), or the position of the specific business within the business environment. Reflecting on these issues, Morgan adopts the idea of Ludwig Bertalanffy, an expert in theoretical biology, who developed an open system idea. In other words, he sees businesses as organisms, in that they are open to their environment and need to achieve an appropriate relation with their environment in order to survive (Morgan, 2006, p. 38).

Therefore, business model designing is system designing; however, it must be open system designing, in order to match our ideas and metaphors of design business (models). Moreover, given that open systems are complex, the designer needs to think in different categories and approach the designing process within different frameworks.

When designing a business, the framework becomes the business system, where the focus is on the changes within the existing business system toward the desired goal. The business model (recipe for business) by itself, even as an open system, could still be designed by an individual; still, within an existing business, there are other actors and stakeholders involved, who are likely to have other interests and speak other languages, and these other actors need to be taken seriously. To frame business systems, many authors have provided their views, some of which are given below.

> We define a business model as consisting of two elements: (a) what the business does, and (b) how the business makes money doing these things.
>
> (Weill *et al.*, 2005)

This is a basic and simple description, but a very common model used. For Magretta (2010, p. 3), referring to Drucker, the answer lies in a good business model:

> Who is the customer? And what does the customer value? It also answers the fundamental story every manager must ask: How do we make money in this business? What is the underlying economic logic that explains how we can deliver value to customers at an appropriate cost?

Another approach, as proposed by Osterwalder *et al.* (2005, p. 17), is to define the various elements:

> A business model is a conceptual tool that contains a set of elements and their relationships and allows expressing the business logic of a specific firm. It is a description of the value a company offers to one or several segments of customers and of the architecture of the firm and its network of partners for creating, marketing, and delivering this value and relationship capital, to generate profitable and sustainable revenue streams.

Johnson *et al.* (2010, p. 13) suggest a similar approach:

> A business model consists of four interlocking elements (customer value, proposition, profit formula, key processes) that taken together create and deliver value.

Hence, when designing a model, we must accept that the business model is a conceptual tool, an image that provides insight, but also provides "not seeing", and answers the question about the customer, stakeholders, and the value creation for the various stakeholders. There is no way to prevent that. There is even a conditional quality which needs to be stated: the more fuzzy and open such a model is, the more unusable a model is, the less "not seeing" it provides. Or the other way around: we can say that the more defined such an image and model is, the more "not seeing" it provides, the more blindness it generates. As phrased by Baden Fuller and Morgan (2010, p. 160):

> Of course many other business model taxonomies could be constructed —indeed, each business model definition will focus on different characteristics and so is likely to produce a different set of classes and so possibilities for classification. For those concerned with taxonomy in management—as in biology—there is no fixed number of labelled boxes, rather a set of kinds which may grow or change over time as ideas and knowledge about things in the world develop. For example, the models of industrial economics developed in the early half of the last century characterised types of firms according to their number in an industry

and their competitive behaviour on the basis of pricing, whereas now (according to game theory) industrial behaviour is more likely to be characterised by a firm's strategic possibilities and choices, which provides quite a different taxonomy. Each different way of sorting—based on new ideas, new empirics, or even new business experiences—may reveal different aspects to be of importance and so different elements to be analysed, . . .

Baden-Fuller and Morgan state clearly that the metaphorical reference is one of the key elements to choose from. In their view, an indefinite number of models is possible, because there is no fixed number of labeled boxes, rather a set of kinds which may grow or change over time as ideas and knowledge about things in the world develop. They see business models as having various functions and indicate the following: Business models are recipes to follow, they are scientific models or scale and role models, and very often they take any—or all—of these different roles for different firms and for different purposes.

Baden-Fuller and Morgan (2010) also indicate categories of models that are generated. They highlight three areas: models to be copied, models to make experiments, and models based on observation and theorizing, a taxonomy if you like, where a bottom-up approach through observation and empirical work is the base, there are types derived top-down through conceptual and theoretical work to classify firms, and there are ideal types, which derive from statistical measurement and analysis of firm characteristics. In the last area, exemplary cases and their analysis drive the outcome (ibid., p. 162). Business models serve various functions but in general they serve to gain more knowledge, exactly as biological models do. In general, they serve several functions, they serve as model organisms for investigation, they are descriptions of "kinds" in a taxonomy, and they are recipes for business and for reshaping business. The last point in particular is pretty clearly designing, since "firms experiment, change, refine and re-invent their business models" (ibid., p. 165). They might not only be considered as recipes, they lie between principles (i.e., general theory) and templates (i.e., exact and exhaustive rules) (ibid., p. 166). But the description of business models as recipes and the analogs and references to cooking from Baden-Fuller and Morgan (ibid., p.167) are quite interesting, since it sees business modeling not directly in the context of design but in the context of art and craft. The recipe would be the kind of dish chosen and how the company will perform depends more or less on the skills and interpretations of the cook. We could also say that a business model can be understood as the notation of a musical piece, which is performed by the members of the orchestra. In some instances, the orchestra would be a better

metaphor since the product is ephemeral, much more so than the outcome of a recipe. But both metaphors fit somehow, because the enactment of the "business," "musical piece," or "dish" is obvious. A business can't be stored, only some of its products may if these products are not services. A dish can be preserved, as music can be recorded and stored and listened to, but it is not the performed music, it is not the performed dish if we warm it up after being in the deep-freeze. The metaphor of a theatre piece works in the same way, but the recording will give us limited information, since the channels and the sensorial impressions accessible through a video or movie are quite limited if we compare them with a real-life performance.

Business models are metaphors and they have multivalent characters as models, role models to be copied, or they describe a business organization so that we can handle it, categorize it, create taxonomies, and typologies. We could also invent business models to be implemented. But in all cases, business models are the only way to approach the complexity of business.

Osterwalder's (2004) comprehensive research on business models provides another perspective on the previous stated elements. Referring to Stähler (2002) and Seddon and Lewis (2003), Osterwalder states that a business model includes three levels: the planning level; the architectural level, and the implementation level. The planning level refers to the strategic layer that focuses on goals and objectives. The architectural level addresses the money-earning logic, which means the business model layer. Finally, the implementation level is the one that focuses on processes, the organization, and workflow (Osterwalder, 2004). In asking what function and role a business model can have, Osterwalder indicates the following aspects: understanding and sharing between the various stakeholders, analysis and comparison of existing models, and management, which means design, plan, change and implement models, and react, align and improve decision-making through adjustment of the models. And last but not least there is a fourth area of innovation, simulation and testing. Simulation is a term we haven't been introduced to yet, but Baden-Fuller and Morgan (2010) also justify the fourth area of innovation, simulation and testing. They see the third category, business models, as recipes: "as practical models of technology that are ready for copying, but also open for variation and innovation" (ibid., p. 157).

Following Osterwalder's discourse and statement, it is possible to see similarities between the presented functions and role of business models to the design process. A traditional understanding of a design process can be generalized as "understand, analyze and compare, design, plan and implement, simulate and test." These steps even if certain parts are repeated are key aspects of designing. Based on this similarity and analogous matching, the understanding of business modeling can be put into the wording of business.

Applying such metaphorical frameworks to business activities can therefore be seen as a designing act—the designing of business. Modeling business through the selection of metaphors is designing business, since the "reality" of business changes with the wording applied.

But is that all, is the business designer only a "wordsmith," somebody who uses words, metaphors to shape reality, a social reality, or is there more to it, does the business designer present something different as well? This question must be addressed, since the various business models comprise several components, which are critical for the reality of business. This is aligned with design processes where we break problems into smaller parts, as we do in classical problem-solving in engineering or computer science. Therefore, the question that arises is as follows: "Can a business model be broken down into parts, and can these parts be designed?

Collecting the various elements of business models together, we have the following: What is the business doing, and how does it make money (Weill et al., 2005)? Who is the customer? What does the customer value? What is the underlying economic logic? How we can deliver value to customers at an appropriate cost (Magretta, 2010)? What value does a company offers to one or several segments of customers? What does the architecture of the firm look like? How is the network of partners for creating, marketing, and delivering value and relationship capital arranged? How does the firm generate profitable and sustainable revenue streams (Osterwalder et al., 2005)? What does the customer value? How is the proposition, its profit formula, its key processes composed (Johnson et al., 2010)? Looking at these elements or parts of business models it can be seen that existing design disciplines are playing a very important role here. To go one step further, we can say that everything covered in these business models occurs also in Krippendorff's "trajectory of artificiality" and in Buchanan's "Four Orders of Design."

What the business is doing, what service it creates is covered in the product design and service design field. Product and service design provides the basic creation of value in design and without this "oldest design discipline" no business design is possible, since value creation is not thinkable without offering a service or a product to the customer. And since business is a complex entity with many people, processes, and products or services involved, usually in a systematic way, system design is another very important design field contributing to business design. The business system, the service system, the product service system, the production system, the architectural system of the company, the stakeholder system and the network, even the financial system can and must be designed if we are thinking of business design seriously and radically. But in addition to product, service, and system design, the discipline of organizational design is also important, since the architecture of the firm cannot only be seen as a system.

When it comes to the value proposition and purpose, strategic design is the contributing discipline, which provides the necessary knowledge and expertise. Interaction design is not only the discipline that provides insight into the interaction between interface and people, it is also an area where the interaction between the various parts of an organization can be designed, where the interplay of the business units can be shaped. The marketing aspect of a company is a result of communication, media, and interaction design, but design research regarding customer and costumer behavior is a very important element in making a business successful. And communication, both within the organization and with the costumer, is crucial and is traditionally already an object of design. And key processes and the design of the value chain can be seen as a project, and project and process design are also essential to business design. Business design is thus a comprehensive design task, requiring several design disciplines to make a business successful. And in many cases business design is a collaborative act between stakeholders, a discursive enacting of business artifacts in a complex environment. Many design disciplines are needed to mold together all those parts that make a business whole.

REFERENCES

Baden-Fuller, C. and Morgan, M.S. (2010) "Business Models as Models," *Long Range Planning*, 43 (2/3), 156–171.

Boland Jr., R.J. and Collopy, F. (eds.) (2004) *Managing as Designing*, Stanford Business Books, Stanford, CA.

Buchanan, R. (2001) "Design Research and the New Learning," *Design Issues*, 17 (4), 3–23.

Corning, P. (1998) "Complexity is Just a Word," *Technological Forecasting and Social Change*, 58, 1–4.

Faust, J. (2015) "Discursive Designing Theory: Towards a Theory of Designing Design," Thesis, University of Plymouth, Plymouth, UK [http://pearl.plymouth.ac.uk/handle/100 26.1/3210?show=full].

Krippendorff, K. (1995) "Redesigning Design: An Invitation to a Responsible Future," in P. Tahkokallio and S. Vihma (eds.), *Design: Pleasure or Responsibility*, University of Art and Design, Helsinki, 136–182.

Krippendorff, K. (2006) *The Semantic Turn: A New Foundation for Design*, CRC Press, Boca Raton, FL.

Johnson, M.W., Christensen, C.M. and Kagermann, H. (2010) "Reinventing Your Business Model," in *Harvard Business Review on Business Model Innovation*, Harvard Business Press, Boston, MA, 47–70.

Magretta, J. (2010) "Why Business Models Matter", in *Harvard Business Review on Business Model Innovation*, Harvard Business Press, Boston, MA, 1–17.

Morgan, G. (2006) *Images of Organizations*, Sage, Thousand Oaks, CA.

Osterwalder, A. (2004) "The Business Model Ontology: A Proposition in a Design Science Approach," doctoral dissertation, Université de Lausanne, Ecole des Hautes Etudes Commerciales.

Osterwalder, A., Pigneur, Y. and Tucci, C. L. (2005) "Clarifying Business Models: Origins, Present, and Future of the Concept," *Communications of the Association for Information Systems*, 16 (1), 10.

Seddon, P. B. and Lewis, G. P. (2003) "Strategy and Business Models: What's the Difference," in 7th Pacific Asia Conference on Information Systems, Adelaide, Australia.

Stachowiak, H. (1973) *Allgemeine Modelltheorie*, Springer, Vienna.

Stähler, P. (2002) "Business Models as an Unit of Analysis for Strategizing," International Workshop on Business Models, Lausanne, Switzerland.

Weill, P., Malone, T.W., D'Urso, V.T., Herman, G. and Woerner, S. (2005) "Do Some Business Models Perform Better than Others? A Study of the 1000 Largest US Firms," *MIT Center for Coordination Science Working Paper*, 226.

CHAPTER 3

THOUGHTS ON DESIGN AS A STRATEGIC ART
Sabine Junginger

This chapter addresses an increasingly important issue in designing business: the differences between employing design as a technique, as a method or as a strategic art within businesses and organizations. Design contributes to businesses, organizations, and society as a whole in all three forms, although not necessarily in the same way or for the same purpose. What is striking, then, is the difficulty managers, professionals, and designers have when talking about when and why they are employing design as a technique, when they are turning to design as a method, or when and how design serves them as an art. This inability to communicate is important. It means that we rarely employ design in all its guises because we talk about methods when we mean techniques and we struggle to communicate about design beyond techniques and methods, which is particularly crucial in the context of designing business as an art.

I see evidence of this confusion in the many publications and materials that promise their readers design methods when they only talk about techniques, which, although useful, do not constitute methods in themselves. This is the case, for instance, with titles that promise an abundance of design methods (see, for example, the books by Curedale, 2012, 2013 and Kumar, 2013). Even books that provide insights into methods that apply to specific design matters (e.g., Simonsen *et al.*, 2014) are rarely able to present the design-interested reader with more than descriptions of specific design techniques.[1]

Of the few people to address this issue, Richard Buchanan has sought to educate others about the differences in these facets of design. In one of his courses he taught while still at Carnegie Mellon University's School of Design, he explained the relationship between techniques, art, and method as follows:

An art is a systematic discipline for thinking, doing, and making. It provides principles and strategic guidance for the use of the many specific methods and techniques that are employed in design. In contrast, methods provide tactical support in addressing design problems. Methods are characterized by a particular intellectual, disciplinary, or scientific framework. They typically bring special knowledge into practical use for the designer. Finally, techniques are individual tools and ways of working to solve technical problems.[2]

In the context of designing business, these differences have implications for organizations that turn to design for innovation and change as much as for sustainable growth. We need to clarify and understand why design techniques in themselves do not constitute design methods, and why that matters to organizations of all kinds and purpose.[2] Introducing design thinking and design methods in the business context can be done in one of three ways: as a technique, as a method, or as an art. Design thinking is already popular as a design technique. Businesses that have successfully relied on technology for innovation often do not know how else to employ design but as a technical device. With that, they isolate design thinking and use it as an individual tool to generate answers to specific 'design technical' problems. Design thinking here has no role as an overarching framework relevant to the organization's purpose or strategy.

Designing business challenges us to look at design as an art for the questions and problems of the organization. For this reason, design thinking cannot be left to a technique, and while its application as a method makes inroads in the organization, unless it is understood as a strategic art, it is bound to disappoint those hoping for new business models, new mindsets, and new ways forward. How can we move design thinking to the level of a strategic art? How can design thinking become "a systematic discipline for thinking, doing, and making" that provides "principles and strategic guidance for the use of the many specific [design] methods and [design] techniques that are employed in design?"[3]

If we are to employ all the facets of design to the benefit of business and society, if we are to clarify the role design has in our everyday lives, we need to pay attention to how design techniques relate to design methods and to design as an art within organizations. Given the many books and tools now available, the problem does not seem to be one of lack of effort. However, what is clear is the difficulty of conveying methods that involve human experience, the human environment, and human action through journal articles and other resources, in isolation of actual practice and engagement. It is through practice and engagement that we situate techniques within a particular intellectual,

disciplinary, or scientific framework. It is therefore also crucial who uses the techniques and what intellectual, disciplinary, or scientific framework a person making use of a design technique promotes, represents or seeks to challenge. It is for this reason that most method books fail to imbue methods. This is not a fault in itself. What I personally find problematic is that the insistence on using the term "method" for what is in essence a technique prevents us from employing design as a strategic method. Moreover, when we confuse techniques and methods, it is difficult to make a case for design as an art that is fundamental to organizational life and purpose.

Because the concepts of technique, method, and art remain abstract and confusing for many—designers and business managers alike—I will illustrate their implications with two stories. The first story reflects on the role design techniques and design methods have for Ndebele women in South Africa. The second story exemplifies the art of teaching Chinese language and clarifies how techniques can be purposefully employed to form a method for learning, in this case language acquisition. I then explore more fully the relationship between techniques and methods. I expand on what is implicit in Buchanan's description: that both techniques and methods can be employed in combination with or in the absence of an overarching art but that designing business demands all three to be in place.

Story 1: Techniques and Methods in the Art of Beading

The Ndebele women in South Africa are famous for their beautiful beadwork. The patterns and colors are striking. They cover bottles and vases in beads, they create bracelets, earrings, brooches, and toys, including beautiful African dolls. For the Ndebele women, the art of beading has a long tradition. It is connected with storytelling and communication, with community and social life, with trading and exchanging goods. For their art, the Ndebele women depend on the skillful application of a basic technique—a particular way of tying the beads together to form these wonderful products. Each Ndebele woman is expected to master this basic technique, which they are taught from childhood. Applying this technique, they transform common beads and common objects into pieces of beauty they can then sell (Fig. 3.1). Technique is essential to their art of beading. These techniques may vary and change over time with the size, shape, and materials of the beads and the materials that connect them. Their techniques serve them well in the production of their beaded products for tourists. For this specific purpose, to make and to sell, they have no need for a method of making. Nonetheless, the techniques of the Ndebele women are the

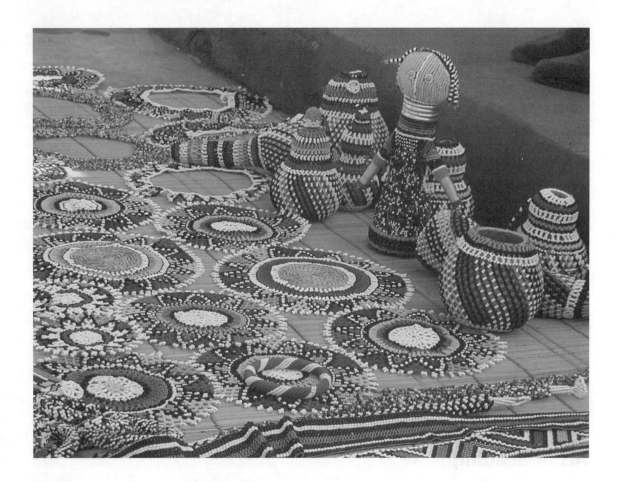

**Figure 3.1
Ndebele: Examples of
the Ndebele's mastery
of beading techniques**
© *Sabine Junginger*

foundation of their art. But they also employ their art methodically: at a time when AIDS raged in South Africa under a government hesitant if not resistant to educate their citizens about the disease, some Ndebele women began to use their beading art to inform and teach women and girls how to protect themselves from becoming infected (Fig. 3.2). They departed from their traditional colorful patterns, instead using white and red beads to create brooches with the Aids symbol. They then used these brooches as conversation starters. When they shifted the purpose of their art from creating products for sale to developing means of communication and engagement, the Ndbele women relied on their techniques to form a method.

Story 2: Techniques and Methods in the Art of (Language) Teaching

Another example of how techniques and methods work together to form an art, here the art of teaching, involves Western children learning Chinese. One

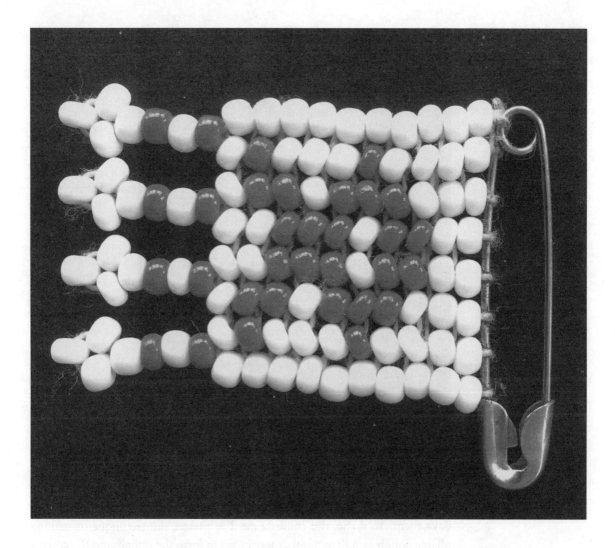

Figure 3.2
Ndebele: Example of
how the Ndebele
employ their beading
techniques as a
method to engage
people in Aids
conversations
© Sabine Junginger

of the challenges of studying the Chinese language, aside from its very subtle nuances in pronunciation, is being able to memorize Chinese characters visually. This skill is very different from memorizing words put together by letters of an alphabetic system. A Chinese language teacher working with primary school age children in Berlin, Germany, demonstrates why techniques are essential yet not sufficient for the art of teaching. To learn a new Chinese character, she encourages the children to form each character by hand with Playdoh™. This requires techniques, as the Playdoh™ demands a certain skill to make it malleable and the characters demand a different skill to form them. Yet, it is not the techniques that produce the desired outcome for the children, which is the acquisition and memorization of a new character—its meaning, its pronunciation, and its appearance. Here, the method of making is central to the purpose of learning. Nonetheless, this method builds and depends on

techniques. The importance of techniques to methods is highlighted when the children are asked instead to make the characters out of cookie dough and bake them. To do so, the children need to master the technique of making pliable dough as well as another technique to form the dough into the correct shape of each character. They also need to employ techniques for baking their work. The quality of their technical abilities will determine how each character looks and tastes. But in the end the method assigns techniques a secondary role in this example, too, because even if the Chinese cookie crumbles (pun intended!), the children still may have learned a new character through their hands-on engagement (Fig. 3.3).

TECHNIQUES AND METHODS: DESIGN AS A TECHNIQUE AND DESIGN AS A METHOD

These two examples show that techniques serve us differently than methods. A technique involves perfection in its application whereas a method involves

communication and engagement with people to achieve a goal or objective beyond technical application and perfection. This has implications for how we may use design in organizations. Applying design as a technique centers our concern on matters of excellence of making, and keeps us preoccupied with material and formal challenges. But in many contemporary circumstances, for example in public sector design and in what is emerging as social design, perfection and excellence are neither to be found in the materials and in the techniques nor in the outcomes. Instead, the focus is on human interaction and human experience. James Wang (2013) alludes to this problem, when he identifies the pursuit of excellence as a barrier for professional designers who seek a greater role in the public sector:

> According to Aristotle's theory of the practical intellect, makers—those who work with techné—are concerned only with the excellence of making, in contrast with doers—those who work prudentially to establish justice and who are very concerned about public values and social effects. The critics of design want designers to be doers, too; but because designers are essentially makers, transforming themselves into public servants is often difficult, if not impossible.

Indeed, the focus on design as a technique presents a barrier for the design activities of non-designers in the public sector and of professional designers who already engage in public sector innovation in countries like the UK, Chile, France, Denmark, and the USA. These designers are working closely with regional and national governments or even within government organizations, such as the US Office of Personnel Management, or within ministries, as does Mindlab in Denmark. These practitioners struggle because the public managers they work with fail to see design as anything but a new creative tool. They, too, have a difficult time moving from design as a technique to design as a method or even a strategic art. All this indicates the need for a more nuanced understanding of how techniques and methods are related. A first observation is that methods depend on techniques. Techniques, in contrast, do not depend on methods. While a singular design technique, however honed, does not constitute a method, several techniques applied methodically and systematically may form a method. To arrive at a method, those who employ design techniques need more than master individual techniques; they also need to develop a rationale and a systematic structure for how and when specific design techniques are appropriate. The problem is that no book in the world can make these judgments. In contrast with techniques, the appropriateness of a method cannot be assumed. The characteristics of beads mean that they can be strung along some kind of thread. The material, its form and structure clarify the kinds of techniques that will or won't work. Techniques can be described as self-sufficient—that is, they are

complete in themselves. There are steps we can follow and if we follow them well we will achieve the result we were looking for. This rigor may inhibit inquiry. Techniques are therefore not well suited to inquire into the unknown. They work best when applied to specific and isolated problems. In beading, the problem is how to connect the string with the beads in ways that allow building shapes and patterns. We may not know the final pattern or shape yet, but we do know the problems we need to overcome to get there. Techniques are useful in helping us generate answers. When we are still looking to understand a situation, a single technique or even a random selection of techniques will be of limited use. At the same time, a beading expert or master can advance beading technology without concerning himself with anything beyond the technical, like social issues.

Techniques can be conveniently "transposed" from one system to another. This is precisely what is happening right now with design thinking. Currently, we witness how design thinking as a technique is being transposed from design to business and now to the public sector. But as a method, design has not made sufficient inroads into business, private or public. We can see this in the calls for certified design thinkers. I am sure that by the time this book is printed we will be able to point out several programs offering various degrees in design thinking technique. But will these certified specialists also understand how to apply these techniques methodically? In other words, will they be able to work with techniques to form strategic methods that purposefully and systematically transform business and management?

The thought of design as a technique is appealing for many managers because a technique can be mastered, applied, and controlled. Techniques are interesting because they can be tested and tried, improved on, and perfected. There are best techniques, right techniques, and wrong techniques. All this provides a sense of reassurance. The contribution offered by design as a technique does not interfere with or challenge present organizational life and current organizational culture. It is a contained, local role where design produces solutions. But while design as a technique falls short of its potential role in designing business, it remains an important and necessary element of it: if we want to knit a sweater, we have to master the technique of knitting. If we do it wrong or if we make a mistake, the sweater unravels. For this reason, it serves businesses well to master basic design techniques. But businesses that seek to benefit from design thinking more fully cannot rely on design techniques alone. They need to become skilled in employing design methodically.

Failing to do so risks applying design techniques randomly because techniques are not part of a larger operational or strategic purpose. We find this quite often in organizations: design activities and design projects are

taking place at the same time in different departments but they are not coordinated or aligned. Resources are wasted and the individual outcomes of these isolated design efforts fail to arrive at a sum bigger than its parts. When it comes to innovation, a shift from techniques toward methods presents a shift for businesses from doing it right to doing the right thing. When we are concerned with methods, we are challenged to inquire about our intent. What do we want to achieve? For whom? What outcome are we looking for? Answers to these questions are not absolute and serve as evidence that methods cannot be perfected in the same way we can perfect techniques. Moreover, the value and relevance of a method changes with the people and situation. For example, people learn very differently. A method of language learning through tactile shaping of letters and the joy of baking will not work for everyone. This method may be right for children who are new to studying an Asian language but perhaps not to some adults, who may be more comfortable writing each character by hand or even through the traditional means of memorizing from books. The moment we move from techniques to methods, we can no longer insist on the purity of one technique or another. When we form methods from techniques, we reach outside of individual expert boundaries and often "muddle" techniques by combining them with techniques from many different areas of expertise. We may adapt specific techniques to create a new method useful to achieve the intended outcome. In all three uses of design—as a technique, as a method and as a strategic art—the purpose of our doing is central. For designing business, the purpose of designing is to develop and implement a strategic framework for transformation that integrates all aspects of the organization.

MOVING FROM TECHNIQUES TO METHODS TO ART

Techniques, methods, and their relationships raise questions about the purpose and meaning of art in designing business. From the two examples above, we can see that there is an art to identifying and developing appropriate methods for design as well as an art in appropriating and employing techniques in such a way to pursue and fulfill a specific purpose through a design product and through a design activity. This indicates that an art involves a range of techniques and methods. Without techniques and methods, there will be no art. Techniques and methods, however, may well exist outside of an art and people may employ them in the absence of an overarching art or purpose. This brings us to the roles of design techniques, design methods, and design as a strategic art within organizations.

MOVING FROM TECHNIQUES
TO METHODS TO ART

Many businesses still view design as an art separate from the organization. As a consequence, they make use of design as a technique in the way the Ndebele women employ and apply beading techniques for their art—with the subtle but important difference that in many businesses there is no overarching art in place to appropriate these design techniques. Not being integrated or part of an overall design strategy, the organization invests in a few design sessions—a co-designing workshop here or a user test there—to expand on existing development approaches.

Organizations employ design thinking as a technique and not as a method or an art when they view its various elements as mechanical gears, as Fraser (2009) suggests business ought to do: one design gear adds empathy and deep user understanding, the second design gear adds concept visualization, and the third design gear gets us up to speed with strategic business design. The consequences in real organizational life are real: I hate to think how often I have participated in sessions that generated an endless number of Post-it® notes and posters that wilted away as the day went on. The people running the sessions shared techniques but were not prepared to use their techniques methodically or strategically. A one-time design exercise leaves participants in the belief that design thinking can be injected into a process rather than form the basis for a comprehensive approach to innovation and development. The latter, however, is complicated, involving, and time-consuming. It takes commitment and vision.

Methods, as has already been stated, offer ways for us to inquire into issues, problems, and situations. When we are concerned with methods, we are asking how do we get there? How do we know?

Organizations are places where a range of techniques and methods are developed, applied, and perfected every day. To add to our confusion, we can also find different arts in organizations. But this is only troubling if we fail to expand the concept of art and aesthetic theory to organizational experiences and managerial problems (Dewey, 1934). Doubtless, techniques and methods bring an art to life. Design as a strategic organizational art promotes the skillful application of techniques and engages people through methods to inquire into problems of managing, organizing, and business that concern the human experience. As a strategic art, design reaches deeply into organizational life where the product of art is the organization itself. As an art, design can unfold its role in designing business, leading to:

> . . . the controlled or directed transformation of an indeterminate
> situation into one that is so determinate in its constituent distinctions

and relations as to convert the elements of the original situation into a unified whole.

<div align="right">(Dewey, 1938, p. 171)</div>

THE ART OF DESIGN AND DESIGN AS A STRATEGIC ART

It may seem odd that in the very places where design might be explored in its fullest extent (i.e., in all aspects of technique, method, and art), we witness the greatest struggles to take advantage of the full spectrum of design. In organizations, private and public, we find design still being "managed", and the ideas of managing as designing (Boland and Collopy, 2004) and designing business often rejected outright. Here, art assumes a separate place within the organization and makes it difficult to talk about design as something non-artists experience, produce or can produce.

For design schools that view their own organizations as a place for and about art (Aritz and Walker, 2012, p. 42), the shift toward design as a strategic art can be disorienting and confusing. In many of these organizations, managers have long separated management from arts. In doing so, management unwittingly promotes a view that design's core contribution to the organization is limited to its technical application. In consequence, design is portrayed as an art that is "remitted to a separate realm, where it is cut off from that association with the materials and aims of every other form of human effort, undergoing, and achievement" (Dewey, 1934, p. 3).

This presents design education with the growing problem that the very institutions that could benefit the most from design being an integral art tend to be the ones that prevent businesses from understanding and applying design as anything but a technique. The insistence that art belongs to artists (i.e., design and designers) ties art to specific places in studios, in workshops, and in classrooms. No matter how well excellent training programs in materials and material forms enable design students and staff to perfect the techniques of their respective art (i.e., fashion design, product design, communication design, design thinking, design management), they are bound to serve the organization on a technical level. This serves the needs of businesses looking to make design another technique in their technical portfolio and it fosters a view of business as a place of design but not of designing.

For design to become a strategic art, it has to be integral to "every other form of human effort, undergoing, and achievement." The inability to understand design as integral to organizational problems, problems of management, and problems of business is both the cause and the symptom of an organization that looks to design as a technique.

The shift from thinking of business as a place of design to business as a place of designing is the reason we need to be articulate about design as a technique, design as a method, and design as a strategic art. It is revealing that we find only a few design schools among the many organizations that have begun to inquire into their own organizational design practices and their own organizational design approaches. Design research, it appears, is left to schools of management (e.g., the Weatherhead School of Management at Case Western University in Cleveland, Ohio), to business schools (e.g., the Copenhagen Business School in Denmark), and increasingly to policy schools (e.g., the Heinz College of Public Policy at Carnegie Mellon University and Milano School of International Affairs, Management, and Urban Policy at The New School in New York). Although they are not stating this, they are pursuing a shift from understanding design as a technique or method to understanding design as a strategic art. This is not an easy shift and there are still people in businesses that cannot make this shift out of a fear of making a mistake, of doing something wrong when confronted with the unfamiliar. But any method degenerates into a set of techniques when we are more concerned with its correct application—that is, with "doing it right" than with "doing the right thing." Doing the right thing allows us to ask questions, doing it right blocks any kind of inquiry.

CONCLUDING THOUGHTS

Design has much to offer businesses and organizations in general. The more we are able to clarify what these contributions are, the more we can all benefit from this human activity. We cannot stop design—we cannot prevent people from designing, and neither should we. But we can become more aware of what our designing implies and does. My aim here is to demonstrate how design as technique, method or art contributes in different ways to businesses and organizations. As design shifts into new areas of practice and research, the skilled application of techniques remains relevant, as do methods of inquiry. But in the new landscape of designing business, it is the inquiry itself that demands our attention. I hope I have been able to show that the distinction among techniques, methods, and art can help us understand, operate, and navigate within this new framework of designing business.

Because techniques, methods, and art are related but not the same, they each deserve careful attention when we seek to understand designing business. The value of doing so may not appear immediately obvious to design professionals and design educators. Nor may it appear worthwhile to a business manager spending her time "philosophizing" about design. But for those looking to designing business as a new approach addressing organizational and managerial problems, these distinctions are most relevant. And while

books and other resources on design methods can help them master techniques, these materials need to be complemented by other means to employ design methodically and strategically. This is not a call to stop sharing design techniques. Not at all. If anything, we need more books that explain and talk about design. This chapter, then, is merely a call to start distinguishing clearly between techniques, methods, and strategic arts as they apply to design. And it is an invitation to engage more fully in design conversations as they relate to business and management.

NOTES

1. Recently, "method card" sets have become popular and assumed an essential place in the toolbox of design educators and design consultants. Major consultancies such as IDEO and Edenspiekermann but also smaller educational institutions (e.g., the Design School Kolding) and small design entrepreneurs (e.g., Designimprov) now offer their own method card sets. Method cards are also a meaningful way to introduce non-designers and early design students to basic concepts and techniques. However, in themselves, they do not explain how, when, and why any of these techniques may inform or form a design method.
2. Excerpt from Syllabus by Richard Buchanan, Human Experience and Interaction Design: Concepts, Methods, and Products, Design 51-701, Fall 2002, The School of Design, Carnegie Mellon University.
3. Buchanan, op. cit., note 1.

REFERENCES

Aritz, J. and Walker, R. (eds.) (2012) *Discourse Perspectives on Organizational Communication*, Plymouth, UK: Fairleigh Dickinson University Press.

Boland Jr., R. J. and Collopy, F. (eds.) (2004) *Managing as Designing*, Palo Alto, CA: Stanford Business Books.

Curedale, R. (2012) *Design Methods 1: 200 Ways to Apply Design Thinking*, Topanga, CA: Design Community College, Inc.

Curedale, R. (2013) *Design Methods 2: 200 More Ways to Apply Design Thinking*, Topanga, CA: Design Community College, Inc.

Dewey, J. (1934) *Art as Experience*, New York: Minton, Balch & Co.

Dewey, J. (1938) "The Pattern of Inquiry," in *Logic: The Theory of Inquiry*, New York: Henry Holt & Co.

Fraser, H. (2009) "Designing Business: New Models for Success," *Design Management Review*, 20 (2), 57–65.

Kumar, V. (2013) *101 Design Methods: A Structured Approach to Innovation in Your Organization*, New York: John Wiley.

Simonsen, J., Svabo, C. and Strandvad, S. M., Samson, K., Hertzum, M. and Hansen, O. E. (eds.) (2014) *Situated Design Methods*, Cambridge, MA: MIT Press.

Wang, J. (2013) "The Importance of Aristotle to Design Thinking," *Design Issues*, 29 (2), 4–15.

ORGANIZATIONAL DEVELOPMENTS

CHAPTER 4
STRUGGLE IN DESIGNING AND IN MANAGING
Richard Boland, Jr.

Need and struggle are what excite and inspire us; our hour of triumph is what brings the void.

WILLIAM JAMES

The designer and the manager both struggle with difficult problems in a world of tensions, contradictions, and unknowns. Designing a valued artifact and organizing an enterprise both involve a search for a dream-like ideal in which designer and manager alike shape and reshape the materials, technologies, and traditions of their situated practice in order to create a new piece of the world. Proposing that design and organizing are a similar type of struggle goes against some common misconceptions that we often see in the media and widespread cultural understandings, especially in Western cultures.

The first misconception concerns the process of designing a valued artifact, and is found in the everyday assumption that artful design is the result of an inspiration—a moment in which an image comes to the designer as if it were being channeled from a higher source. The hard work, the self-doubt, and the challenge involved in making something new are overlooked, replaced with an image of almost magical prescience of anticipation of what is to come.

The second misconception concerns the act of managing, and is found in the widespread assumption in business school curriculums that managing is fundamentally about making decisions—it is a moment of deciding between alternative courses of action that have been presented to a manager for making a choice. Managers certainly do engage in moments of decision-making, but like designers, there is much difficulty, ambiguity, and contradiction that must

be grappled with first, such as recognizing the need to act, formulating a problem, inventing alternatives, and negotiating their multiple logics and dynamics.

Both of these popular misconceptions reflect a similar perspective on the artist and the manager. Both reflect the view that they are engaged with environments that are, in a sense, already whole and complete. The creation of a design is assumed to come to the artist as a complete whole in a single moment of inspiration. The decision situation, in turn, is assumed to be presented to the manager as a complete whole, with a problem formulation and alternative courses of action that are already known. In this way, the work of designing and the work of organizing are seen as unproblematic, once the form of the artwork and the structure of the decisions have come to the artist and the manager. If the manager has sufficient analytic ability to calculate a best course of action and make a clear choice, and if the designer has sufficient skill to realize the desired outcome and complete the vision for the valued artifact, then all is well.

I want to contrast these common conceptions with an alternative understanding of the designer and the manager that is rooted in their actual experience, emphasizing the ways in which each of them brings something new into existence through a slow, difficult, even painful process of trying to give shape to an emerging sense of possibilities. Facing unlimited alternatives and an uncertain way forward, both of them struggle to bring a body of work to life—both are caught between the constraints of their immediate setting and the openness of creating their future.

They both agonize about what they are producing and how they should proceed; seeking an outcome valued by society, but committed to avoiding a mere repetition of what has gone before. They hope to innovate by going beyond familiar boundaries, without offending—to surprise their public, without shocking them, and to break expected patterns, yet create something desirable. There are no rules to follow in this quest, no reliable answers that could be provided by an inspiration or a decision analysis. But nonetheless, they go on, struggling against the mounting difficulties of their quest to create value in novel ways.

STRUGGLE BY THE DESIGNER

At the Weatherhead School, we are privileged to have had the great architect Frank O. Gehry design our school home, the Peter B. Lewis Building. We have had the opportunity to live through the process of planning, design, and construction with him, and to conduct a series of research projects on the

unique practices, processes, and technologies that he employs. The design and construction of his complexly shaped buildings, which are works of sculpture on a grand scale, could only be achieved by using 3-D CAD systems. To build the difficult surface geometries of his designs required him, his partners, and their staff to adapt software tools that were originally developed for the aeronautical industry. But the construction of his design was not the only form of struggle for Frank Gehry. The process of designing his buildings itself was also a struggle, as well represented in the following quotes from an interview with him on December 6, 2004:

> . . . You get a glimpse in your mind of a building. Once I understand the scale and program, it's all mixed in my memory box. Then I can fantasize the building. I do sketches and I do models. They are all part of it. They are all informing me and informing my fantasy and I respond to them intuitively, in search of the realization of the dream image that you can't quite put your finger on. But the dream image, it's ephemeral. It is always incredible.
>
> . . . Those ideas are in my memory and you can't get rid of them. But how do you take the dream image into a reality over a period of 2 to 3 years, which is a normal process time for a building? How do you take it to reality without losing the character that this image has? . . . It is like a search, a constant search. It's like you are in a foggy city and trying to find something. It is like you are not sure where you are going, but you have this image.

You can kind of draw it, you can kind of model it, but you can't exactly draw it and you can't exactly model it. And you are always falling short. Everything you do always fall short of that image. In fact, you are never going to get that image perfectly. So the models and drawings are attempts at getting that image. You make a model, you look at it, and you say, "No, that is not it."

For Frank Gehry, designing and constructing a building is a continuing existential struggle to pursue a dream image that he can never fully realize in reality.

> When [the building] is built—by then you already have dreamt this image way down the line, especially when you start seeing it going up from the ground—you see all the things that you could have done, would have done, and should have done. That's why the first encounter with the finished building is always disappointing. It is very hard to explain this to the client. They just paid a lot of money to do the job and you come in and you are disappointed.
>
> And they don't know what to make of that. So I keep trying not to tell people that I am disappointed, because they don't quite understand this

dream image thing. It's just that you are suffering from a rude awakening that your thing is not as good as you thought it would be. That's how you grow to the next project.

Another artist who reflects the struggle of achieving an idea is Vincent Van Gogh. In his letters to his brother Theo, he writes most eloquently about the difficulty of achieving his desired effect in a painting or drawing. The following excerpts are from some of those letters.

The Hague, early May 1882

Dear Theo . . .
Mauve takes offense at my having said, "I am an artist"—which I do not mean to take back, because that word of course included the meaning: always seeking without absolutely finding. It is just the converse of saying, "I know it, I have found it."
As far as I know, that word means: I am seeking, I am striving. I am in it with all my heart.

The Hague, mid May 1882

. . .
In short, I want to reach so far that people will say of my work: he feels deeply, he feels tenderly . . .
It seems pretentious now to speak this way, but that is the reason why I want to push on with full strength.
. . .
. . . It is true that I am often in the greatest misery, but still there is within me a calm pure harmony and music. In the poorest huts, in the dirtiest corner, I see drawings and pictures. And with irresistible force my mind is drawn towards these things.
. . . Art demands persistent work, work in spite of everything, and a continuous observation.

The Hague, early September 1882, Sunday morning

. . .
The question was, and I found it very difficult, to get the depth of color, the enormous force and solidity of that ground—and while painting it I perceived only for the first time how much light there still was in that dusk—to keep that light, and to keep at the same time the glow and depth of that rich color.
. . . While painting it I said to myself: I must not go away before there is something of an autumn evening air about it, something mysterious, something serious.

. . . In a certain way I am glad I have not learned painting, because then I would have learned to pass by such effects as this. Now I say, no, this is just what I want, if it is impossible, it is impossible; I will try it though I do not know how it should be done. How I paint it I do not know myself. I sit down with a white board before the spot that strikes me, I look at what is before me, I say to myself that the white board must become something; I come back dissatisfied—I put it away, and when I have rested a little, I go to look at it with a kind of fear. Then I am still dissatisfied, because I still have too clearly in my mind that splendid subject, to be satisfied with what I made of it. But after all I find in my work an echo of what struck me. I see that nature has told me something, has spoken to me, and that I have put it down in shorthand. In my shorthand there may be words that cannot be deciphered, there may be mistakes or gaps, but there is something in it of what wood or shore or figure has told me . . .

Notice the remarkable similarity in the experience of struggle that Gehry and Van Gogh describe. Striving with a nobility of purpose toward an ideal that they do not know how to achieve—breaking with traditions, inventing techniques, revisiting the attempt to capture an elusive image or feeling over and over. Frustrated and feeling a lack of success, yet continuing to strive toward their elusive and ineffable goal.

STRUGGLE BY THE MANAGER

The same kinds of struggle—seeking an ideal that remains forever elusive—can be seen in the experience of the manager as well. For examples of this, I turn to our research on some of the unusual organizational control practices that managers adopt in struggling with difficult projects of various kinds. The examples from our research will show that innovations in design and construction of Frank Gehry's buildings, innovations in off-shore drilling partnerships, and innovations in globally distributed software development teams, disturb accepted approaches to controlling complex projects, causing anxiety for traditional managers, and forcing them to struggle with richly paradoxical situations in which familiar ideas of project control, efficiency, risk management, power, organizational culture, and language practices are challenged and require the invention of new ways of organizing.

In these examples, managers are going into unchartered territory where they abandon accepted, sensible practices and struggle with new ways of organizing that contradict the accumulated wisdom of their industries. I'll

begin with the construction projects of Frank Gehry, where we see a form of organizing that is as full of tensions and struggle as his design process. The underlying motive is always to achieve something remarkable that following the taken-for-granted approach to organizing would likely fail to do.

In the construction industry, standard contracting arrangements (both formal and informal) have evolved over centuries to balance the tensions and reduce overall risk in a large, complex project. Some standard organizing features on construction projects include:

- Open bidding with contracts awarded to the lowest, competent bidder is order to reduce the risk of over-paying.
- Change orders tied carefully to contract language and drawings in order to reduce the risk of cost over-runs by assigning responsibility for added costs.
- Minimum communication among parties before bidding in order to avoid the risk of favoritism or collusion in the bidding process.
- Delay in payment of contractor invoices of 45 or more days in order to audit them and avoid overpaying and loss of the time value of money.
- Control systems in place at the building site in order to minimize the risk of scope creep, cost overruns, unauthorized activities, etc.
- Layers of approval that include communication between owner, contractor, architect, and consultants in order to avoid the risk of unauthorized decisions.
- Professional liability insurance for each firm that participates in the project in order to protect from the negligence or failed judgment of professionals.

All of these practices seem at face value to be sensible, and have come to be accepted standards over time. But when the technologies change, when representational practices change, and when work practices change, as is increasingly the case in all industrial sectors, these tradition-bound elements of a management control system cease functioning as intended. The open bidding system becomes a game in which contractors rely on ambiguities in the contract documents and changing representational forms to make claims for extra payments (change orders) during construction, which can be significant. Minimizing communication slows learning and insures that new circumstances will be approached with inappropriate, older construction techniques. Delays in making disbursements create a space in which the change order gaming can take place by building arguments and collecting data for supporting contentious claims.

Spreadsheet-wielding managers on site can inhibit collaborative communications among the project team by focusing energy on developing arguments to support change order requests. Layers of approval with contractually explicit patterns for exchanging communications and obtaining signatures from

the hierarchy of each firm involved, predictably slow the problem-solving process down and increase the risk of cost overruns. Having separate professional liability policies for each type of professional adds motivation to game project communications to assign blame for change order requests to other team members.

In short, a key problem we observed in the organizing of construction projects is that their success is dependent on communication among all participants—communication reflecting intent to collaborate in a joint problem-solving effort. Team-building exercises among firms are increasingly standard in these large multi-firm project organizations. But, the management control systems that are employed usually mimic those of a single firm that has been decomposed into divisions to create a competitive atmosphere among units, rather than one that has been synthesized from separate, competing firms into a single construction project. The two logics do not match and the result is a form of management control that is intended to decrease the risk of a project, but serves instead to increase the project risk.

EXAMPLES FROM THE CONSTRUCTION INDUSTRY

Below I present some examples from our research on Frank Gehry and the construction industry.

..

The Fish Sculpture Project: An example of reducing management control over a project in order to increase chances for project success. Gehry Partners' first use of three-dimensional software tools in design and construction was a Fish Sculpture that Frank Gehry proposed for the Barcelona Olympics. Jim Glymph, Frank Gehry's senior partner, tells it best:

> The first project (using 3-D) was the most successful we may have ever had ... it was supposed to be finished by the Olympics, and at the time we decided to do it there was only nine months to the Olympics. So we ... got the contractors to agree we wouldn't be drawing, and we did that project paperless. And ... we got the job done a month early. Everybody made money, there were no extras—that never happens.
>
> ... We literally agreed to attempt it only if the project managers were left out of it and the whole management process was abandoned because it was too slow ... a lot of deals were made to operate outside the rules and basically, most of the deals had to do with peeling away layers of

oversight and management and getting down to just the people that are doing the work. And then putting only the absolute minimum amount of management back on top of that to keep it from going off the rail.

... We didn't sacrifice any quality control measures, we clearly didn't sacrifice any management. We just eliminated management where it wasn't necessary, which was most places ... We haven't done a paperless project again, because we've not had that environment where we were committed to suspend all the rules. And so that still remains the most efficient, the most successful use and it was the first use.

Jim Glymph, November 9, 2002

..

The Experience Music Project: How layers of decision oversight were removed in order to improve decisions. On the Experience Music Project (EMP) in Seattle, the construction company Hoffman Construction organized project teams in a unique way. Normally, teams would include contractor, owner, and architect representatives who, when a problem was encountered, would discuss issues, identify alternatives, return to their respective firms to make engineering studies, have further discussions, and make approvals before the next scheduled team meeting or preset deadline. This standard procedure in construction projects reduces the risk that sub-optimal actions will be taken or that actors would make agreements that their superiors would later undo. But it also increases the time required for making a decision and draws out the problem-solving process.

On the EMP Project, Hoffman responded to the high levels of complexity on the project by forming the teams to include all the usual actors, plus any advisors, engineers, and fabricators who would eventually be involved in the decision process. They then set as a rule that all decisions were to be made in the team meetings. This was a major change in the coordination mechanism, and increased the risk that a decision might lead to a costly error, but it also created an atmosphere of genuine collaboration, intense creativity, and one of the most memorable and exciting project experiences that many of the highly seasoned participants had ever encountered.

..

The MIT Stata Center: Eliminating oversight and omissions insurance policies to reduce risk. Each professional firm on a large construction project (architect, engineer, consultants, etc.) buys a professional liability policy, to protect against liability for oversights and omissions. This is an eminently sensible idea, but

rather than stimulate collaboration, it encourages strategic behaviors that will tend to protect one professional group from liability and point blame toward another. On Gehry's MIT Stata Center Project, one insurance company was enticed to write a single professional liability policy for the entire project, covering all architects, engineers, and specialized consultants involved in the project. The ability to assign blame for any mistakes was reduced, which could increase the risk that errors might occur, but this innovative insurance policy encouraged all professionals to collaborate, reduced strategic behaviors, and resulted in lower than normal claims.

..

The MIT Stata Center: Speeding up cash disbursements to slow down change order requests. Traditionally, the multiple firms on large construction projects submit invoices for work to date on a monthly basis. The invoices will include request for additional payments, beyond the contract, based on "change orders." These are claims by the contractor that a change in the scope of work has created additional expenses that should be reimbursed over and above the fees specified in the contract. The owner, in turn, traditionally paid progress invoices 45 or more days after they were submitted. The total elapsed time between submitting an invoice, resolving change order disputes, and final payment could be substantial.

On the MIT Project, the university changed its progress payment policy, and agreed to pay invoices within 24 hours if there were no open disputes concerning change order requests. This restructuring of their organizing practices increased the risk that a proper approval could not be performed on the invoiced amounts and that an inappropriate payment could be made. It also reduced the school's ability to gain the advantage of the time value of money. Nonetheless, it dramatically reduced requests for change orders, which allowed more of the project communication to be about solving construction problems and less spent on assigning blame and making claims.

EXAMPLE FROM A STUDY OF ORGANIZING FOR OFFSHORE OIL DRILLING

Reducing technical engineering oversight by one partner in order to increase technical engineering project success (Boland *et al.*, 2008). The West African coastline is rich in large oil deposits. However, these reservoirs lie many miles offshore in very deep water, making their development an especially expensive and risky endeavor. This particular case study research was part of a large,

multi-project study and was compiled from interviews with a non-operating company in a two-party (50/50) multi-billion dollar West African oil and gas joint venture. Even though the operating agreement was structured to reduce risk through an independently designed and strictly defined chain of operational control, the operator's culture and procedures dominated the joint venture operations.

The non-operator's manager and technical center was located in Houston, Texas, while the operator was housed in London, UK. Early in the relationship, the non-operator recognized the geographical gap was causing information asymmetry between the partners, mostly to the detriment of the non-operator. Senior non-operator managers moved to London to be closer to operator management, leaving their technical staff behind in Houston in the process. Thus, to avoid a gap within operator/non-operator managers, the non-operator was willing to create a gap within its own organization.

The joint venture needed technical agreement between partners as to the state of the oil field and the technical options open to them, but with two technical groups separated by the Atlantic, agreement became difficult to obtain. The structure of the joint venture was intended to reduce risk by engaging the technical capabilities of both parents. The two technical teams (divided by an ocean) were getting in the way of each other more than they were helping to provide better engineering solutions. Internal conflict within the joint venture clouded the engineering discovery process, and led to confusion as to the best technical way forward. With both operating and non-operating management consolidated in London, the decision was made to forgo operational review boards in Houston. Thus, to enhance engineering design clarity and the speed of technical decision-making, the joint venture reduced its engineering resources.

LANGUAGE IN ORGANIZING: STRUGGLE IN MAINTAINING AND CHANGING VOCABULARIES

Dynamics of language change in globally distributed software development teams. Our research group at Case Western Reserve University has undertaken several projects studying distributed teams. Here, I focus on one of those studies by Alex Citurs (2002), who explored the dynamics of language use in distributed teams of software developers. He proposed that software development teams periodically experience moments of crisis during a project, in which they struggle with interpreting what is happening and what it means for continuing their project. He hypothesized that he would observe a pattern of shifts in their

language as a result of the struggles during these points of crisis, and expected to find:

- a shift from the use of implicit language to the use of more explicit language;
- the emergence of new vocabulary elements; and
- an increase in the integrative complexity of their language practice (number of distinct concepts and interrelationships being treated as a whole).

In 2001, he conducted a six-month study of a distributed software development team whose members were located in the USA, India, and the UK. Citurs found that they did indeed experience periodic moments of crisis in their work. He also found that the periods of crisis were associated with a shift from implicit to explicit language along with the emergence of new vocabulary items and an increase in their integrative complexity. After the crisis had passed, he observed fewer new vocabulary items, and reduced integrative complexity. But what was even more interesting was the finding that this type of oscillation in language practice continued in wave patterns throughout the project. Moments of crisis were correlated with peaks in these oscillations, but the oscillations were ongoing, even when the team members did not identify that a crisis was occurring.

These oscillations in language are a result of the ongoing struggle with the shifting tensions between local (collocated) and global (distributed) logics of organizing that are experienced by knowledge workers in a distributed project. The tension and the resulting oscillation between the local and the global are continuous. Language is always breaking down in the face of this tension, and is always being repaired but in ways that lead to further breakdown.

As language becomes more implicit, relying on nonverbal understanding, and as integrative complexity is reduced, the knowledge worker is coming closer to the local experience and relying more intimately on the unstated local logic of practice. As this trend progresses, the global logic becomes less relevant. Things happen in the local practice for which no global term applies. Communication between teams suffers. Their language then begins to shift as they struggle to repair the breakdown by becoming more explicit, inventing new vocabulary items to capture the local experience that is escaping the global logic, and building more integrative and complex arguments to bring the diversity of local experience within a global framework.

This trend to strengthen the global logic eventually leads to the emergence of new problems, in which the local practice is burdened by the attention to global logics and vocabularies. It is inefficient for the team to spend time being explicit, using integrative complex reasoning and inventing new vocabulary items. Their language practice then begins a reverse shift toward a different lexicon more attuned to the local logic. The image of language as always

breaking down and always being repaired in ways that keep reversing themselves is an exciting and highly generalized manifestation of struggle in organizing. It is an aspect of our existence that is not apparent to us in our day-to-day experience, but is highlighted for us in this careful study of distributed practice.

That this language dynamic generally remains hidden from us is, I believe, related to the way we privilege space over time in our thought. Temporality is almost impossible for us to express in language, or to think about in its own terms. The very idea of temporality has to be translated into a spatial representation in order to be conceptualized in language. Time is shown as a line in Cartesian space. Temporal duration is discussed as movement along the line. An instant of experience is a limitlessly small point on the line. In this way, our ability to conceptualize the dynamic nature of language use and learning is made within a spatial framework that includes built-in inhibitions against a thoroughgoing sense of temporality.

This suggests that many of the forms of struggle in organizing are ultimately related to the fundamental concepts of space and time that shape our schemas for making sense of the experience of organizing. But that is a topic for another essay.

IMPLICATIONS FOR EDUCATION AND RESEARCH ON MANAGING AS DESIGNING

The major implication of recognizing the struggle that permeates the experience of organizing is to see the manager as an active source of invention, as opposed to an analytic expert who makes choices among alternatives. We increasingly live in a world that requires continuous creation of the new, which brings with it the need for a design attitude, which is rooted in the assumption that whatever the current situation we can always do better. Not better in a marginal sense of continuous improvement and commitment to more efficiency, but in the transformative sense that managers' responsibilities include reshaping the world they encounter and produce.

Our educational establishment has for too long portrayed managers as rather passive beings who accept the world as it is given to them and set goals for improvement within familiar boundaries. We have for too long glorified financial "wizards" who do not produce value in the form of products or services. Making credit available to growing businesses is unquestionably a valuable contribution to our economy. But as we have seen in the current financial crisis, that is not how Wall Street makes its money. Their revenues come from making gambles in the financial instrument market, from inventing instruments to gamble with, and from taking thin slices of money from the rush of transactions that flow in systems of production, which they had no role in creating.

There seems to be a welcome change in priorities on the horizon, as more business schools are moving toward more design-oriented education, helping students develop the skills and knowledge needed to create new products and services and bring new organizational forms into being. Entrepreneurship, strategy, information systems, marketing, accounting, and other business disciplines will benefit from an increased attention to design in the business school curriculum. Our graduates will become more well-rounded in a liberal arts sense, more able to see the need to challenge and reinvent familiar ways of organizing and managing, and more aware of their larger responsibilities to create value in society.

Finally, and perhaps most importantly, if we accept the reality of struggle in organizing, we will have a heightened attention to the ethical issues that saturate managers' lives. We will make our desire that managing is seen as a noble profession into a reality. We will find our graduates inventing positive approaches to improving the human condition and breaking free from the constrained images of being a passive decision-maker. We will educate our students to be true leaders whose skills in designing and organizing are worthy for and reflect the highest ideals of humankind. But shifts in our educational practices start with shifts in our research that help us to understand the struggle of organizing as being akin to the struggle of creating true art. As our research becomes more engaged with enduring problems of practice, we will begin developing pedagogies for teaching our students concepts and methods of design that will guide future leaders in creatively seeking human betterment.

ACKNOWLEDGMENT

This material is based in part on work supported by the National Science Foundation under Grant IIS-0208963. Any opinions, findings, and conclusions or recommendations expressed in this material are those of the author and do not necessarily reflect the views of the National Science Foundation.

REFERENCES

Boland, R., Sharma, A. and Alfonso, P. (2008) "Designing Management Control in Hybrid Organizations: The Role of Path Creation and Morphogenesis," *Accounting, Organizations and Society*, 33, 899–914.

Citurs, A. (2002) *Changes in team communication patterns: Learning during project problem/crisis resolution phases: An interpretative perspective*, PhD thesis, Weatherhead School of Management, Case Western Reserve University.

Van Gogh Museum (2009) "Vincent Van Gogh The Letters," Amsterdam, Huygens ING, The Hague [http://vangoghletters.org/vg/copyright.html].

THREE THOUSAND YEARS OF DESIGNING BUSINESS AND ORGANIZATIONS
Ken Friedman

Designing businesses is, in essence, designing human organizations to produce the systems, services, and products. The idea that design firms such as IDEO, Nielsen Norman, and the Policy Lab are addressing these problems from a design perspective anchored in the four orders of design is new. Management consultants and management experts are now working from the design thinking perspective. This is also new. Organization design is not new. While organization design as a specific term in management dates back to the 1940s, the idea of organization design is far older. The purposeful design of organizations for human purposes is as old as the first groups of people who organized governments and governance based on customary law and local versions of black-letter law. The first writings on organization theory are embedded in documents that we think of as philosophy, religion, or political science. This is in part because early writings on the organization and conduct of life in all its aspects were framed in a general wisdom literature. It is also because many early thinkers explicitly believed that it was impossible to separate out the different parts of life and human experience.

Many early documents on organization did not involve explicit reflection on how organizations function but served as partial and normative instructions on organizing tribes, religious behavior, cultures, or societies. Along with guides to individual behavior, the first five books of the Bible also contain extensive instructions on how to organize public life, conduct legal trials, perform worship, and organize the social systems that make these activities possible. In Exodus

18:13-26, for example, Moses's father-in-law Jethro offers advice on how to delegate authority that leads to the first judicial system of the twelve tribes. Exodus 29:1-37 and Leviticus 8:1-36 prescribe the ceremonial consecration of the priesthood and establish the legitimate line of succession for priests. Deuteronomy prescribes organizational norms for law courts and kings, requirements for government leaders, and laws of succession. As early as 1000 BC, the Egyptians had the equivalent of a civil service handbook that is preserved in fragmentary form as *The Instructions of Amenemopet*. Written as a training manual for Egyptian civil servants and a guide to wise professional practice, fragments of this document survive in the Bible. We can still read traces of Amenemopet's advice to young managers in the Book of Proverbs (22:17–24:22).

Around 800 BC, Hesiod created his *Works and Days*, examining organization at the level of the single farm and farm household. Efficiency—the relationship between input and output—is one of Hesiod's main concerns. Around a hundred years later, 700 BC, the Chinese scholar Guan Zhong wrote the *Guan Zi*. Increasingly acknowledged as one of the first great treatises on economics, it also discusses administration, markets, and how to organize societies. Sun Tzu's *Art of War*, written around 300 BC, also addresses issues in organization. Most think of it as a treatise on military strategy, and it is. Nevertheless, military success requires preparation and logistics, it demands the support of a national economy, and the army requires a culture, a staff, and structure. Sun Tzu gave attention to these issues as well and his work continues to have a place in organization theory and management, despite the fact that crossbows and chariots have little use in most organizations.

At roughly the same time, Xenophon wrote his *Oeconomicus*, going beyond the level of the individual household to other kinds of production, and to the military and public affairs. Xenophon, who lived in Plato's time, was a famed general whose ability to organize and lead others enabled him to bring ten thousand Greek soldiers back from Persia in the first great Long March of military history—this, too, involved organization. Much of Xenophon's thinking addresses the organizational conditions that enable individuals to work effectively in groups. Plato takes up similar themes at the level of the city-state and the nation in his *Republic*, and Aristotle's *Politics* does the same. Aristotle conducted significant empirical research on the organizations of his time, including a major study of Greek political organizations based on a survey of the laws and constitutions of more than one hundred Greek city-states. The analytical and practical traditions of Hellenic Greece informed the Roman citizen Paul in his missionary work for the new religion that blossomed in the first century after Christ. Paul's genius as a missionary required more than skillful rhetoric or theological genius. It rested on his ability to establish

organizations that would carry the mission of the church forward. His letters guided the churches he left behind in his travels, and the New Testament provides normative guidelines to establish the cultural structures and common ceremonies of the Christian community of the newborn church. In Timothy 3:1–13, for example, Paul sets forth qualifications for the bishops who will guide the church and deacons who will serve it. He repeats some of these in Titus 1:7-9, and in Titus 2:1–3:11 he provides a foundation for the organizational culture of the church and its community, a theme that recurs throughout his letters.

The scholars of the next great religion, Islam, also gave attention to organizational issues. Such scholars as Abu Hamid al-Ghazali discussed organizational and economic issues, as did Ibn Khaldun, who also wrote on issues that parallel later works in sociology. Ibn Khaldun presented ideas that presage both the functionalist perspective and the conflict theory perspective in organization theory, though these had little effect on the development of social theory because Western thinkers did not know them. Medieval Arabic literature included a special genre of writing known as the "mirror for princes" (Fox, 1995, p. 62). The concept of such books is found in many times and cultures. In Asia and Europe, writers from Lao Tzu to al-Maghili to Machiavelli discussed both the conduct of wise rulers and how they should organize affairs of state for national prosperity and successful reigns.

It is also useful to mention a special literature, mostly invisible, that guided the development of organizations in practice for thousands of years. These books and documents were able to generate organization theory in the workplace without contributing to the literature even to the degree that al-Ghazali or Ibn Khaldun might have done had their published works been available in the West. This is the literature of house books, internal rules, and accounts maintained by organizations while protected as trade secrets and intellectual property.

The first multinational business firms began some 2000 years before Christ, and many maintained far-flung empires (Moore and Lewis, 1999). Like the early churches, they required a way to maintain common bonds and standard procedures. Some did this through correspondence, others through direct private instructions, and some through a literature known as the "house book." These books are similar to the secret family books of the great warrior families. One example of such a book is that of Yagyu Munenori, martial arts teacher to the family of the Shoguns in the first Tokugawa Shogunate (in Musashi, 1982). House books may have been as explicit and rich as Munenori's book, as sketchy and aphoristic as the Wisdom of Amenemopet, as simple as a bundle of Paul's letters, or as amorphous as a few scribbled words in the margin of an account book together with the stories that senior partners might share with younger ones. This seems to have been the case for Cosimo de Medici, who created one

of the first M-form corporations and who wrote his thoughts on organization and management in unpublished letters to family and colleagues. Western political scientists and economists also paid attention to issues that are central to organization theory. Machiavelli wrote two books that are, in great part, an extended conversation on organization. The first is the well-known *Prince*, the second the less known *Discourses*. In each, he discusses the organization of the state, with consideration to such issues as motivation, commitment, and participation.

Another great contribution to organization theory is Adam Smith's (1976) classic, *The Wealth of Nations*. While this book is essentially a contribution to macroeconomic theory and political economics, Smith addresses many issues on the level of the firm or the organization. The first three chapters in Volume I consider the division of labor (Smith, 1776 [1976], pp. 7–25). In addressing this topic, Smith (ibid., pp. 8–9) wrote the single best known case study in all of organization theory, a case that remains lively and fascinating nearly two and a half centuries after he wrote it. This is the classic example of how an organizational structure based on division of labor renders an organization more productive. Smith (ibid., pp. 11–16) offers modern reasons for increased efficiency, and he addresses topics that involve increased effectiveness through what would now be labeled individual and organizational learning.

In politics, the representatives of the Scottish and Anglo-American Enlightenment traditions developed a major branch of philosophy around questions that we now identify with organization design: Thomas Hobbes, John Locke, James Madison, Alexander Hamilton, and John Jay are representative exemplars. Many distinguished historians examine specific periods in history in the light of the ways in which statesmen crafted social and governmental organizations to solve specific problems. This tradition has become so common, in fact, that major historians analyze the work of other historians as solutions to historical questions about the ways in which they analyze the eras and organizations about which they write (see, for example, Wood, 2008).

Explicit attention to organizational structure and the practices of public service and industrial organizations became a distinct field in the early twentieth century. Mary Parker Follett was the first great pioneer of this field, beginning in the 1890s with her study on the organizational role of the speaker of the House of Representatives and moving through three creative decades of work on industrial, business, and social organization (see Follett, 1896, 1918 [1998], 1924 [2013], 1941 [2013]). The next key writers in the field were Frederick Winslow Taylor and Henri Fayol. Taylor was the influential and much debated engineer who developed the concept of scientific management (see Taylor, 1911 [1967]). At the same time, Fayol, a French mining engineer, was examining the entire process of organization for industrial production (see Fayol, 1916 [2013]).

Questions in organization theory and design—and in business design—took off slowly, but surely, often with significant but long-delayed impact. Perhaps the longest such delay was the 1991 Nobel Prize in economics awarded to Ronald Coase for his 1937 article on "The Nature of the Firm" (Coase, 1937 [1990]).

From the 1940s on, organization design grew as a significant discipline in management schools and business schools. While business schools taught organization design as a specific discipline, however, they taught the subject in a far different way to the way that we understand it through the design thinking perspective. With a few notable examples, organization design is taught as a strategic management discipline in which top managers impose their vision on an organization often by imposing their will on the organization through delegated authority using organizational and economic force, or perhaps a softer human relations approach backed by the *sotto voce* threat of force if a manager requires force to achieve organizational goals. In contrast, the concept of design thinking generally involves interdisciplinary working groups attempting to reach genuine solutions on behalf of legitimate stakeholders through iterative trials and repeated prototyping.

The difference may reasonably be framed as a difference between Taylor's approach to management and Follett's. Taylor, like Fayol, advocates an approach that we may term managerialist. It is a directive, an engineered approach that treats the organization as a machine designed to achieve the purposes of the owners or shareholders. Follett's approach is an engagement with people, and Follett sees the organization as comprised of all the people in it. By extension, Follett's organization is embedded in a larger community and in a greater society still, and all have a legitimate stake in the organization, though the legitimate stake may involve different aspects of the organization. The issue of organization design is complicated by the question of who it is that is a legitimate stakeholder.

RESPONSIBLE PESSIMISM AND THE CHALLENGE TO DESIGNING BUSINESS

The new tradition of organization design as a design discourse is a significant contrast with the managerialist discourse or the engineering discourse applied to the organization as a machine. This new discourse blossomed in the twenty-first century. Notably foreshadowed by Buchanan's concept of the Four Orders of Design (Buchanan, 2001), the new discourse entered business schools in three ways.

One approach began in the discourse of design management. This discourse sees design as a corporate resource. This has in large part been a project-centered

discourse in which design is an important but subsidiary discipline of corporate management. The design management discourse notably developed in North America and the United Kingdom with some influence from continental Europe. Professional associations such as the Design Management Institute influenced the development and growth of this discourse. It grew from a professional practice into an academic discipline as academics began to study and make use of the work that practitioners did. The literature of design management is in large part located in practitioner books, case studies, and a smaller peer-reviewed literature addressing design management concerns.

Another approach involved the strategic design discourse. This discourse saw design as both a corporate resource and a way of approaching work. Beginning in a rather diffuse series of approaches, the strategic design discourse was notably visible in Scandinavia and Northern Europe. Heavily influenced by concepts of the role of work in a democratic society, it was also linked to such issues as knowledge management, information studies, and philosophy of management. While there is an interesting strategic design literature scattered across several fields, a significant part of this literature involves gray literature and working notes by academics, much in the tradition of house manuals. Part of this has to do with the lack of publishing venues, and part with the relatively new nature of the work. Key books by Pelle Ehn (1988), Harold Nelson and Erik Stolterman (2012), and Christian Bason (2010) exemplify the concepts and concerns of strategic design. The terms that different authors use vary, along with their concepts and models—much like the term "design thinking," the term "strategic design" remains fuzzy. In recent years, the literature has grown, especially through the influence of such organizations as Helsinki Design Lab (see, for example, Boyer and Cook, 2012a, 2012b, 2012c; Boyer et al., 2011, 2013).

The third discourse of design thinking in management began with Buchanan and moved through a key conference at Case Western Reserve University School of Management. A key book on *Managing as Designing* edited by Richard Boland and Fred Collopy (2004) became a focal point of a conversation that promises to bring the different management discourses together. But despite these factors that offer the hope of guarded optimism, there remain troubling challenges that are difficult to overcome.

Design is a process. Merriam-Webster's dictionary (1993: 343) defines design as: "1a: to conceive and plan out in the mind <he ~ed a perfect crime>; 1b: to have as a purpose: intend <he ~ed to excel in his studies>; 1c: to devise for a specific function or end <a book ~ed primarily as a college textbook>; 2 *archaic*: to indicate with a distinctive mark, sign or name; 3a: to make a drawing, pattern or sketch of; 3b: to draw the plans for; 3c: to create, fashion, execute or construct according to plan: devise, contrive . . ."

The key issue in design involves choice of goals. Many organizations, perhaps most, function as what Michael D. Cohen, James G. March, and Johan P. Olsen describe as "organized anarchies." That is, the organizations exist with a legitimate order and a constitutional form, but they involve a wide range of individual human beings, each with his or her own preferences, and most with varying agendas. Some may have goals closely aligned with the stated purpose of the organization. Others may have highly personal goals in which organizational membership plays a short-term instrumental role. Most organizational members occupy a position between the two extremes of complete alignment and completely personal purposes. Cohen *et al.* (1972, p. 1) argue that:

> organized anarchies ... are organizations—or decision situations—characterized by three general properties. The first is problematic preferences. In the organization, it is difficult to impute a set of preferences to the decision situation that satisfies the standard consistency requirements for a theory of choice. The organization operates on the basis of a variety of inconsistent and ill-defined preferences. It can be described better as a loose collection of ideas than as a coherent structure; it discovers preferences through action more than it acts on the basis of preferences.
>
> The second property is unclear technology. Although the organization manages to survive and even produce, its own processes are not understood by its members. It operates on the basis of simple trial-and-error procedures, the residue of learning from the accidents of past experience, and pragmatic inventions of necessity. The third property is fluid participation. Participants vary in the amount of time and effort they devote to different domains; involvement varies from one time to another. As a result, the boundaries of the organization are uncertain and changing; the audiences and decision makers for any particular kind of choice change capriciously.
>
> These properties of organized anarchy have been identified often in studies of organizations. They are characteristic of any organization in part—part of the time. They are particularly conspicuous in public, educational, and illegitimate organizations. A theory of organized anarchy will describe a portion of almost any organization's activities, but will not describe all of them.

While Cohen *et al.* describe this situation as conspicuous in public organizations, I would assert that the literature of management shows these situations to be the case in most large-scale organizations, including the vast majority of public shareholder companies. David Halberstam's (1987) discussion

of the North American automobile industry at a time when Ford and General Motors were two of the world's largest corporations is a case in point. Dozens of books and hundreds of articles describe how the global finance industry generated the recent global financial crisis. This is another case in point.

The garbage can model is a decision-making process that emerges when different actors choose among alternate goals.

> To understand processes within organizations, one can view a choice opportunity as a garbage can into which various kinds of problems and solutions are dumped by participants as they are generated. The mix of garbage in a single can depends on the mix of cans available, on the labels attached to the alternative cans, on what garbage is currently being produced, and on the speed with which garbage is collected and removed from the scene.
>
> (Cohen *et al.*, 1972, p. 2)

In essence, all actors dump their goals and preferences into the garbage can, and those who can control the draw pull out the decisions that meet their preferences or needs.

While many people have offered solutions to the garbage can model (see, for example, Padgett, 1980), this remains a recurring problem in organizations. We can describe the problem in two ways. One way to view the difficulty is the ethical problem of agency and moral hazard. Once again, we find ourselves asking who it is that is a legitimate stakeholder. If there were some way to engage all legitimate stakeholders in a responsible conversation, this might offer hope. To me, reviewing the state of large organizations and the state of the world, it seems highly unlikely that most stakeholders who create what others perceive as problems are willing to engage in responsible conversation. In most conflicts—and in nearly all intractable conflicts—key stakeholders seem at best to accept ameliorating conversations as they prepare for the next stage of conflict.

The other way to view the difficulty is through the lens of wicked problems. While this does not create a better approach in the sense of solutions that would help us to move around moral hazard, it does allow us to describe the nature of the problems more accurately. Horst Rittel and Melvin Webber (1973, pp. 161–166) define the attributes of a wicked problem:

1) There is no definitive formulation of a wicked problem.
2) Wicked problems have no stopping rule.
3) Solutions to wicked problems are not true-or-false, but good-or-bad.
4) There is no immediate and no ultimate test of a solution to a wicked problem.

5) Every solution to a wicked problem is a "one-shot operation" because there is no opportunity to learn by trial-and-error, every attempt counts significantly.

6) Wicked problems do not have an enumerable (or an exhaustively describable) set of potential solutions, nor is there a well-described set of permissible operations that may be incorporated into the plan.

7) Every wicked problem is essentially unique.

8) Every wicked problem can be considered to be a symptom of another problem.

9) The existence of a discrepancy representing a wicked problem can be explained in numerous ways. The choice of explanation determines the nature of the problem's resolution.

10) The planner has no right to be wrong.

Buchanan (1992) offers the classic discussion of this issue in design thinking. Many problems of this nature occur in human organizations. The nature of wicked problems is that solutions get foisted on the wrong problem. Wicked problems dovetail very nicely with the garbage can model when decision-makers choose the solution they wish to implement regardless of the problem (see also Friedman, 1997).

The nature of moral hazard and wicked problems in human organizations is the reason for my pessimism. So far, I see that design in the sense of design thinking or strategic design can work in projects where people meet in responsible conversation to solve problems with a group of legitimate stakeholders. I remain pessimistic for a simple reason. Much of the behavior I see in organizations involves people attempting to impose their preferred solutions on problems without respect to the nature of the problem or the consequences beyond personal goals.

A DANGEROUS WORLD: SOME CONCLUDING THOUGHTS

The initial conversations around designing business considered the nature of design specifically for social business with a strong emphasis on sustainability. This is a profound, ethical issue. If we do not solve this issue, the human race will not survive. James Lovelock has predicted that catastrophic climate change will be far worse than anybody dares to say. He predicts that 90 percent of the human species will die as a result of the changes that are coming to the planet. This means more than six billion people—perhaps a lot more, since there will be many more people when these changes hit hardest. Lovelock argues that

we must find effective ways to build for the future to save as many people as we can. If we can do this, we can also start to reverse changes. Have we reached the tipping point? I do not know.

The Stockholm Resilience Group has been working to define the limits and boundaries we face. Rockström *et al.* (2009) have defined ten crucial planetary boundaries. We are well into the danger zone on three, we are safe but at potential risk on five, and we do not yet know what the safe limits are on the other two. The group has examined many problems (cf. Palsson *et al.*, 2013) and proposed solutions (cf. Lynam *et al.*, 2012; Rogers *et al.*, 2013). M. P. Ranjan, an internationally respected design scholar from India, once said that all we really have in life is the square foot of earth on which we stand. The challenge we face is to work our own square foot of earth so that it is better and more fertile when we leave than when we got here. In *The Gift of Good Land*, Wendell Berry (1981) describes how Amish farmers restore the land they till. They take over old, worn-out farms to rescue them and bring new life to the soil through their agricultural practices. They create more value than they harvest, building the world around them as they do.

It would be optimistic to believe that we can leave our little square foot better and more fertile than when we got here. This is something that others know how to do, but in this modern networked world, our economy makes it difficult. If we consider Amish farming, an Amish family takes over a farm and returns it to productivity over decades as they create more value than they can capture. The Amish are a community of believers. They do not believe that we have dominion over the Earth, but stewardship. We must nourish, protect, and restore the Earth. As stewards of creation, we are obliged to nourish, protect, and restore what we find when we arrive. But the Amish adhere to an early Christian philosophy that requires them to conform to their view of God's ways and not the world's ways.

The question we must ask is ethical. What is the nature of a good, fair, and just society? If we can answer this question, we face the challenge of designing and building such a society. We also face an existential question. If the society we believe to be good, fair, and just is different to the society we have today, the existential question comes to the fore. Do we want such a society after all? In developing his position on justice as fairness, the philosopher John Rawls proposed that we should develop the laws we make and the societies we create without knowing what position we will hold in the societies that follow from our laws and actions. Rawls described this as a veil of ignorance, and he believed, reasonably, that we would make better laws and design better societies if we could not know whether we would be among one group or another, rich or poor, healthy or disposed to illness, members of a favored social class or members of a less fortunate group.

We also know that laws are not made this way, but rather made by the wealthy and powerful, or made by those whose election they influence disproportionately and whose actions they may therefore influence directly in a way that those without wealth and power cannot do. We play on an unleveled playing ground. As designers, we must ask how things should be different, and we must understand what kind of change we wish to introduce to the world. Creating effective social businesses is one of the ways in which we can introduce change to the world, change that serves more human beings than we serve today while shaping justice through fairness.

Buchanan's fourth order of design involves integrated systems for the totality of life to address these kinds of problems. Some aspects have to do with policy issues that must be negotiated with politicians and legislation in mind. Consider the question of externalities. In economics, an externality is a way of externalizing the costs of a process or product while retaining the profits. What would the world be like if we could shift profit ratios by transferring the burden of externalities back to those who create them? Imagine that a company manufactures a highly profitable widget that generates immense toxic waste in the production process. Rather than clean the waste using an expensive, environmentally responsible process, the company ships toxic waste to a poor country where local inhabitants must deal with it. By shipping off toxic waste as ordinary freight, the manufacturer can achieve profits with little cost. If designers could change the role of externalities and the way that some groups benefit unfairly from the system, it would make social business—and socially responsive business—more profitable by addressing the true nature of values. It will make irresponsible business less profitable by forcing those businesses to become responsible by paying their full costs.

Human beings have been talking about the fourth order of design in different ways for a long time. This is what W. Edwards Deming (1993, p. 96) terms profound knowledge, comprised of "four parts, all related to each other: appreciation for a system; knowledge about variation; theory of knowledge; psychology." The question each of us must ask is whether and how we are willing to act on what we know.

The conversation on designing business requires us to recognize the deep nature of the problems we face. We must understand the real conditions that confront a vast number of the world's human beings. In itself, this knowledge leads to the conditions that Martin Buber (1999, p. 116) identified as existential guilt. Recognizing how much there is to do provokes existential anxiety. When it comes to the deep questions of existence, Viktor Frankl, a professor with whom I studied, used to say that the great question we face as human beings is not what we ask of life, but rather what life asks of us. It is how we choose to answer that defines us as human beings.

I am a guarded optimist because I believe it is better to live as though what we do in life can make a difference that improves the world into which we are born. I am a responsible pessimist because I believe that we find ourselves in the most dangerous situation that human beings have ever found ourselves with respect to the world around us. For the first time in human history, second-order evolution has overtaken first-order evolution on a planetary basis with respect to most of the systems that sustain life on our planet.

Stephen Emmott (2013) reviewed the global situation to reach a blunt and decidedly pessimistic conclusion. He does not think that we will escape the kinds of catastrophe that Lovelock predicts. Like Lovelock, Emmott believes the situation is worse than we can imagine. For Emmott, the willful blindness of policy-makers, economists, and business leaders makes the situation worse—and as inevitable as the recently announced collapse of the West Antarctic ice sheet. It is a dangerous time. I suspect that we can design businesses more effectively and responsibly on a small-scale basis, just as we can use design thinking and strategic design to create better systems, products, and services. On a larger scale, I am not hopeful. I would like to believe that if we model workable systems, we might be able to scale up our skills and capacity to prevent the worst of what might otherwise be our fate.

REFERENCES

Bason, C. (2010) *Leading Public Sector Innovation: Co-creating for a Better Society*, Bristol: Policy Press.

Berry, W. (1981) *The Gift of Good Land: Further Essays Cultural and Agricultural*, Berkeley, CA: Counterpoint Press.

Boland Jr., R. J. and Collopy, F. (eds.) (2004) *Managing as Designing*, Palo Alto, CA: Stanford Business Books.

Boyer, B. and Cook. J. W. (2012a) *Creating New Opportunities and Exposing Hidden Risks in the Healthcare Ecosystem*, Helsinki: Sitra, the Finnish Innovation Fund.

Boyer, B. and Cook. J. W. (2012b) *Thinking Big by Starting Small: Designing Pathways to Successful Waste Management in India and Beyond*, Helsinki: Sitra, the Finnish Innovation Fund.

Boyer, B. and Cook. J. W. (2012c) *From Shelter to Equity*, Helsinki: Sitra, the Finnish Innovation Fund.

Boyer, B., Cook, J. W. and Steinberg, M. (2011) *In Studio: Recipes for Systemic Change*, Helsinki: Sitra, the Finnish Innovation Fund.

Boyer, B., Cook, J. W. and Steinberg, M. (2013) *Legible Practices*, Helsinki: Sitra, the Finnish Innovation Fund.

Buber, M. (1999) *Martin Buber on Psychology and Psychotherapy: Essays, Letters and Dialogue*, Syracuse, NY: Syracuse University Press.

Buchanan, R. (1992) "Wicked Problems in Design Thinking," *Design Issues*, 8 (2), 5–21.

Buchanan, R. (2001) "Design Research and the New Learning," *Design Issues*, 17 (4), 3–23.

Coase, R. H. (1937 [1990]) "The Nature of the Firm," in *The Firm, The Market, and the Law*, Chicago, IL: University of Chicago Press, 33–55.

Cohen, M. D., March, J. G. and Olsen, J. P. (1972) "A Garbage Can Model of Organizational Choice," *Administrative Science Quarterly*, 17 (1), 1–25.

Deming, W. E. (1993) *The New Economics for Industry, Government, Education*, Cambridge, MA: Massachusetts Institute of Technology, Center for Advanced Engineering Study.

Ehn, P. (1988) *Work-Oriented Design of Computer Artifacts*, Hillsdale, NJ: Lawrence Erlbaum Associates.

Emmott, S. (2013) *Ten Billion*, New York: Vintage Books.

Fayol, H. (1916 [2013]) *General and Industrial Management*, Eastford, CT: Martino.

Follett, M. P. (1896) *The Speaker of the House of Representatives*, New York: Longman Green & Co.

Follett, M. P. (1918 [1998]) *The New State: Group Organization, the Solution for Popular Government*, Pittsburgh, PA: Pennsylvania State University Press.

Follett, M. P. (1924 [2013]) *Creative Experience*, Eastford, CT: Martino.

Follett, M. P. (1941 [2013]) *Dynamic Administration: The Collected Papers of Mary Parker Follett*, edited by Henry Metcalf and Lionel Urwick, Eastford, CT: Martino.

Fox, E. (1995) *Obscure Kingdoms*, London: Penguin.

Friedman, K. (1997) "Design Science and Design Education," in P. McGrory (ed.), *The Challenge of Complexity*. Helsinki: University of Art and Design Helsinki UIAH, 54–72.

Halberstam, D. (1987) *The Reckoning*, New York: Avon Books.

Lynam, T., Mathevet, R., Etienne, M., Stone-Jovicich, S., Leitch, A., Jones, N., Ross, H., Du Toit, D., Pollard, S., Biggs, H. and Perez, P. (2012) "Waypoints on a Journey of Discovery: Mental Models in Human–Environment Interactions," *Ecology and Society*, 17 (3), art. 23.

Merriam-Webster, Inc. (1993) *Merriam-Webster's Collegiate Dictionary*, 10th edn., Springfield, MA: Merriam-Webster, Inc..

Moore, K. and Lewis, D. (1999) *Birth of the Multinational: 2000 Years of Ancient Business History—From Ashur to Augustus*, Copenhagen: Copenhagen Business School Press.

Musashi, M. (1982) *The Book of Five Rings* (With Family Traditions on the Art of War by Yagyu Munenori), translated by Thomas Cleary, Boston, MA: Shambhala.

Nelson, H. and Stolterman, E. (2012) *The Design Way: Intentional Change in an Unpredictable World*, 2nd edn., Cambridge, MA: MIT Press.

Padgett, J. F. (1980) "Managing Garbage Can Hierarchies," *Administrative Science Quarterly*, 25 (4), 583–604.

Palsson, G., Szerszynski, B., Sörlin, S., Marks, J., Avril, B., Crumley, C., Hackmann, H., Holm, P., Ingram, J., Kirman, A., Buendía, M. P. and Weehuizen, R. (2013) "Reconceptualizing the 'Anthropos' in the Anthropocene: Integrating the Social Sciences and Humanities in Global Environmental Change Research," *Environmental Science and Policy*, 28, 3–13.

Rittel, H. W. J. and Webber, M. M. (1973) "Dilemmas in a General Theory of Planning," *Policy Sciences*, 4, 155–169.

Rockström, J., Steffen, W., Noone, K., Persson, Å., Chapin, F. S., Lambin, E. F., Lenton, T. M., Scheffer, M., Folke, C., Schellnhuber, H. J., Nykvist, B., de Wit, C. A., Hughes, T., van der Leeuw, S., Rodhe, H., Sörlin, S., Snyder, P. K., Costanza, R., Svedin, U., Falkenmark, M., Karlberg, L., Corell, R. W., Fabry, V. J., Hansen, J., Walker, B., Liverman, D., Richardson, K., Crutzen, P. and Foley, J. A. (2009) "A Safe Operating Space for Humanity," *Nature*, 461 (7263), 472–475.

Rogers, K. H., Luton, R., Biggs, H., Biggs, R., Blignaut, S., Choles, A. G., Palmer, C. G. and Tangwe, P. (2013) "Fostering Complexity Thinking in Action Research for Change in Social–Ecological Systems," *Ecology and Society*, 18 (2), art. 31.

Smith, A. (1776 [1976]) *An Inquiry into the Nature and Causes of the Wealth of Nations*, Chicago, IL: University of Chicago Press.

Taylor, F. W. (1911 [1967]) *The Principles of Scientific Management*, New York: W. W. Norton.

Wood, G. S. (2008) *The Purpose of the Past: Reflections on the Uses of History*, New York: Penguin.

REDESIGNING ORGANIZATION DESIGN

Daved Barry

I'd like to start with a conundrum: how is it that Organization Design looks, talks, and acts nothing like its contemporary design counterparts? Why does Organization Design (hereafter OD) seemingly shun creativity, making things from scratch, playfulness, beauty, or even interest (financial interest excluded), things which are intrinsically part of other design professions?

I suspect the reason isn't a lack of awareness. According to Google's NGram service, OD was first mentioned around 1900, and grew up about the same time as other design fields. Clearly the people developing it knew that there were other people out there calling themselves designers. They likely knew there were whole schools devoted to design. And yet until Boland and Collopy's (2004) edited title *Managing as Designing*, OD theorists and practitioners seldom, if ever, read what other designers wrote, visited a general design conference, or considered using "designerly ways of knowing" (Cross, 1982). Relative to this, I want to follow Dickens's lead and consider the ghosts of OD's past, present, and future—inquiring a bit into what OD was, what it is today, and how it might re-design itself in the future.

THE SPIRIT OF OD PAST

For most of its life, OD has been concerned with organizational structure—what's the best arrangement of people and goods to achieve a given purpose? What's the optimal boss-to-staff ratio? Should you group operations by geography, product, or business function? Should you have a tall, flat, fat, or lean structure? Who should work under whom? With all this, the organization chart has long represented the field, and optimization has been the name of the

game. In many ways, OD has been a type of engineering, similar to mechanical or civil engineering, where the fundamental premises are that organizations are governed by scientific laws, that there is an optimal arrangement for a given situation, and that the engineer's job is to find it. Once the right blueprint is found, building and running the thing is assumed to be a relatively straightforward task. This engineering-based OD is essentially decisional in character ... to a point where we might call this *Analytic OD* (AOD). The OD analyst lines up the proven diagnostics, finds solutions that have worked elsewhere, undertakes cost–benefit analyses, and then makes the correct "go/no-go" decisions (cf. Burton *et al.*, 2011; Daft, 2012).

Charlie Chaplin's "Modern Times" captures this nicely. As the "Tramp," Chaplin works for a nameless business portrayed via a large clockwork machine. The workers are variously pushed by its cogs and repair its workings, forced to become cog-like themselves. There is undoubtedly a master engineer somewhere who designed and built the organization using principles of efficiency and material science. Perhaps he sits in one of the many high-rise offices of the twentieth century—buildings where organization designers worked in penthouses. Or perhaps, like the Wizard of Oz, he stands on the ground floor behind closed curtains, pushing and pulling tall levers to keep everything ticking along.

Just as mechanical engineers learned to design different engines for different industries and topographies, AOD designers came to formulate different organizational structures for different environments—adopting the contingency perspective that dominates the field today. Interrelationships of variables like structural height, centrality, environmental change, organizational history, and competencies became the basis for design decisions. Importantly, one size doesn't fit all. But equally important is the assumption that there are "local optimums"—that there are correct fits based on correct assessments.

In sum, we see that OD has been a rational endeavor that revolves around problem-solving, contingent decision-making, and optimization. Presumably the higher you sit, the greater your perspective, the more coolly rational you can be, and the bigger the decisions you can make. It's the proverbial "25,000 foot view." With this view come a number of assumptions:

- As a designer, you can control ever larger organizations.
- Upper echelons can make "this" grow—scaling up whatever this business is. Bigger is mostly better and tweaking is both possible and desirable.
- You can get higher production and efficiencies by making sure that everyone has a proper place and everyone is in their place.
- Designing and running an organization is like flying a Boeing 747 in the dark—it's no sweat as long as you have good instruments that can make

good measurements, and there are well-defined blueprints for making and working with these instruments.

Going back to my question about why OD looks, talks, and acts so differently than other design fields, I suspect the answer has to do with the high stakes inherent in organizations—which typically subsume many products, are very expensive to run, and are mostly conceived as investments rather than living arrangements. Organizations are a lot more costly than the buildings, individuals, machines, cafeterias, furniture, and land that they encompass. The bigger and more costly the organization and the more the organization is based on profit, the more this tends to hold: "If we're going to spend this much time and effort, we'd better get it right . . . exactly right." Investors, financial or otherwise, want a design orientation that is based on sureness, rightness, and precision, one that will give them a predictable outcome on which go/no-go decisions can be made.

So far, this approach to organization design adds up. If one believes that organizations are goal-driven entities that can do the job better than free-form market processes, and that there are X number of ways to do this, some better than others, then searching for best bet structural templates makes a lot of sense. Up until the mid 1980s, this OD approach was very popular. A Google N-gram (Figure 6.1) on the terms "organization design" and its cousins (e.g., organizational design, organisational design) shows a distinctive upward usage curve from the 1950s until the mid 1980s, meaning that organization design was increasingly at the center of things.

Yet it turns out that this was a temporary peak. Another Google N-gram (Figure 6.2) shows that OD's popularity in 2007 was about the same as it was in the 1970s. Its downward curve is relatively steady, apart from a small spike

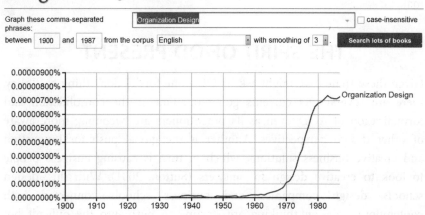

Figure 6.1
Google NGram of the term "Organization Design" from 1900 to 1987.
Source: Google Books Ngram Viewer [http://books.google.com/ngrams]

Figure 6.2
Google NGram of the term "Organization Design" from 1900 to 2007.
Source: Google Books Ngram Viewer [http:// books.google.com/ ngrams]

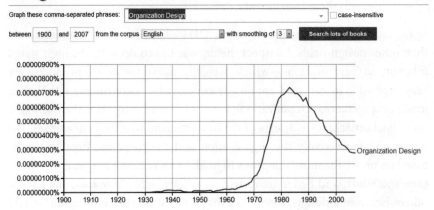

in the mid 1990s, suggesting that this was more than a temporary loss of favor. Out of curiosity I ran an N-gram on the term "design," and it turns out that it's been steadily increasing in popularity since 1900. So it's not that design has been waning and taking OD with it, quite the contrary.

Why this decline? Perhaps it is because OD is notoriously hard to test—it's very difficult to do controlled experimental studies on organizations. Professor Borge Obel, an OD scholar at the University of Aarhus, puts it well: "We don't have wind tunnels for organizations" (personal communication). Perhaps it was the entrance of other more sensate and action-oriented perspectives that caught the public eye (e.g., organization culture, strategy, or practice theory). Or maybe it was OD's inattention to people, taste, and imagination, even though most employees have taste and imagination. Maybe CEOs and other executives didn't like being turned into buyers of "plug and play" structures—perhaps this went against their view of themselves as leaders and makers?

THE SPIRIT OF OD PRESENT

Given these trends, we might ask "Is OD done for?" I don't think so. Today, there are several OD currents going on. One is the consolidation and formalization of AOD, even as its practitioners are becoming more aware of other design perspectives. Another is the global push for innovation and creative business solutions, which in turn is causing business people to look to creative design for answers (Sutton, 2001). With this, design schools, design companies, and business schools connected with contemporary design thinking are starting to push into the difficult but

potentially lucrative OD area, bringing in their "other worldly" techniques and perspectives.

Relative to AOD, the biggest development is the formation of the international Organizational Design Community (ODC; http://orgdesigncomm.com/). The group's founders consist of many of OD's most notable scholars, and they have recently launched the *Journal of Organizational Design*, along with an annual conference, website, and global seminar series. Coupled with the fact that there are hundreds of academics worldwide doing large sample, survey-based, contingency-generating AOD research, this movement points to both a solidification of the field and markets for this kind of OD approach. With this, researchers are investing heavily in trying to computerize and standardize AOD's tenets. For instance, Professors Richard Burton and Borge Obel have compiled many of the classical contingency OD approaches and stepwise OD methods (Burton *et al.*, 2011) into "OrgCon," a question/answer software program that asks users to evaluate their organization's environment and current design, and then provides diagnoses and suggestions. According to the OrgCon website, the software:

> ... systematically guides the executive team to determine an organizational design solution for the organization. The OrgCon software program is central to the design process. The OrgCon program focuses on identifying design alternatives, which are efficient (resources) and effective (results). OrgCon helps diagnose the strategic and organizational situation to highlight organizational misfits and what can be done to develop an organization in fit. It is a logical tool, which incorporates knowledge from the organizational design literature, and which has been validated in use by executives. The OrgCon design process allows you to analyze many scenarios quickly and efficiently.[1]

Paralleling these developments have been some very important state changes in the business landscape. Whereas it used to be that organizational life was relatively predictable, now organizations are mostly unpredictable and organizing has become a constant. With the advent of global markets, instantaneity of communication, shortening of product lifecycles, and hypercompetition, we have seen a huge push for innovation and creative business solutions—one that shows no signs of stopping. Recently, an exhaustive study of business performance by McKinsey, captured in the book *Beyond Performance* by Scott Keller and Colin Price (2011), shows that innovation and change have definitively replaced scale and stability as determinants of organizational survival and success, throughout the world and across most industries. Everyone has been saying this for over a decade, but now the numbers prove it. Hence, many of today's organizational executives have

innovation firmly in mind, if not in practice, and are regularly looking for distinctive and competitive ways to increase innovative capacity. Importantly, innovation doesn't come from machines—it comes from inventive, motivated people and creative social processes, thus putting pressure on OD to rethink how the people part can be brought in.

Jumping in to fill this need has been IDEO's version of "design thinking." ABC's documentary on IDEO's use of design thinking to redesign the American shopping cart (Koppel and Smith, 1999) has now been seen by tens of thousands of business students and executives worldwide, as has Tim Brown's 2008 design thinking article in the *Harvard Business Review*. Both have become baseline sources for how to "innovate by design." The IDEO-driven design thinking methods at Stanford's dschool and the Hasso Plattner Institute in Germany, IDEO's proliferation of books and articles, and Roger Martin's work at the Rotman Business School in Toronto, has many business leaders and business schools believing that (1) IDEO and design thinking *ARE* design, (2) that these methods are the holy grail for innovation, and (3) that design thinking—as a collection of user-based research techniques, Post-it® note brainstorming, and frequent prototyping—is something that any business person can do. So who needs professionally trained designers?

Of course, design thinking—and design period—is a lot harder to do than these sources suggest. Ramping all this up to the organizational level is harder still. Apart from a small handful of OD engagements, IDEO tellingly continues to get most of its revenue from product and service design. Concomitantly, prominent designers and design researchers (e.g., Don Norman, Helen Walters, Bruce Nussbaum) have fought back against design thinking's territorialization, trying to show the world that there is more to designing than seven or so steps (see Kimbell, 2011, 2012; Newman, 2011). Empirically, researchers like Roberto Verganti (2008, 2009) have shown that design thinking's user-driven focus often leads to mediocre, incremental innovation, and that successful radical innovation requires more arts-based design methodologies, which in turn require talent and years to master.

Other business design techniques have also entered the picture, loosening design thinking's grip. For instance, Alexander Osterwalder and Yves Pigneur's "Business Model Canvas" (2010), which is essentially an aesthetically charged version of the value chain, is intertwined with engaging social processes (e.g., business model parties), making the whole task of business modeling much more enjoyable. Jacob Buur's work around tangible business modeling (Buur and Matthews, 2008; Buur and Mitchell, 2011), the Serious Play system from Imagination Lab (Roos and Victor, 1999; Roos *et al.*, 2004), Lucy Kimbell's social design methods (Kimbell and Julier, 2012), the strategic design methods

of the now defunct Helsinki Design Lab (Boyd *et al.*, 2011; Hill, 2012), as well as my own work in this area (Barry, 1994, 1997; Barry and Meisiek, 2010), are giving us more aesthetically heightened ways to represent and redesign organizations. For instance, over the last decade I have run numerous OD courses where students apply designerly methods to challenges presented by executives from prominent European organizations—for example, how to redesign a company's innovation system or increase governmental innovation capacity. This has resulted in many inventive organizational designs, a number of which have been successfully adopted.

Taken together, this work has created a conceptual opening for new, more designerly approaches to OD. Whereas OD has always emphasized the "deliver" side of design—seeking organizational designs that are efficiently functional above all else—these new currents are pushing OD to add *delight* and *deepen* to the mix. That is, OD will need to create designs that delight, deliver, and deepen, ones that are pleasurably surprising, enlivening, and engaging (i.e., delightful), capacity building and agile (i.e., deepen), and practically functional (deliver). To get to "delight and deepen" will require OD methods that are more people-centered, socially conscious, creative, emergent and iterative, tangible and making-based rather than just analytic and decisional—something we might call Designerly Organization Design (DOD). Other candidates could be Human Organization Design, Creative Organization Design, or Tangible Organization Design. This brings us to what's next.

THE SPIRIT OF OD FUTURE

As I noted earlier, Analytic OD (AOD) seems to be pulling itself into a tighter orbit, and I can imagine that it will carry on trying to develop more accurate analytical and decision-making tools similar to the OrgCon program. It may be that AOD designers come up with the equivalent of the Black Scholes equation in finance, which accurately predicts whether derivative investments will pay off or not. I would predict that AOD's formulas will gradually incorporate complexity thinking, perhaps using higher-order mathematical modeling and fuzzy logic systems to determine best fit designs.

What's harder to imagine is that AOD'ers would incorporate designerly design methods. The kind of data that DOD generates tends to be noise for AOD (and perhaps vice versa). And the skill sets needed for each approach go in very different directions. AOD requires a penchant for convergent, law-directed formulations, while DOD asks for divergent, law-breaking ideas. Hence becoming good at a given orientation requires thinking and working in almost opposite ways.

Some of my thoughts on this come from a pilot study of how designers and executives go about solving an OD problem, conducted by Ingrid Østensjø (a thesis student) under my supervision. After a number of pre-interviews with recent graduates of design and business schools, Ingrid gave ten prominent designers and eight executives a short Harvard case where the challenge was to redesign EuroDisney (Nanda, 1996). The case has been used in business schools worldwide, and has extensive teaching notes around what should be done. The designers came from various design areas (e.g., product, graphic, communication, interaction, scenography, architecture, strategic design). The executives were mostly CEOs of medium to large companies (IT, furniture, engineering, valve manufacturing, and entertainment). Each person had up to three hours to work on the case, and all were asked to "think out loud" as they read it through; that is, to say everything that occurred to them as they read and thought about it.

To some extent the results fit the stereotypes we have of designers and executives, and of analytic versus designerly design. The trained designers came up with innovative, holistic, and human-centered designs, focusing on how Disney's employees might better work together within different reshufflings of the country offices. Meanwhile the executives' designs looked a lot like the Harvard solutions, revolving around structural rearrangements and reporting relationships, cost-cutting, and rethinking the product mix. Whereas the designers construed Disney as a social network, the executives saw it as an abstract series of cost and profit centers to be moved around.

What was surprising was just how different the two groups were when it came to apprehending the case. The executives all breezed through it, typically jotting down a few notes, confident in their analyses, and finishing within twenty to forty minutes. Comparatively, the designers struggled with the material. For instance, the first designer to be interviewed, the owner of a prominent architecture company and a well-known architect himself, stopped halfway through the case, put it down, and said, "I don't get this. What am I supposed to do? There's nothing to work with here." Like the other designers, he asked if he could bring in some of his colleagues to help. He wanted a few days to work on it (other designers wanted a week or more). And he wanted a lot more information about the people in the case. In the end, he didn't do any design work, choosing instead to critique EuroDisney's ethics.

After several of these encounters, we recognized that the case needed to be altered in order to make it more accessible to the designers. The first attempt consisted of dividing up the case into small slivers of information, which were handed to the interviewees upon request. This didn't help—they still struggled a lot. Finally, Ingrid rewrote the case as a set of correspondences between the actors in the case (letters and emails). The information existing between the

lines was clearly spelled out, and more graphics and a different layout made the case more visually rich. The designers responded better to this setup and were able to get into the design process. But regardless, they all wanted to work with others on it, wanted much more time, and asked for more sensate information.

If we extend this and start thinking about how to do OD along designerly lines, the scope of design opens up quite a bit, going well beyond the usual concerns around organizational structure. From a DOD perspective, other considerations could (and probably should) include the design of organizational events, projects, job titles, identities, strategies, processes, conversations, business models, work environments, analogies and metaphors, and representations. All of these become interactive within DOD—changes in one area have implications for the others.

As an example, consider the Lagrimas corporation in Lisbon, which owns and runs some of Portugal's most successful high-end restaurants and hotels. Employees' business cards are miniature versions of the "Please Do Not Disturb" cards one finds in hotels, only these say "*Please Disturb*." Everyone in the company chooses their own job titles, based on their personalities and values. Miguel Júdice, for instance, has the title "CEO and Globetrotter," which he does his best to live up to. The full name of the holding company is Lagrimas Hotels and Emotions, stressing the experiential nature of their business. All these elements are integral parts of the company's identity, one that has been carefully designed with the help of professional designers, and which is intertwined with other OD elements including structure, strategy, financing, and product-service offerings. Employees tend to go where their job titles take them, and thus the corporation's structure is a dynamic one.

IN THE END

Lagrimas, though unusual, is not unique—there are many companies today that are experimenting with these more designerly ways of organizing, including Apple, Google, GoreTex, Semco, and even Proctor and Gamble. With all this experimentation, I am guessing that it's only a matter of time before AOD meets DOD in some complementary ways. Maybe DOD will come up with the innovative designs and AOD will test their effectiveness. Or maybe AOD will make initial designs that DOD can depart from. Or perhaps a more unified OD will emerge, where "delight, deliver, and deepen" all come together using bits and pieces from both orientations. To be successful, though, this new OD will require a lot more than asking executives to brainstorm, prototype, and otherwise "get creative." Coming up with effective organization designs that deliver, delight, and deepen will require training along the lines that designers get—years of learning how to reframe organizational problems into evocative

questions, finding inspirational networks alongside solution-based ones, creative and aesthetically sophisticated experimentation, and working with multiple mediums and representational forms. It will also require systematic testing over time, to see where and how these innovative designs work and don't work. Clearly, OD is heading toward a new chapter, perhaps its most interesting and inventive one yet.

NOTE

1. http://www.ecomerc.com/content/diagnosis-and-design-executive-team-process [accessed March 1, 2012].

REFERENCES

Barry, D. (1994) "Making the Invisible Visible: Using Analogically-based Methods to Surface the Organizational Unconscious," *Organizational Development Journal*, 12 (4), 37–49.

Barry, D. (1997) "Artful Inquiry: A Symbolic Constructionist Framework for Social Science Research," *Qualitative Inquiry*, 2 (4), 411–438.

Barry, D. and Meisiek, S. (2010) "Seeing More and Seeing Differently: Sensemaking, Mindfulness and the Workarts," *Organization Studies*, 31 (11), 1505–1530.

Boland Jr., R. J. and Collopy, F. (eds.) (2004) *Managing as Designing*, Palo Alto, CA: Stanford Business Books.

Boyd, B., Cook, J. and Steinberg, M. (2011) *In Studio: Recipes for Systemic Change*, Helsinki: Sitra Publishing.

Brown, T. (2008) "Design Thinking," *Harvard Business Review*, 86 (6), 84–92.

Burton, R., Obel, B. and DeSanctis, G. (2011) *Organizational Design: A Step-by-Step Approach*, Cambridge: Cambridge University Press.

Buur, J. and Matthews, B. (2008) "Participatory Innovation," *International Journal of Innovation Management*, 12 (3), 255–273.

Buur, J. and Mitchell, R. (2011) "The Business Modeling Lab", in *Proceedings of the Participatory Innovation Conference* 2011, Sønderborg, Denmark.

Cross. N. (1982) "Designerly Ways of Knowing," *Design Studies*, 3 (4), 221–227.

Daft, R. (2012) *Organizational Theory and Design*, New York: Cengage Learning.

Hill, D. (2012) *Dark Matter and Trojan Horses: A Strategic Design Vocabulary*, Helsinki: Strelka Press [Kindle Edition].

Keller, S. and Price, C. (2011) *Beyond Performance: How Great Organizations Build Ultimate Competitive Advantage*, New York: John Wiley.

Kimbell, L. (2011) "Rethinking Design Thinking: Part 1," *Design and Culture*, 3 (3), 285–306.

Kimbell, L. (2012) "Rethinking Design Thinking: Part 2," *Design and Culture*, 4 (2), 129–148.

Kimbell, L. and Julier, J. (2012) *Social Design Methods Menu*, London: Fieldstudio Ltd.

Koppel, T. and Smith, J. (1999) "The Deep Dive: One Company's Secret Weapon for Innovation", ABC News, Nightline Series. Princeton, NJ: Films for the Humanities & Sciences.

Nanda, A. (1996) "Walt Disney's Dennis Hightower: Taking Charge", case no. 9-395-055, Boston, *Harvard Business School Publishing*, May 6.

Newman, D. (2011) "The Short Happy Life of Design Thinking", *Print*, 65 (4), 44–45.

Osterwalder, A. and Pigneur, Y. (2010) *Business Model Generation: A Handbook for Visionaries, Game Changers, and Challengers*, New York: John Wiley.

Roos, J. and Victor, B. (1999) "Towards a Model of Strategy Making as Serious Play," *European Management Journal*, 17 (4), 348–355.

Roos, J., Victor, B. and Statler, M. (2004) "Playing Seriously with Strategy," *Long Range Planning*, 37, 549–568.

Sutton, R. (2001) "The Weird Rules of Creativity," *Harvard Business Review*, 79 (8), 94–103.

Verganti, R. (2008) "Design, Meanings, and Radical Innovation: A Meta-model and a Research Agenda," *Journal of Product Innovation Management*, 25, 436–456.

Verganti, R. (2009) *Design Driven Innovation: Changing the Rules of Competition by Radically Innovating what Things Mean*. Boston, MA: Harvard Business Press.

DESIGN THINKING APPROACHES

PART 3

CHAPTER 7
BRIDGING DESIGN AND BUSINESS THINKING
Charles Burnette

Design thinking and business thinking have more in common than might be expected. Businesses typically address the same kinds of information as design thinking, usually with different goals in mind. Business thinking often focuses on corporate earnings, marketing effectiveness, and manufacturing efficiency, while design thinking seeks to improve whatever problematic situation it addresses. Businesses often do not understand that design thinking is not simply a methodology they can apply.

> Design thinking is to design what the scientific method is to science. It's the steps without the knowledge and the years of training. And design thinking is a real danger because many companies think they're doing design and they're not.
>
> (Burke, 2013)

In this remark, Paola Antonelli of the Museum of Modern Art in New York is referring to the lack of education, experience, talent, knowledge, and versatility that an accomplished designer brings to the task of design and to the fact that these cognitive, expressive, and practical skills are not generally available in industry. Design thinking is likely to remain largely an isolated process implemented by outside consultants until those who fully understand its goals and can creatively implement its processes are integrated into companies across the entire spectrum of business at every level and in every domain of corporate activity. This chapter will suggest the nature of the bridge that could bring business, design thinking, and the act of designing together. The bridge is built on the understanding that designing is innovative, creative, human-centered, forward-looking, and focused on improving problematic situations.

The structure for that bridge is a theory of design thinking that focuses on innovation and creativity.

LEVELS OF PURPOSEFUL THOUGHT

Business people and designers often fail to appreciate that both design and business thinking are rooted in purposeful thought.

Purposeful thought at any level responds to needs and desires, is goal-directed, and pragmatic. At a basic level it usually occurs in a familiar context using procedures that yield predictable outcomes. Such thought is also how we learn to do things like riding a bicycle, or becoming more skilled and knowledgeable about what we do. We learn, rehearse, and gain competence as we apply thought for a purpose. Most businesses remain at this lower level of purposeful thought, guided by what is familiar, predictable, productive, and rewarding in the short term.

Design thinking is purposeful thought focused on improving experiences, artifacts, and services to meet a wider range of concerns than the basic level of purposeful thought normally addresses. It tends to broaden and reframe a problematic situation, to re-conceive it, and find innovative ways to reformulate and resolve the circumstances of concern.

Creative design thinking is an even higher level of purposeful thinking, one that applies design thinking to attain extraordinary, inventive, and culturally significant outcomes. Creative design thinking requires new ways of approaching a problematic situation and the ability to resolve them insightfully, inventively, and for a greater good.

MODES OF PURPOSEFUL THOUGHT

Purposeful thought is familiar to everyone. We feel a need or desire; seek relevant information; organize and analyze alternatives; formulate a plan of action; carry out the plan; evaluate its progress; and reflect on our experience. In "A Theory of Design Thinking" (Burnette, 2009), these seven shifts in thought are identified as "intentional stances" and occur at all three levels of purposeful thought. The purposeful stances direct thought to different information in a focal situation to consider and express intentions, information, organization, forms, processes, evaluations, and knowledge appropriate to each stance. The modes of thought generated from each stance collaborate to express objectives, objects of thought, ideas, artifacts, processes, outcomes, and the knowledge gained during an episode of purposeful thought. Creative strategies may be

applied in any mode, or by collaborating modes, to generate extraordinary outcomes within any domain or problematic situation. The modes of thought involved in purposeful thought at any level are:

- *Intentional thought* addresses wants and needs, sets goals, prioritizes them, and manages their pursuit. It is forward-looking, effortful and requires attention, focus, and commitment to goals regarding whatever is addressed. Its primary objective is to resolve problematic situations.
- *Referential thought* identifies, locates, and defines information of interest and potential use. It recognizes the utility, potential, and availability of resources. Its primary objective is relevant definition.
- *Relational thought* links, models, and analyzes referential information to fit the purpose at hand and the focal situation. It constructs, explores, compares, and differentiates the organization of resources to fit the problematic situation, the people involved, the intentional goals and their criteria. Its objective is a conceptual approach to resolving the problem.
- *Formative thought* synthesizes information from all modes of thought into imagery, artifacts, messages, meanings, affects, and plans of action through which intentions and expectations regarding a focal situation are expressed and communicated. It also formulates and interprets these expressions for different media, users, and environments. Its primary objective is an appropriate resolution of the problematic situation.
- *Procedural thought* implements and executes plans of action to change the products of formative thought and/or the focal situations it addresses. It is the domain of execution, production, technology, performance, and skill. Its primary objective is timely effectiveness in its operations.
- *Evaluative thought* measures progress and tests the outcomes of procedural thought against intentional goals, values, and circumstantial imperatives, be they physical, cognitive, social, or cultural. Its primary objective is to determine improvement in the situation being addressed.
- *Reflective thought* remembers, assimilates, recalls, and applies to the current focal situation what is learned through all modes of thought. It accumulates and integrates experiences and feelings, and builds histories, knowledge, beliefs, and identity. Its primary objective is to learn.

ORGANIZING PRINCIPLES

Purposeful thought, design thinking, and creative design thinking apply principles of organization appropriate to the kind of information addressed by each mode. *Priority* is the principle by which intentions are organized.

Nominal order (number, alphabet, class, category) is the principle by which the semantically distinct information of referential thought can be identified, itemized, and listed for use in specifications, processes, and artifacts. *Association* is the organizing principle for relational thought by which referential items can be linked, networked, structured, compared, and analyzed to model the purposes at hand. *Spatial mediation* is the organizing principle for formative thought by which images and messages can be composed, synthesized, expressed, communicated, and experienced. *Time* is the organizing principle by which actions and events can be programmed and sequenced through procedural thought. *Magnitude* is the principle by which values and effects can be ordered through evaluative thought. And *Utility* is the organizing principle by which knowledge can be ranked for assimilation and recall during reflective thought. Each organizing principle is appropriate to the kind of information addressed by the mode of thought it organizes. Forms, processes, evaluations, and the knowledge used are specific to the information addressed in each mode. Since all modes of thought are employed to complete any intentional thought, every principle of organization is applied in every thought, task, or project. All may be creatively applied through design.

Sabine Junginger suggested that people constitute a basic organizing principle. People left in a room together can organize themselves to pursue shared goals as students did in a project for Asko (described below). This ability to organize meets the definition of a basic organizing principle in that it is limited to a single class of entity, and the relationships between members of the class. However, when people self-organize, they must resolve feelings, preferences, circumstances, and background if their collaboration is to be successful. They must prioritize, order, organize, formulate, process, evaluate, and assimilate information relevant to the situation they are addressing as a group. How each member of the group interprets and applies each mode of thought will differ based on their understandings, preferences, knowledge, and background. They must apply all seven basic organizing principles to structure their intentions, information, models, forms, processes, values, and experiences. These may be manifested through feelings, intuitions, expressions, understandings, behaviors, or votes that blend information from many sources and all modes of thought. Compound outcomes result as consensus is reached. These artifacts may need to be deconstructed, analyzed, and explored. Sabine is right to bring consideration of people into the discourse about organization, but the seven basic principles of organization are tools they will probably use.

How modes of thought correspond to domains addressed by purposeful thought in business thinking, design thinking, and creative design thinking is suggested in the following.

Business Thinking

Businesses already use the domains of purposeful thought to structure their work. They recognize the need for executive management (intentional mode), information gathering (referential mode), modeling and analysis (relational mode), communication and marketing (formative mode), production (procedural mode), fulfillment, assessment, and support (evaluative mode), and adaptive use of what is learned through their experiences (reflective mode). These domains are often reflected in corporate structure as departments, or in the expertise of members chosen for a project team. Each domain is characterized by its own intentions and responsibilities, information addressed, organizing principle, forms of expression, processes, valuation methods and criteria, and knowledge base. Each corresponds to a functional concern of any business, project, or strategy.

Design Thinking in Business

An example of how design thinking can enrich business thinking is provided by the story of "Good Grips" kitchen utensils (Corporate Design Foundation, 1996). A retired CEO of a cookware company asked himself what he could do to help his wife cope with arthritic hands. He realized that a better handle for her kitchen implements would enable her to continue her enjoyment of cooking. He also wanted to appeal to the broadest possible market, explaining: "Why shouldn't everyone who cooks have comfortable tools?" He knew a lot about manufacturing, cookware, and marketing but not a lot about designing a handle that would help her. He hired a design firm, Smart Design, with whom he had worked. (Most designers are good at solving problems they have not been exposed to before.) In all of these considerations he was thinking intentionally. The designers conducted research and talked to people who knew how arthritis affects hands. They determined:

> ... the basic handle had to be large enough to avoid hand strain. It had to
> be oval to keep it from turning in the hand. The short round end had to
> fit comfortably in the palm and evenly distribute the pressure in use ...
> It should have a warm, non-slip handle ... made with flexible fins giving
> the user more cushion and control ...

This was referential thinking to define features of the object of intentional interest. They designed an easily manufactured handle that flexed to fit different hands and was comfortable to hold. This involved relational thought to conceptually model and analyze possibilities, formative thought to synthesize, express, and communicate the designs, and procedural thought to think

through how the handle was to be produced. Through testing and evaluative thought it became obvious that the handle worked well for other users too.

Through reflective thought the manufacturer saw a large potential market and (through more intentional thought) launched a new company to make an entire line of kitchen utensils comfortable to use. The results: A company called OXO with more than 100 products and more than 30 percent annual growth in sales between 1991 and 2007. The distinguishing features of the company are products that are easy to use by the widest spectrum of users. Their products won many awards as examples of Universal Design. The forms of the utensils were familiar and easily accommodated by normal patterns of production, marketing, distribution, and use. All domains of purposeful thought were employed even though design focused primarily on one innovative component—the handle.

Creative Design Thinking in Business

Steve Jobs and Apple have shown that it is possible for an entire corporation to operate at the creative level of purposeful thought. Job's background as an abandoned child adopted by loving parents, a father who taught him to care about unseen craftsmanship, an early interest in electronics, and growing up in the entrepreneurial, hacker community of Silicon Valley and the California counterculture of the time, shaped his extraordinary views of products and services that would be "insanely great" (Isaacson, 2011). This background strongly influenced his intentions and efforts. He exhibited creative referential thought by remaining alert to new information, resources, and techniques, and applying a perfectionist's concern for small details, materials, and finishes and the operational features, experience, and aesthetics of Apple products and services. He creatively applied relational thought by organizing Apple as one collaborative enterprise with no departments and only one budget and through participation in the conceptual modeling, and analysis of all Apple products during their development. He demonstrated creativity as a formative thinker and master communicator by shaping presentations (Macworld), marketing ("Think Different") and environments (Apple Stores, Pixar Headquarters), and by demanding collaboration, integration, simplicity, beauty, and a pleasing, seamless user experience across all products, services, and environments. He applied procedural thought to shape both human and material processes to make them collaborative, timely, and efficient, often applying funds in creative ways to assure outstanding execution, performance, and delivery. As an evaluative thinker he demanded quality in everything, people included, and was often a harsh judge who applied his own goal criteria. Through reflective thought he extended his knowledge and vision to transform whole industries

and shape cultures. Aided and informed by Apple staff, Jobs creatively applied all the dimensions of purposeful thought. No one has been able to integrate design and business better than he, or build a company more creative than Apple.

Designing Business Strategy

Increasingly, to be successful in the global marketplace or at home, companies must establish and communicate an identity that has credibility and relevance to the customer, occupies a unique yet sustainable position within the marketplace, and can evoke the affection and loyalty of customers. Although individuals like Steve Jobs can orchestrate and spur creative achievement in a company like Apple, teams of less empowered individuals can also be creative, especially if they have developed the motivations and capabilities of a true designer.

They can, for example, collaborate to generate strategies to help a company improve its approach and focus its efforts. Asko Furniture, a Finnish company, sponsored a project in which six students in the Design Leadership Program at UIAH Helsinki (now part of Alto University) explored what it might do to improve its prospects (Burnette, 1993). Asko faced enormous competition in the export market and, with entrance to the European Union, greater competition within Finland. As with any design problem the team of three men and three women from various disciplines had to understand the circumstances, potentials, products, resources, and issues involved. To launch the project the managing director, business director, and a designer from Asko introduced the company and the problematic circumstances it faced. The team then visited Asko stores and those of its competition to gather information (referential thinking). They began to focus their efforts by identifying and prioritizing aspects of the problematic situation. The aspects they identified and selected to focus on were company communications, customer service, structure of product lines, store interiors, advertising, recycling, export relations, personnel training, and ways to introduce the new strategy into the existing company. Each member of the team assumed responsibility and the empowering agency for one or more aspects of the project that interested or challenged them. To unite the group, they then focused on values they could all believe in and work to implement (intentional thought). The values the team selected were: caring for people, security, ecology, and women as decision-makers (reflective and evaluative thought). They explored how their shared values might affect the areas of their responsibilities (relational thought). This free-flowing discussion then led to specific proposals (formative thought) and ways they might be implemented within the company (procedural thought). These included using "A Letter from Asko" as a more caring form of

communication than existing advertising and one especially appealing to women.

The team proposed that pictures of people be included in a warmer, more natural catalog based on the informal graphic style of the letter. They proposed that the stages of life be the organizing principle for the catalog, product lines, and stores (relational thought). These stages were identified as Active Children, Independent Young Adults, Middle-aged Settlers, and the Less Active Elderly (referential and formative thought). People at each stage of life would find information, furniture, and spaces designed especially for them at Asko stores. The stores themselves would be organized as a community of homes containing the product line for each stage of life personalized for that age group and hosted by a person in that group. Homes would also be personalized for the people of the country the store was in. The community of homes in each store would be linked by paths containing "shops" and "public squares" where people could come for information, entertainment, celebration, or to learn home improvement skills, get assistance or seek repairs. Caring for people, security, and ecology were the values that inspired a policy of lifelong support for Asko furniture through repair, replacement, repurposing, or recycling of their furniture to assure customers that the company cared about quality, the environment, and people (evaluative and reflective thought). Many other features were proposed to reinforce the caring role of Asko in a community and to assure its credibility, relevance, uniqueness, durability, and empathy with people. An executive from another company attending the presentation offered an evaluative judgment: "That is a company we could very much admire."

The student team had no power or responsibility to implement their proposals and the company had made no commitment to consider them further. The creative talent and imagination of the team was exercised outside the company, which perhaps had no ability to implement them. As Paola Antonelli's remark in the introduction to this paper suggested, the openness and imagination that creative design thinking brings to a project team must be understood and developed by all concerned to reach the creative level.

ROLES

A successful technique to introduce people of any background or expertise to a responsible, effective, and enjoyable process of design thinking that often produced creative outcomes using the modes of thought has been developed and broadly applied. It offers a role-oriented approach to problem-solving in which people are organized into a team of agents individually responsible for the different domains of purposeful thought. It has proven to be an excellent

way to learn the modes of thought and how they interact during design thinking (Burnette, 1982). Team members learn to help one another meet their individual responsibilities as they collaborate to reach a shared goal. The history of this method and examples of its application in many venues, including businesses and schools, are available in a paper entitled "A Role Oriented Approach to Problem Solving" (Burnette, 1982). Some examples of how modes of thought can be used to structure information for different purposes are also available at http://www.idesignthinking.com and http://independent.academia.edu/charlesburnette/.

COMPUTATIONAL SYSTEMS

Computational systems are not required to implement or apply the modes of thought addressing each type of information. But, as in other agent-oriented business frameworks, all levels and dimensions of purposeful thought regarding any subject, task, or project could be supported through a system of computational agents collaborating to resolve any kind of problematic situation within the constraints that apply to it.

Business and design could share information across the domains of the corporation through a collaborative computational framework such as outlined in Figure 7.1 (Kobryn, 2000). Whether implemented in a single computer or

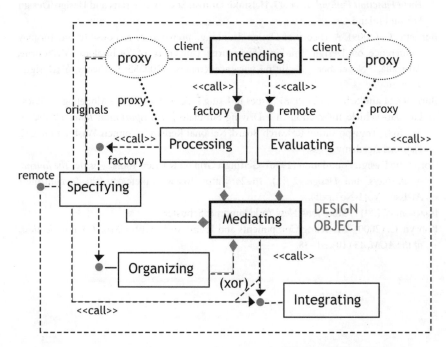

Figure 7.1
A collaborative computational framework
© *Charles Burnette*

Component Enterprise Framework for distributed design computing

distributed across many devices, users could introduce changes in different aspects of a project or respond to them as they occur.

All seven modes of purposeful thought were implemented in a previous, less sophisticated, computer-based system to support the design of advanced driver interfaces incorporating human factors assessment of driving behavior in a driving simulator (Burnette and Schaaf, 1998). Other work to develop applications of the modes of thought has produced useful tools and explored the systems potentials to manage, index, structure, express, execute, evaluate, and reflect on concerns of interest to business during design thinking. The bridge between business and design thinking exists, has been tested, and applied for a variety of purposes. The bridge to real design thinking remains to be crossed by most businesses.

REFERENCES

Burke, A. (2013) "Paola Antonelli Interview: 'Design has been misconstrued as decoration,'" *The Conversation*, December 5 [http://theconversation.com/paola-antonelli-interview-design-has-been-construed-as-decoration-21148; accessed December 10, 2013].

Burnette, C. (1982) "A Role-Oriented Approach to Problem-Solving," in S. A. Olsen (ed.), *Group Planning and Problem-Solving Methods in Engineering Management*, New York: John Wiley [available at http://independent.academia.edu/charlesburnette/].

Burnette, C. H. (1993) "Designing a Company: Report from The Savitaipale Workshop," *Form Function Finland*, 1, 14–17, Helsinki: Finnish Society of Crafts and Design/Design Forum Finland.

Burnette, C. (2009) "A Theory of Design Thinking," prepared in response to the Torquay Conference on Design Thinking, Swinburne University of Technology, Melbourne, Australia, November 1 [http://www.academia.edu/209385/A_Theory_of_Design_Thinking].

Burnette, C. and Schaaf, W. (1998) "Issues in Using Jack Human Figure Modeling to Assess Human–Vehicle Interaction in a Driving Simulator," *Transportation Research Record No. 1631*, Transportation Research Board, National Research Council. Washington, DC: National Academy Press.

Corporate Design Foundation (1996) "Getting a Grip on Kitchen Tools," *@issue: The Journal of Business and Design*, 2 (1), 16–24 [https://www.sappietc.com/sites/default/files/At-Issue-Vol2-No1.pdf].

Isaacson, W. (2011) *Steve Jobs*, New York: Simon & Schuster.

Kobryn, C. (2000) "Modeling Components and Frameworks with UML," *Communications of the ACM*, 43 (10), 31–38.

DESIGN THINKING AS AN INDICATION OF A PARADIGM SHIFT

Oliver Szasz

The term design, and the practice it describes, have been associated with the creation and production of artifacts for decades. Recent technological, social, economic, and environmental developments have brought about a fundamental change, which has had significant effects on problem-solving methods beyond traditional object making. These trends have had an impact on current design practice and the role of the designer. More research-based, methodical, and interdisciplinary approaches to designing would now appear necessary.

Design thinking focuses on a human-centered approach, which combines design activities with research on human needs, and technological and business aspects, in order to create knowledge, solve problems, and to innovate. Design thinking has received a lot of attention in the last decade, not only in the realm of design, but also as a methodology which uses strategies that can be applied by professionals of various disciplines—not exclusively designers. Does this suggest that design thinking moves us further away from design practice, and thus from designers? Could this development constitute a paradigm shift in the role of the designer?

In the eighteenth century, the Western world also faced fundamental change, which had radical effects on the economic, social, and cultural make-up of society. Such a profound transformation can be described as a paradigm shift. The origin of the term paradigm shift is chiefly associated with the philosopher of science Thomas S. Kuhn. The *Oxford Dictionary* describes it as a "fundamental change in approach or underlying assumptions" (http://www.oxforddictionaries.com/definition/english/paradigm-shift?q=paradigm+shift+). In an epistemological context, as Kuhn (1962) describes, paradigms are scientific achievements universally recognized in the scientific community.

Yet, a paradigm shift occurs when anomalies are encountered, such as scientific discoveries and substantial technological innovations, which initiate new thinking and theories. However, a paradigm shift first demands the destruction of the current paradigm. Thus, the "emergence of new theories is generally preceded by a period of pronounced professional insecurity" (Kuhn, 1962, p. 68). A society entangled in a state of profound insecurity could be described as being in a state of crisis.

The term crisis describes a variety of significant events that require change in order to avoid undesired outcomes. There is evidence to suggest that we are currently facing an unprecedented global crisis, whether it be food scarcity, financial meltdown, fuel shortage or climate change—all of which have attracted much attention in the media recently. Moreover, it appears that this crisis is more substantive than familiar transitions between economic phases. We are encountering a period where innovation in technology has begun to fundamentally change our society and where affluent consumption has an ever-increasing impact on our resources and environment. New models of thinking, which discuss new patterns of behavior and social values, are beginning to appear. Furthermore, it seems that the technological advances of the last four decades, including the rise of the Internet, have significantly transformed the way we communicate, initiating an unprecedented increase in complexity. It has even be argued that we are facing a 'complexity crisis' (Siegel, 2012). One could conclude that we are experiencing a transition to a new paradigm. For decades, designers have been seeking to design products to meet what seems never-ending consumer demand. We appear to have evolved from an industrial economy to a service-, knowledge-, and experience-driven economy. This development will in turn affect the design practice and role of the designer.

Similar significant change emerged during the Industrial Revolution, when the Agrarian Age was gradually replaced by an industrial economy. This paradigm shift had fundamental effects on the way we made things in Western culture. Design became separated from art and craft. This development "led to the separation of 'having ideas' from 'making objects'. It has also led to the idea that there exists some sort of mental attribute known as 'creativity' that precedes or can be divorced from knowledge of how to make things" (Dormer, 1997, p. 12).

To understand the fundamental changes that occurred during this paradigm shift, it is useful to further scrutinize craft and design in the pre-industrial era.

FROM CRAFT TO DESIGN

The Industrial Revolution was undoubtedly one of the most influential paradigm shifts in recent history, and changed the world profoundly and irrevocably. The term Industrial Revolution, which was first used by Louis-Auguste Blanqui in

1837, can be misleading when interpreted literally. It implies that change happened relatively rapidly, whereas, in fact, transformation of the world occurred gradually, over centuries—contrary to what the term itself suggests (Mokyr, 2001). The phrase also seems to emphasize the industrial aspect of the revolution. As Crafts (1985) notes, "the Industrial Revolution was not narrowly economic but social, intellectual, and political . . ."

It had its origins in the eighteenth century in Britain. It has been argued that the supply of sufficient food for a rapidly growing population provided the crucial conditions to enable the factory-based production of goods (Buchheim, 1997). Others point out that it was in fact a complex combination of agricultural, manufacturing, transportation, and technological advances that enabled this development. Furthermore, changes in the legal system, cheap energy sources, and in particular low labor costs also helped drive growth, as did Britain's success in the international economy, which created an altogether unique environment for entrepreneurs in which to pioneer and thrive. One could argue that the "Industrial Revolution was a response to opportunity" (Allen, 2006, p. 2)—an opportunity strongly underpinned by the key ideas of the Age of Enlightenment. Groundbreaking scientific discoveries, such as those made by Isaac Newton, provided the foundations for explaining nature through science. This promoted knowledge from experience and reasoning, thus challenging the inherent power of church and state. Men began to realize that they could be the masters of their own world and their own destinies. As a result, the Industrial Revolution became not only an idea but a reality. New means of communication, especially the printed word, helped to spread these novel ideas. According to Outram (2005, p. 15), in Western Europe, "the eighteenth century was a time of economic expansion, increasing urbanization, rising population and improving communications in comparison to the stagnation of the previous century."

In pre-industrial times, it was largely simple, functional objects that were produced—items such as tableware and furniture were made by artisans and craftsmen with specific local design attributes and some freedom of expression. It seems that the design process was inherent in the craft process. Design had not yet appeared as a distinct part of the making process, as we know from industrial production. At that time, the processes of designing and making were inseparable: "Craftsmen do not, and often cannot, draw their works and neither can they give adequate reasons for the decisions they take" (Jones, 1992, p. 19).

Industrial processes radically changed the way in which products were made. Instead of making spontaneous decisions in accord with craft skills and intuition, the making of a product was increasingly mechanized. The form of a product needed to be thought up and planned ahead in order to fit into

the new mass production process. In factory production, introduced at the beginning of the Industrial Revolution, the previously unified craft processes were divided into specialized tasks. They were rationalized, simplified, and incorporated into efficient production practices. As Ure (1835, pp. 20–21) points out: "The principle of the factory system is, to substitute mechanical science for hand-skill and the partition of process into its essential constituents, for the division or gradation of labor among artisans."

There was a growing emphasis on innovation and technology during this period, rather than on traditional craft knowledge. In order to develop efficient mass production processes, a new manufacturing approach was required. Accordingly, there was a transition from a craft approach to a design approach, which separated the conceptual part (design) from the traditional making part (craft). Yet, simultaneously, services provided by specialized craftsmen were still in demand, since some traditional and labor-intensive production procedures could not be implemented in factory processes.

The design of early mass-produced products was made in accordance with the technology available at the time. Moreover, the relatively little competition that existed between manufacturers, and a managerial focus on maximizing profit, often resulted in rather crude and unrefined products, which showed only minimal attention to quality, visual aesthetics, and usability. Manufacturers during this period did not seem to regard design as a way of differentiating between competing products. At the beginning of mass production, manufactured products were marketed like commodities, and valued only in terms of function and price. As the Industrial Revolution proceeded, however, markets slowly became more competitive, and the design of goods became more relevant as a means of trying to stand out from competitors' products. But, the distinct profession of the designer had not yet been formed. As a result, artists were instead engaged to fill this role. Only they had the necessary skills to conceptualize and visualize ideas to be implemented into a mass production process. The first "designers," so-called "modelers," came mostly from artistic fields, such as painting and sculpting. One of the early representatives of the new profession was John Flaxmann, a sculptor who used his artistic skills to produce prototypes for new product lines of the British ceramic manufacturer Wedgwood. Architects and engineers followed artists into the new profession.

As a process that mediated between ideas and their implementation into mass production, designing became the new preferred way of thinking. It soon was considered superior to the pre-modern approach of the craft era, where tacit knowledge, intuitive reasoning, and making skills were the predominant means and methods of creating. Since then, the design profession has developed significantly—it has become a highly segmented and sophisticated activity,

which is now widely acknowledged as a successful means of differentiating products and creating value.

FROM DESIGN TO DESIGN THINKING

The technological developments that the world has witnessed over the past three decades, including the introduction of the personal computer and the Internet, have profoundly transformed our working environments and our means of communication. These developments have provided a fertile environment for an unprecedented increase in complexity. The present growth in complexity could be compared with the increase in complexity experienced during the Industrial Revolution. The new era showed an unparalleled increase in communication and the exchange of ideas, with the help of the printed word. This laid the foundation for the ever-growing complexity that we see in today's information society.

Complexity has been augmented further by the transition from a focus on economic goods to the predominance of services and experiences. Pine and Gilmore (2011) argue that we are currently experiencing a shift to an experience economy from a post-industrial service economy, which had been preceded by an era of survival, agriculture, and industry. They describe the progression of economic value as a process, starting with the commodification of agricultural products, followed by an intense period of making tangible goods, and then a service economy to drive the ongoing need for differentiation. The current, still emerging next stage of the service economy seems to be the experience economy, which "is as distinct from services as services are from goods, but one that has until now gone largely unrecognized" (Pine and Gilmore, 2011, p. 2). The authors continue by providing a reason for the timing of this development:

> Why now? Part of the answer lies with technology, which powers so many experiences, and part with increasing competitive intensity, which drives the ongoing search for differentiation. But the most encompassing answer resides in the nature of economic value and its natural progression—like that of the coffee bean—from commodities to goods to services and then to experiences.
>
> (Pine and Gilmore, 2011, p. 5)

These factors could be considered crucial to effecting change within society: substantial progress in technology and communication, an environment that provides new theory and challenges current paradigms of thought, and a societal situation that could be described as being in crisis. All of these attributes have not only contributed significantly to the paradigm shift in the

Industrial Revolution, but also provide a reason to believe that we are indeed in the midst of a contemporaneous transition to a new era.

Design practice has experienced substantial change over the last three decades, initiated by the introduction of the first personal computer and the World Wide Web. This has not only initiated a period of accelerated development, innovation, and communication, but has also revolutionized design tools, methods, and processes. However, in the last decade there has been evidence of an unprecedented global crisis. The enormous complexity involved seems overwhelming, and finding solutions is no longer possible using traditional problem-solving approaches. Traditionally, design provided methods to tackle complexity: "Good design can help tame the complexity, not by making things less complex—for the complexity is required—but by managing the complexity" (Norman, 2011, p. 4). Yet "traditional" design, even though acknowledged for its problem-solving and creative capabilities, seems to have come up short. New approaches are now required. A new methodology has appeared: design thinking. The theories and methodologies of design thinking strive to provide methods and tools to tackle the often highly complex challenges of today's design problems. They seek to solve their at times vague formulations and complex interdependencies. These so-called "ill-defined"' or "wicked" problems arise where there is "neither an immediate nor an ultimate test to the problem" (Rittel, 1972, p. 393).

The design thinking approach promises to provide solutions for complexity. But what skills do "design thinkers" need, and are "traditional" designers fit for the task? In order to analyze the necessary capabilities to design for complex problems, Terrey (2008) investigated the implications of involving "traditionally" trained designers and non-designers in organizational design. She presented evidence "that non-designers can demonstrate skills and strategies of designers." Moreover, Simon (1996, p. 111) observed that: "Everyone designs who devises courses of action aimed at changing existing situations into preferred ones." Design thinking has been widely discussed, not only in the realm of design, but also as a methodology that utilizes strategies that can be applied by professionals of various disciplines, not exclusively by designers. Most design thinking schools, such as the HPI School of Design Thinking, invite students from all disciplines and professional backgrounds to apply to their classes, which in some cases results in a significant under-representation of designers. Does this development suggest that design thinking increasingly separates itself from design practice, and thus from designers? Could this change indicate a paradigm shift in design and the role of the designer?

Undoubtedly, designers add valuable skills to the design thinking process. However, they might also bring a potential disadvantage to the table, which originates from the designer's ability to generate feedback. In the context of

design thinking, a strong emphasis on the quality of tangible artifacts and the designer's attention to their aesthetic values and style might even have an inhibiting effect when the subject matter of the design is an intangible knowledge or service. However, prototyping and the creation of process artifacts play an essential role in the design thinking methodology. Yet the aim of the prototyping process is to produce simple artifacts in order to quickly investigate the strengths and weaknesses of ideas. Brown (2008, p. 3) explains as follows: "Prototypes should command only as much time, effort, and investment as are needed to generate useful feedback and evolve an idea. The more 'finished' a prototype seems, the less likely its creators will be to pay attention to and profit from feedback."

Designers are not only trained to use artifacts, which provide instant feedback from users, but they also are deeply engaged with the design qualities of objects. The designer's attention to the aesthetic qualities of an artifact is deeply rooted in "traditional" design education, which fosters a combination of skills and knowledge development with a tangible object as part of the process and final outcome. The current transition to a new paradigm in the twenty-first century, and a potential paradigm shift from the "traditional" design practice to a design thinking approach, might challenge the "traditional" design education. While "traditional" design skills remain valid and are still an asset to the design thinking process, through visual methods, prototyping, an ability to work with complexity and skills for collaborative dialogue, the designer's dominant position has nevertheless been challenged by Terrey (2008).

DISCUSSION

Field research and knowledge accumulation across diverse scientific fields is mandatory in the context of design thinking, in order to be able to design solutions for highly complex tasks in an increasingly globally connected network society. Yet "traditional" design, with its roots in visual design theory and a focus on the aesthetic qualities of artifacts, seems to be insufficiently and inappropriately equipped to cope with the fundamental change in expectations regarding the "design thinker's" capabilities.

Does this suggest that "traditional" design has to evolve or even to revolutionize its thinking and paradigms of practice? Design practice, which was born during the Industrial Revolution, became profoundly successful because it initially freed itself from craft standards and processes, in order to create the necessary space to develop into the sophisticated discipline it is today. Yet, craft did not disappear in Western industrial society. It merely became less prominent, and changed its role in society and the economy. It maintained an emphasis on making processes and quality standards, which

cannot be achieved in mass manufacturing. In summary, craft has not only survived the emergence of design practice, but has successfully evolved independently by utilizing and refining highly specialized skills.

Since its beginnings, design practice and design education have progressed and developed their own values and standards to assure quality, successful communications, and aesthetic experiences. However, as history suggests, in the context of today's paradigm shift, which is marked by an unprecedented increase in complexity and pressing issues in the current consumption paradigm, design and design education may well require substantial adjustments to deal with the complex challenges posed by modern society. Almost two decades ago, Buchanan presciently described a shift in design, from its legacy in craft and industrial production, to a design thinking approach, which could be applied to any tangible artifact or even any intangible system. He continued by noting that design transforms from "a segmented profession to a field for technical research and to what now should be recognized as a new liberal art of technological culture" (Buchanan, 1992, p. 5).

Krippendorff (1997, p. 91) appears to concur by announcing a trajectory of design problems, which identifies "a shift in emphasis from technological to human considerations or from hardware to information." Training in the liberal arts is centered around a general education in the humanities, rather than on specialized pre-professional training. Faced with the prospect of a paradigm shift, some professors across the liberal arts disciplines have identified the potential for an increased interest in their field. They see a broad interest in the liberal arts as especially relevant during times of uncertainty, such as the recent economic crisis, which shook the world. These are times when "people are more apt to critically question various aspects of human life" (Lee, 2009). Universities such as Tel Aviv University (http://www.liberal-arts. tau.ac.il) offer a B.A. program in liberal arts in order to motivate their students to critically question an increasingly complex and diverse world, beyond the confines of a single discipline.

Contemporary design is segmented into an increasing variety of sub-disciplines, which are characterized by a growth of specialized knowledge. Yet, in order to be able to successfully collaborate in a complex problem-solving inquiry, designers need to be willing to extend their existing knowledge of design theory and practice by expanding into the realm of liberal arts and technology. According to Brown, there has been a steady decline in designers' interest toward science and technology. Nonetheless, he also believes that "The twenty-first century will be the scene of significant scientific developments, that may fundamentally change our human experience" (Brown, 2011).

From this perspective, the concept of combining liberal arts with a specialization in one discipline seems contradictory. Enabling thinking beyond

a single discipline, and considering a broad variety of methodologies, is often viewed as the crucial benefit of the liberal arts approach. However, "traditional" design cannot simply depart from "traditional" design values. Design has played a significant role in unprecedented economic development, and plays a full role in the product and service value chain. This value creation is based on creativity and innovation, yet it also draws from traditional knowledge, skills, and quality standards.

Design practice, as it emerged during the Industrial Revolution, needed to fully embrace innovation and technology, and had to emancipate itself from traditional craft thinking in order to achieve its full potential. At the same time, craft maintained, specialized, and innovated its traditional processes in order to provide custom made objects for niche markets.

Comparing the events in the Industrial Revolution with the current situation, it seems that "traditional" design, as a discipline, has begun to show its limitations. "Designing" needs "revolutionizing" once more. Changing from a "traditional" design practice to a design thinking practice, which embraces not only research in science and technology, but also research in diverse fields such as philosophy, sociology, and psychology, seems to be unachievable in the context of "traditional" design education, owing to the sheer complexity of the involved fields of knowledge.

CONCLUSION

Does history suggest that design thinking needs to liberate itself as a new design discipline? Is this essential to enable design thinking to develop into an independent design discipline, which emphasizes ethnography and liberal arts, yet also includes specific design skills, which are suitable and valuable in a design thinking process? And would specialized design thinking students, with a focus on the fundamentals in design and design processes, on co-creation in multi-disciplinary teams, on process and prototype visualization, and on using imagination to conceive and present concepts without being too entangled in the aesthetics of their prototype artifacts, be best suited for this task?

The answer to these questions seems to be self-evidently "yes." However, design thinking should not be considered as inherently superior to the "traditional" design practice. By promoting an independent design thinking discipline, "traditional" designers would be able to maintain their focus on conceiving ideas and visual concepts, but would also still retain their familiar emphasis on the aesthetic qualities of their artifacts. Just as craft has continued to develop in the context of an industrial era, "traditional" design might continue to evolve according to economic needs, and provide highly specialized

design services appropriate for an emerging experience economy with its demand for personalized aesthetic experiences.

To summarize, the emergence of the design thinking methodology could be seen as additional evidence for a social and economic paradigm shift, which provides fundamentally new challenges for design practice, due to "wicked" problems with unprecedented complexity. Design thinking, seen as a new discipline, could make itself distinct from design, much like design emancipated itself from craft during the previous paradigm shift in the Industrial Revolution. Design thinking could then focus on specific design thinking skills and on liberal arts disciplines. It could act independently from "traditional" design practice, producing a new breed of "designerly" educated "design thinkers," who would practice next to non-designers in the context of design thinking teams.

BIBLIOGRAPHY

Allen, R. C. (2006) "The British Industrial Revolution in Global Perspective: How Commerce Created the Industrial Revolution and Modern Economic Growth," unpublished paper, Nuffield College, Oxford.

Brown, T. (2008) "Design Thinking," *Harvard Business Review*, June.

Brown, T. (2011) "Design Renews its Relationship with Science," *Design Thinking, Thoughts by Tim Brown*, Category: Science and Design [http://designthinking.ideo.com/?cat=199].

Buchanan, R. (1992) "Wicked Problems in Design Thinking," *Design Issues*, 8 (2), 5–21.

Buchanan, R. (2012) "Interview for the Kolding School of Design International Advisory Board" [http://www.designskolenkolding.dk/index.php?id=3469].

Buchheim, C. (1997) *Einführung in die Wirtschaftsgeschichte*, Munich: C. H. Beck.

Crafts, N. F. R. (1985) *British Economic Growth during the Industrial Revolution*, Oxford: Oxford University Press.

Dormer, P. (1997) *The Culture of Craft*, Manchester: Manchester University Press.

Jones, J. C. (1992) *Design Methods*, 2nd edn., Chichester, UK: John Wiley.

Krippendorff, K. (1997) "A Trajectory of Artificiality and New Principles of Design for the Information Age," in K. Krippendorff (ed.), *Design in the Age of Information: A Report to the National Science Foundation (NSF)*, Raleigh, NC: School of Design, North Carolina State University, 91–96.

Kuhn, S. T. (1962) *The Structure of Scientific Revolutions*, 50th anniversary edition, Chicago, IL: University of Chicago Press.

Lee, P. (2009) "In Today's World, do Liberal Arts Matter?," *Yale Daily News*, March 6 [http://www.yaledailynews.com/news/2009/mar/06/in-todays-world-do-liberal-arts-matter].

Mokyr, J. (2001) "The Rise and Fall of the Factory System: Technology, Firms, and Households since the Industrial Revolution," *Carnegie-Rochester Conference Series on Public Policy*, 55, 1–45.

Norman, D. A. (2011) *Living with Complexity*, Cambridge, MA: MIT Press.

Outram, D. (2005) *The Enlightenment: New Approaches to European History*, 2nd edn., Cambridge: Cambridge University Press.

Pine, J. and Gilmore, J. H. (2011) *The Experience Economy: Work is Theater & Every Business a Stage*, updated edition, Boston, MA: Harvard Business School Press.

Rittel, H. W. J. (1972) "On the Planning Crisis: Systems Analysis of the 'First and Second Generation,'" *Bedriftsokonomen*, 8, 390–396.

Siegel, A. (2012) "The Complexity Crisis," *Design Management Review*, 23 (2), 4–14.

Simon, H. A. (1996) *The Sciences of the Artificial*, 3rd edn., Cambridge, MA: MIT Press.

Terrey, N. (2008) "Design Thinking Situated Practice: Non-designers—Designing," in K. Dorst, S. Stewart, I. Staudinger, B. Paton and A. Dong (eds.), *Proceedings of the 8th Design Thinking Research Symposium (DTRS8)*, Sydney, NSW, 369–380.

Ure, A. (1835) *The Philosophy of Manufactures, or, an Exposition of the Scientific, Moral, and Commercial Economy of the Factory System of Great Britain*, reprinted 2010, Whitefish, MT: Kessinger Publishing LLC.

DESIGN THINKING IN TEACHING INNOVATION

Castulus Kolo and Christoph Merdes

Today, it is widely understood that the ability to continuously innovate is key to the competitive advantage and hence the sustainable success of national economies, entire industries, and individual firms alike. Throughout the last decades and beginning with the first systematic approaches to innovation research (cf. Rogers, 1962 [2003]), "innovation" became a defined term and a phenomenon sufficiently captured as to be measured. Today, the defined and operationalized concept of innovation is applied not only to products but also to services, organizations, and processes. Empirical evidence demonstrates innovation's role in growth and profitability or, more specifically, in how firms achieve "greatness" and "longevity" (Collins 2001). It comes as no surprise that trying to be innovative became like the quest for the Holy Grail in strategy and leadership. Many approaches were proposed to achieve an innovative edge over one's competitors.

Early on, innovation studies focused on the role of existing or newly invented technology that organizations had at their disposal in an attempt to identify novel profitable ways in which to employ the technology (technology push). Subsequently, it became clear that users not only contribute to innovations (cf. Baldwin and von Hippel, 2009) but also change innovations—that is, they evolve as they are put to use (cf. Oudshoorn and Pinch, 2003). Hence, companies' innovation activities could also help in areas where customers' needs are yet to be met—whether the latter are already evident or have yet to be systematically searched for. Development efforts could then be steered toward them in order to find solutions to those needs (demand pull).

The aim of innovation management is to allow the organization to respond to such external or internal opportunities and to use its creative capabilities to introduce new ideas, processes, or products. For this reason, innovation management is more than just a set of tools or specific sequence of activities. Besides a range of factors that are still disputed,[1] success in innovation at the company level relies on two main ingredients: (1) a favorable context for acts of creation, and (2) efficient processes to transform these creations into offerings (i.e., solutions)—for example, to produce or deliver offerings that will find acceptance in the marketplace (by users who have a choice).

Workers at every organizational level contribute creatively to a company's success in development, manufacturing, and marketing (cf. Davila and Epstein, 2006). Some research emphasizes that innovation is much less dependent on the individual creativity of employees than, for example, their interaction within social milieus, which creates a "cultural swirl" by incorporating heterogeneous actors for serendipitous encounters and exchange (Welz, 2003). Others emphasize the role of the individual. To the dismay of many innovation managers, exceptional people like Steve Jobs imply that particularly disruptive innovations (Christensen and Overdorf, 2000) may require some sort of genius. The innovator DNA, however, is rare (Dyer *et al.*, 2011). While the role of outstanding individuals is a matter of debate, it is undisputed that "the creative class" in some way—whether as a single brain, group of people, or simply an inspiring background noise—is a key driving force for innovation and subsequently economic development. Florida (2002) was one of the first to systematically describe this socio-demographic class and the specific role of its "super-creative core", including a wide range of occupations in education or research, but with arts, design, and also media workers forming an important subset.[2]

THE NEED TO BRIDGE THE GAP

The creative class, known for its departure from traditional workplace attire and behavior, is setting its own hours and dress codes. Or as Sutton (2001) states:

> Every company wants innovation, but few have developed methods for managing the process. That's because the normal rules for rational management don't apply [...]. If it's creativity you want, you should encourage people to ignore and defy superiors—and, while you're at it— get them to fight among themselves.

So, what does all this ultimately have to do with design thinking? The "a-ha moment" at the base of innovation as a "way of thinking" can be traced back to

Simon's (1969) book on *The Sciences of the Artificial*, a cornerstone of theory in design thinking. Hence, more theoretically driven design thinking should benefit, anticipating the empirical results of innovation management research and systematic studies on the role of the creative, its management and therefore favorable framework conditions. It could and should tap much more into this existing body of knowledge, which will sound familiar given the process orientation, the role of the user and user insights (including ethnographic studies of the usage context), and the role of meaning. Moreover, the three strands of research into innovation management, creative industries, and design thinking can be linked to benefit all three when the question is about preparing young people for a future where a continuous stream of ideas needs to be funneled into commercial successes. We can think of this in terms of how to "domesticate" a-ha moments.

Merely teaching students to think will not suffice. At the end of the day, it is the ability of a manager or a designer to transform ideas into realities that counts. The prerequisite of a T-shaped qualification—that is, to have depth in one knowledge area and breadth across many others, as IDEO suggests as a key characteristic of the best innovators—is plausible but not easily explicitly or specifically trained. Additionally, although the desire to think outside the box and to challenge conventional wisdom is laudable, it can also lead to rash decisions and a "fetishization of novelty at the expense of continuity" (Bilton and Puttnam, 2006).

Hence, the challenge is to overcome the stereotypes of novelty and continuity and find ways of bridging the contradictions between them (Mintzberg and Waters, 1985). As part of this effort, we also need to challenge the stereotypes of the creative designer and the uninspired manager. Education may yet turn out to be the proof of concept, the real litmus test for all sound theorizing and empirical research on the role of the creative individual, the group, and its proper management and fostering: Well-prepared students leaving their footprint in the course of a successful career.

OVERCOMING THE CONJECTURE OF "OTHERNESS"

The unnecessary emphasis on being different or "other" displayed by some design thinkers in an effort to distinguish themselves from "managers" and vice versa is an obstacle to the introduction of their intellectual postures for the benefit of future designers and managers alike. While the construction of difference is understandable for a newly flourishing academic field, this may also be an impediment, just like the presumed schism of "the two cultures"

alleged by Snow (1959 [2001]). He stated that the intellectual life of the whole of Western society was split into the titular two cultures—namely, the sciences and the humanities—and that this was a major hindrance to solving the world's problems. In fact, this supposed schism might as well have been a self-fulfilling prophecy in some instances; in others—probably the predominant ones—the good examples for bridging the gap made Snow's provocation obsolete. While the notion of "two cultures" is limited, the differences between design and management thinking may still be overemphasized (cf. Dunne and Martin, 2006; Avital and Boland, 2008, p. 9).

Contemporary business thinking shares strong common intellectual ground with design thinking and their differences arise mostly in their practices. Calling for more in-depth research into the underlying structure, common patterns may occur within the different ways of thinking that shed light on a fundamental structure of acting. Burnette's theory of design thinking addresses this issue by relating the construct of design thinking to "scientific findings of how the brain functions" (Burnette, 2009, p. 1; see also Chapter 7, this book). Design thinking in this context may be the mental framework for creating novelty and generating knowledge through the reflection of actions. The observable phenomena—the activity and the outcome of design practice—may be regarded as the effect of design thinking. Burnette distinguishes between seven modes of thinking: (1) Intentional, (2) Referential, (3) Relational, (4) Formative, (5) Procedural, (6) Evaluative, and (7) Reflective. To describe his model, Burnette (2009, pp. 1–2) uses the example of crossing a street:

> A problematic situation arises when the need or desire to cross a street is felt (intentional). To determine how to cross the street you must gather information about the situation such as the layout of the street, the state of the traffic light, the flow of traffic, your relative location, etc. (referential). You organize this information into alternative options for crossing the street and analyze which best serves your immediate goals (relational). If you are in a hurry you may consider running across between moving cars. Whatever option you choose you formulate it as a plan of action (formative) that you then carry out to cross the street (procedural). As you do so you evaluate progress and assess risk while adjusting your action as required (evaluative). Once across you reflect on the experience and incorporate what you learn from it into your knowledge about crossing streets (reflective). Such thought is so familiar that we don't realize that different ways of thinking are.

The definition of design thinking as a "systematic approach to problem solving" (Liedtka and Ogilvie, 2011, p. 4) highlights the nature of the demands in management where "challenges to business grow" and "design is playing a

central role in helping solve problems and drive the future" (Roscam Abbing and Zwamborn, 2012). Problem-solving abilities in this sense are more than a way of thinking. As Liedtka and Ogilvie (2011, p. 5) state: "design thinking can do for organic growth and innovation what Total Quality Management did for quality—take something we always have cared about and put tools and processes into the hand of managers to make it happen." Combined with a perspective on technology, for Brown (2008, p. 2) design thinking "is a discipline that uses the designer's sensibility and methods to match people's needs with what is technologically feasible and what a viable business strategy can convert into customer value and market opportunity."

CYBERNETICS AS A COMMON INTELLECTUAL GROUND

Whether we consider the outcome of a design process—the design or the artifact—or the outcome of management decisions, due to the inherent links to the environment, activities constituting the outcome cannot be separated from it. In the field of design, Krippendorff (1997, p. 95) sees the difficulty in knowledge generation about and through the activities of design—which is crucial to create a common understanding of the subject matter—as residing in the complexity of the connections with and effects on the environment.

Observations within the environment, as well as observing the observer of the environment, point to cybernetics and second-order cybernetics, both of which developed out of an interest in "Circular Causal and Feedback Mechanisms in Biological and Social Systems" and the "'governance' of human systems" (Scott, 2004, p. 1366). "Governance," in this sense, can also refer to the management and controlling of organizations—systems in which humans are involved and carry out activities. Owing to individuals from many different fields, including Ludwig von Bertalanffy, Warren McCulloch, Gregory Bateson, Margaret Mead, William Ross Ashby, Norbert Wiener, Heinz von Foerster, Gordon Pask, and Stafford Beer, the subject of cybernetics broke free from the boundaries of disciplines and established itself as a discipline in its own right.[3] Scott (2004, pp. 1376–1368) speaks of an interdisciplinary, transdisciplinary, and metadisciplinary character—just as design thinking is considered to have by some (cf. Jonas, 2011).

The roots in cybernetics are just as apparent in management, especially when it comes to innovation and complex decisions. Nevertheless, there is a substantial difference in modes of activity—whether performing an action or observing the activity. Glanville (2007, p. 1173) makes a clear distinction between the role of design and cybernetics in systems theory: "Cybernetics is presented as theory

for design, design as cybernetics in practice." In this sense, the theoretical character of cybernetics and its relation to design allows a comparison to be made with the principle of design thinking. In the same way as design thinking may be observed within the activities of a designer, cybernetics may deliver reasoning to the way of thinking. This is the principle of circularity von Foerster proposes for a theory of cognition. Particularly important is what Glanville (2001, p. 148) has to say in relation to circularity and uncertainty:

> I believe circular behavior (interaction) with an unknowable is a good description of what designers do (as opposed to what at least some theorists believe they should do!). This approach allows me to understand design, giving it its due place as a serious activity. Designers go through an iterative and circular process, a sort of conversation with themselves using pencil and paper, ending up with something (a design), which is a token of the circular action. The design can be seen as an embodiment of the process and outcome of a conversation.

For the phenomenon of design thinking, second-order cybernetics provides a framework that allows a designer to explain to others what he or she is doing and thinking while designing. The designer deals with complexity, the unknown, works in an iterative way, and stops at some point to deliver the designed outcome (Glanville, 2007, p. 1196). Dealing with complexity in this sense requires a mindset that is open to uncertainty and repeated trial and error. By using design thinking as an approach to cope with complexity, cybernetics provides the foundation to explain how to overcome disorientation by isolating structures in complexity, synthesizing structures to form new meaning and to communicate with the awareness of one's own limits of perception.

In the context of management, especially systemic management, Malik (2008)—building on models from Stafford Beer and disciplines like system science and bionics—refers to cybernetics as an outcome of inputs and outputs of managerial decisions to the environment. Models such as the "Viable System Model" or the "Sensitivity Model" were developed with an awareness of uncertainty and the cause and effect of actions as a consequence of decisions. These models show the applicability of the theory of cybernetics in practice— what in the sense of Glanville may be called design.

CONTRIBUTION TO INNOVATION AS A JOINT CHALLENGE

From a management and design perspective, Avital and Boland (2008, p. 10) state that: "As part of treating management as designing, it has been argued

that managers should adopt a design attitude, but it is less clear how they can actually apply it in their practice." For Brown, parts of the answer can be found in the process of creating artificiality from a business point of view: innovation. Design thinking in his sense is "a methodology that imbues the full spectrum of innovation activities with a human-centered design ethos" (Brown, 2008, p. 1). Innovation is not carried out in a particular department or within a set time frame. It is a free-flowing movement that encompasses the whole organization. Thinking in design thinking may open the way to be aware of constant innovation, encompassing economic success and matching the needs of human beings (Brown, 2008).

The series of actions that lead to innovation—the innovation process— is also perceived as innovation itself: "Innovation from idea generation to problem-solving to commercialization, is a sequence of organizational and individual behavior patterns connected by formal resource allocation decision points" (Dean and Goldhar, 1980, p. 284). In more detail—and with a focus on commercial success—Roberts (1987, p. 3) adds the formula: "innovation = invention + exploitation."

Hence, the invention process covers all efforts aimed at creating new ideas and getting them to work. The exploitation process includes all states of commercial development, application, and transfer, including the focusing of ideas or inventions on specific objectives, evaluating those objectives, downstream transfer of research and/or development results, and the eventual broad-based utilization, dissemination, and diffusion of the technology-based outcomes.

The process-character of an innovation allows a connection to be drawn to the practice of a designer and, in a broader sense, to design thinking. Based on the formula of "innovation = invention + exploitation," the meaning of invention as "find or come upon," and the implication of "change"—derived from innovation—it is possible to establish a connection to Simon's statement (1969, p. 111) and his definition of design: "Everyone designs who devises courses of action aimed at changing existing situations into preferred ones." Thus, the designer can be seen as an inventor that comes upon actions that change means and purposes that are perceived as innovations. In the first place, this comparison in the context of Simon's principle of "bounded rationality" focuses on the process-character of design and innovation. But as Hobday *et al.* (2011, p. 15) argue, "design as a creative, generating, change-inducing activity has been left on the sidelines." Yet—and this might be the subject for further research—the process of innovation and the design process share attributes that are separated through their formulation in different languages, in different disciplines, and in different areas of knowledge.

In order to locate design thinking and innovation within the framework of a company, Martin (2009, p. 54) introduced the concept of the "predilection gap" to highlight the need for design thinking as a bridge between reliability as analytical thinking and validity as creative thinking. Between reliability and validity, there is obvious tension in terms of risk and predictability of outcomes. The exploitation of current knowledge and the improvement of existing products and services are contrasted with the generation of new knowledge and potential sources of innovations. As Martin observed, many companies focus on algorithms and the production of reliable results for the future (Martin, 2009, pp. 39–40). Relying solely on increasing efficiency of production mechanisms is a dangerous approach, since it may lead to the poor prediction of cataclysmic events that threaten a company from within and without. Observable from an outside perspective are organizational structures, processes, and norms that emerge in this context.

On the other hand, for example, "Unilever and Colgate spend billions each year to explore the mysteries of consumer desires and the products that might satisfy them" (Martin, 2009, p. 40). These activities are hardly predictable and cannot be transferred into exploitable algorithms. Only through the search for insights and ideas and their transformation into reliable ways of producing an outcome will design thinking be considered as a mindset bridging the gap between analytical and intuitive thinking.

MUTUAL BENEFITS FOR DESIGN AND MANAGEMENT THINKING

Creating novelty or being inventive implies a broader view of the environment of a company since innovation is related to market success, translation of human needs into exploitable goods and services, and constant change inside and outside of an organization. The role of a designer as a facilitator for interdisciplinary development of products and services highlights to some extent the stated value of design thinking as a bridging function between analytical and creative thinking—contrast that with the predominant role of a designer as being mainly creative. Within the innovation process, a designer is perceived as being able to find a solution for complex and wicked (Rittel and Webber, 1973) problems. Dealing with complexity according to Krippendorff—building on Heinz von Foerster—is characteristic of human activities:

> It suggests that the worlds as we know them cannot exist without human involvement. They are brought forth when recognizing stabilities in the circularity of acting and sensing the consequences of one's actions in

return. Stabilities of this kind enable us to draw distinctions among them and to rely on them selectively.

<div align="right">(Krippendorff, 2007, p. 1385)</div>

Krippendorff's concept of recognizing stabilities opens a discussion for a new perspective on design thinking. Since design has been recognized as a fundamental way of acting, design thinking points to the raising of consciousness of building upon reflected actions—including theories, models, and processes of improving and inventing (Schön, 1983). Based on Simon's (1969) statement that "everybody designs," combined with the model of circular causality from cybernetics and the concept of reliability within innovation theory, the future of design may be located in a framework for conscious evolution—or counteracting a "determinate situation" in Weick's sense (Weick, 2004: 77). Being able to induce change independent from natural causes like evolution, human beings have the opportunity to direct their future to a certain extent. This implies an awareness of cause and effect of human actions, but also the development of knowledge to deal with uncertainty and to work toward a better future.

While design thinking will not be the philosopher's stone long searched for in innovation management for the successful new, it may open the mind for a new perspective on and a different posture toward innovation. By envisioning the process undergone by individuals in their dealings with innovation, an overemphasis of an abstract, rather mechanical process of innovation management may be overcome. On the other hand, innovations do not simply happen out of the blue. They are the result of human activity that can be given a more or a less beneficial environment—purposively shaped.

It remains far from clear which elements of the two ways of approaching innovation are best combined and how. To do this will mean observing the empirical evidence. To get to this point, new generations of students should be trained in new ways embracing design and management thinking alike. That does not mean simply merging the insights, but rather combining their complementary strengths. Teaching common theoretical foundations will exhibit similarities within the differences, and bridging the gap in meeting the innovation challenge will possibly show ways to domesticate a-ha moments.

NOTES

1. Although a variety of success factors were studied, not a single best "recipe" was derived (cf. Hauschildt, 2004). This comes as no surprise as rigid processes are in any case obstructing the very idea of innovation.
2. A key issue in current research on media management is the question of how to more systematically stimulate the creative element. Küng (2008), for example, has spent much effort determining the criteria that lead to sustained superior performance

in the media and more generally the creative industries. Recent research goes into the question of whether other industries can learn from companies that have succeeded in the environment that is the media business. Torr (2008) goes as far as to emphasize the general lessons in leadership learned from the difficulties in managing such creative people for an economy based on innovation and new ideas respectively.

3. Today, the interest in different fields and the exchange of knowledge between experts may lead to the concept of T-shaped qualifications as mentioned in the context of IDEO's characteristics of innovators.

REFERENCES

Avital, M. and Boland. R. J. (2008) "Managing as Designing with a Positive Lens," in M. Avital, R. J. Boland and D. L. Cooperrider (eds.), *Advances in Appreciative Inquiry*, Vol. 2, Oxford: Elsevier, 3–14.

Baldwin, C. Y. and von Hippel, E. A. (2009) "Modeling a Paradigm Shift: From Producer Innovation to User and Open Collaborative Innovation," Working Paper, Cambridge, MA: MIT Sloan School of Management [http://papers.ssrn.com/sol3/papers.cfm?abstract_id=1502864; accessed October 20, 2010].

Bilton, Ch. and Puttnam, Lord (2006) *Management and Creativity: From Creative Industries to Creative Management*. Oxford: Blackwell.

Brown, T. (2008) "Design Thinking," *Harvard Business Review*, 86 (6), 84–92.

Burnette, C. (2009) "A Theory of Design Thinking," prepared in response to the Torquay Conference on Design Thinking, Swinburne University of Technology, Melbourne, Australia, November 1 [http://www.academia.edu/209385/A_Theory_of_Design_Thinking].

Christensen, C. M. and Overdorf, M. (2000) "Meeting the Challenge of Disruptive Change," *Harvard Business Review*, 78 (2), 66–76.

Collins, J. (2001) *Good to Great: Why Some Companies Make the Leap . . . and Others Don't*. London: Random House.

Davila, T. and Epstein, M. J. (eds.) (2006) *The Creative Enterprise: Managing Innovative Organizations and People*, Westport, CT: Praeger.

Dean, B. V. and Goldhar, J. D. (1980) *Management of Research and Innovation*, New York: North Holland.

Dunne, D. and Martin, R. L. (2006) "Design Thinking and how it will Change Management Education: An Interview and Discussion," *Academy of Management Learning and Education*, 5 (4), 512–523.

Dyer, J. H., Gregersen, H. B. and Christensen, C. M. (2011) *Innovator's DNA: Mastering the Five Skills of Disruptive Innovators*, New York: McGraw-Hill Professional.

Florida, R. (2002) *The Rise of the Creative Class: And how it's Transforming Work, Leisure, Community and Everyday Life*, New York: Basic Books.

Glanville, R. (2001) "An Observing Science," *Foundations of Science*, 6 (1/3), 45–75.

Glanville, R. (2007) "Try Again. Fail Again. Fail Better: The Cybernetics in Design and the Design in Cybernetics," *Kybernetes*, 36 (9/10), 1173–1206.

Hauschildt, J. (2004) *Innovationsmanagement*, 3rd edn. Munich: Vahlen.

Hobday, M., Boddington, A. and Grantham, A. (2011) "An Innovation Perspective on Design: Part 1," *Design Issues*, 27 (4), 5–15.

Jonas, W. (2011) "Schwindelgefühle – Design Thinking as General Problem Solver?," paper presented to the EKLAT Symposium, Berlin, Germany, May 3.

Krippendorff, K. (1997) "A Trajectory of Artificiality and New Principles of Design for the Information Age," in K. Krippendorff (ed.), *Design in the Age of Information: A Report to the National Science Foundation (NSF)*, Raleigh, NC: School of Design, North Carolina State University, 91–96.

Krippendorff, K. (2007) "The Cybernetics of Design and the Design of Cybernetics," *Kybernetes*, 36 (9/10), 1381–1392.

Küng, L. (2008) *Strategic Management in the Media Industry: Theory to Practice*, Thousand Oaks, CA: Sage.

Liedtka, J. and Ogilvie, T. (2011) *Designing for Growth*, New York: Columbia University Press.

Malik, F. (2008) *Strategie des Managements komplexer Systeme: Ein Beitrag zur Management-Kybernetik evolutionärer Systeme*, Bern: Haupt.

Martin, R. L. (2009) *Design of Business: Why Design Thinking is the Next Competitive Advantage*, Harvard Business Press, Boston, MA.

Mintzberg, H. and Waters, J. (1985) "Of strategies, deliberate and emergent," *Strategic Management Journal*, 6, 257–262.

Oudshoorn, N. and Pinch, T. (2003) "Introduction: How Users and Non-Users Matter," in N. Oudshoorn and T. Pinch (eds.), *How Users Matter: The Co-construction of Users and Technologies*, Cambridge, MA: MIT Press, 1–28.

Rittel, H. W. J. and Webber, M. (1973) "Dilemmas in a General Theory of Planning," *Policy Sciences*, 4 (2), 155–169.

Roberts, E. B. (1987) *Generating Technological Innovation*, Oxford: Oxford University Press.

Rogers, E. M (1962 [2003]) *Diffusion of Innovations*, 5th edn., New York: Free Press.

Roscam Abbing, E. and Zwamborn, R. (2012) "Design the New Business," Rotterdam: Zilver Innovation [http://www.designthenewbusiness.com/; accessed 11 July 2012].

Schön, D. (1983) *The Reflective Practitioner: How Professionals Think in Action*, New York: Basic Books.

Scott, B. (2004) "Second-order Cybernetics: An Historical Introduction," *Kybernetes,* 33 (9/10), 1365–1378.

Simon, H. (1969) *The Sciences of the Artificial*, Cambridge, MA: MIT Press.

Snow, C.P. (1959 [2001]) *The Two Cultures*, Cambridge: Cambridge University Press.

Sutton, R. (2001) "The Weird Rules of Creativity," *Harvard Business Review*, 79 (8) [http://hbswk.hbs.edu/archive/2712.html; accessed October 10, 2011].

Torr, G. (2008) *Managing Creative People: Lessons in Leadership for the Ideas Economy*, New York: John Wiley.

Weick, K. (2004) "Design for Thrownness", in R.J. Boland and F. Collopy (eds.), *Managing as Designing*, Stanford, CA: Stanford University Press, 74–78.

Welz, G. (2003) "The Cultural Swirl: Anthropological Perspectives on Innovation," *Global Networks*, 3 (3), 255–270.

EMERGING PRODUCTION MODELS
A design business perspective
*Stefano Maffei and
Massimo Bianchini*

A COMPLEX SYSTEMIC TRANSITION

Although many studies have shown that the productive-creative systems of many advanced economies are in decline,[1] closer observation reveals that a systemic transition is in fact taking place.[2] This transition may be understood by starting from an initial *problem setting* that describes changes in the market, in design processes, and in the design profession on a "micro-macro" scale, which affect Western industry, its products, and its production models.

Change in the Production Model

In advanced capitalist societies, there are a few complex and global objects that pertain to the mass production sector (cars, smartphones, consumer electronics, computers),[3] and simple and global objects linked to consumer trends (footwear, sports equipment, household appliances, apparel, and so on). By contrast, all the other artifacts are produced through specialized and flexible production models, on a small scale, and adopt the concept of "small series" or even limited editions. However, the latter, by now largely commodified, are not marketed in volumes sufficient to be considered substitutive, but rather as supplementary, in terms of existing objects. Moreover, these distribution-consumption dynamics

are increasingly enabling the creation of "long-seller products" for very small niches, as well as bestsellers, a factor which exponentially increases the possibilities for new design-productive entries (von Hippel, 2005; Anderson, 2006; Piller, 2006).

Change in Market Structure

People usually refer to the market as if it were a single large social institution. Today, however, it would be better to talk of different markets with new, complex, and distinctive dimensions—what Anderson (2006) calls "long-tailed markets.[4] Simplifying, it would appear that the changes in products, production, distribution, and consumption will have effects also on companies, which will no longer produce high volumes of mass-produced items, but small batches of nearly-one-off tailored pieces on demand.

Change in the Nature of Products

The relationship between design and industry grows ever more complicated. Everyday life is being populated by interactive and complex objects, which have a tangible and/or intangible nature and structure (software technologies, smartphones, services, communication platforms, etc.). These artifacts obey different structural ontologies, and therefore have different attitudes to the definition of form (aesthetic appearance), structure, identity, and innovation. This new design space cannot be addressed with the old design categories and disciplines alone. Hence hybridization between crafts and design can produce excellent experimental results. Joint exploration in the fields of interaction design, hacking, Do It Yourself approaches (DIY), and the *Makers* phenomenon (connected to the idea of Fab Lab;[5] Gershenfeld, 2007) makes it possible to recast the concepts of shop, workshop, laboratory, atelier, and factory, creating new models of design and also production[6] (Maffei and Bianchini, 2013a).

Change in Design Processes

The above points show that if design products are not simply tangible artifacts or objects, then also the design processes change. In this case, it is models of collaborative software production (Himanen *et al.*, 2001; Benkler, 2006; Tapscott and Williams, 2010)—generative design and open source design (Bauwens, 2007; Van Abel *et al.*, 2012; Reas and McWilliams, 2010)—that are influencing the design scenario, fostering the growth of non-exclusive or collective intellectual production models. This sharing attitude becomes almost obligatory given all the complex projects involved, such as the interfaces

used for interactive artifacts or for the control and command platforms of almost all digital technology (interfaces that combine aesthetics, functions, and interaction-navigation on a technological basis).

Change in the Designer's Work

The development of open innovation and peer production models, complex artifacts, and change in production processes (long networks, outsourcing, economies of scope) has thus given rise to increasing complexity in design. Today, the creative act is often the result of a complex interactive process in which the attribution of intellectual ownership and rights to exploit that process is increasingly difficult. Added to this is a differentiation among professional categories: the ever-greater availability of educated individuals—design is a *mass profession* (Branzi, 2010)—is not balanced by an equally growing demand for professional services. There are increasing numbers of designers who work using tentative design models—in other words, they offer designs to companies that have not requested them, which are hard (and in any case expensive) to protect, and which may end up without finding any production-distribution.

CHANGE IN THE RELATIONSHIP BETWEEN DESIGN AND ENTERPRISE

All the above-mentioned topics and issues mean that the traditional relationship between design and the enterprise is no longer a given (or at least it is rapidly evolving); the relationship between the supply and demand for professional design services is changing. Consequently, the relationship between the commissioner and the executor is also changing. In fact, one witnesses an overlapping of roles. Historically, the manufacturing firm and the designer were separate organizations/functions/competences with a clear distinction between their roles, tasks, and hierarchies: an organization (the manufacturing firm) commissioned the project and another actor (the designer) executed it. Today, owing to the transformation and convergence of the design, production, and distribution processes, what was previously undertaken jointly by a firm, a designer, and a possible distribution firm can now be incorporated into a single actor that possesses or manages all those competences. This is the particular case of the *Designer=Enterprise* (Arquilla, Bianchini and Maffei, 2011), an emerging category of multispecialized subjects (Khanna and Khanna, 2012) that mix different design, manufacturing, and technological skills in order to work in the field of micro-scale production, or micro-production.[7]

THE GROWTH OF A NEW
MICRO-PRODUCTION ECOSYSTEM

Currently, different models of the design–production relationship co-exist in the advanced economies and their small-scale production activities (Maffei and Bianchini, 2013a, p. 5). Besides the traditional design–microenterprise relationship, new and renewed approaches are emerging in micro-production. There is a heterogeneous system made up of small players linked to the world of self-production.[8] They operate autonomously and spontaneously— whether on an individual or collective level—to activate new on-demand and on-site production and distribution projects. In these cases, the designer tends to coincide with the manufacturing company itself and becomes the enabler (owner) and manager of the entire process, reconfiguring the design–production–distribution chain and establishing a direct relationship with a "community-market" of users-clients-designers-businesses.[9] There is an ecosystem of actors combining design and autonomous production skills with diverse goals, and distinguishable into three main categories according to their amateur/professional nature and their entrepreneurial vocation (see Table 10.1).

All these actors have in common the desire and the ability to "make" and manage in person the materialization of their ideas, sharing part of this

TABLE 10.1

THE MICRO-PRODUCTION SYSTEM*

1. *Micro-production of parts and components*

Remaker	Someone who uses design and technical-productive skills (his/her own or those of other people) to develop creative solutions aimed at recovering or boosting the functionalities of existing products (for instance, by working contrary to the logic of planned obsolescence#).
Customizer	Someone who uses design and technical-productive skills (his/her own or those of others) to intervene on existing products by re-designing and producing individual parts or components of them, the overall objective being to modify their appearance and performance while ensuring their functions and modes of use are unchanged.

2. *Micro-production of products and services*	
Hacker	Someone who uses design and technical-productive skills (his/her own or those of others) to intervene on existing products by re-designing and producing individual parts or components with the aim of modifying or innovating their appearance, functions, and modes of use.
Maker	An amateur/professional self-producer who uses design and technical-productive skills (his/her own or those of others) to develop product-service solutions, including technologies or devices necessary for production if they are not available on the market.
3. *Enterprises engaged in micro-production*	
Designer = Enterprise	A "temporary" self-producing entrepreneur who uses design and technical-productive skills (his/her own or those of others) to develop product-service solutions to distribute on the market, including technologies or devices necessary for production if they are not available on the market.
Micro-factory	Evolution of the Designer = Enterprise into a "permanent" self-producing entrepreneur who uses design and technical-productive skills (his/her own or those of others) to develop product-service solutions to distribute on the market, producing microstructures dedicated to design, manufacture/fabrication, and distribution (micro-plants, laboratories, maker facilities).

* The definitions of this table consider the point of view of design, and in some cases they re-elaborate previous definitions created by experts in other disciplines. The remakers and customizers take some values and skills from the world of repairing (fixers) and re-manufacturing (refurbishing) and that of extreme customization (tuning and pimping). Hackers and makers take values and skills from their respective worlds, which are described by sociologists of networks, experts on personal digital fabrication (Himanen *et al.*, 2001, Lipson and Kurman, 2013), and DIY culture, as in the case of Expert Amateurs (Kuznetsov and Paulos, 2010). The Designer = Enteprise and micro-factory have traits in common with the Designer-Craftsmen evoked by those involved in contemporary crafts (Schwarz and Yair, 2010).

See Slade (2006).

work within their social and productive groups and networks. Increasingly, economists, technologists, and scientists are studying these micro-manufacturers from the innovation processes perspective, in particular those that can be interpreted as informal, improvised and independent (see indie micro-capitalism in Nussbaum, 2012). Many micro-producers develop their own businesses, starting from the production of unexpected and spontaneous ideas in order to solve concrete personal or social problems ("street corner entrepreneurs"; Radjou *et al.*, 2012) often within large urban areas ("small urban manufacturers"; Mistry and Byron, 2011). These players thus contribute to redefining the concept of micro-production as an open and distributed system (Maffei and Bianchini, 2013a):

> ... a "community" of practices and production processes geared to the materialization of material artefacts (or parts of them) in unique items or limited series, conceived with a purpose or a "design intent", constructed and assembled by hand or fabricated using analogic and digital tools and machinery, in individual or community form, by a plurality of actors (amateurs, professionals and enterprises) in temporary or permanent premises of small size (not necessarily dedicated production sites) and therefore distributed in non-typologized ways and contexts.

This emerging ecosystem of actors and activities is supported by an interconnected set of digital and mechatronic technologies, which become smaller, multifunctional, and accessible-connective upon individual or collective use. This mix of new tools/new processes underpins the realization of tools for design, production, and distribution, and the creation of new marketplaces based on one or more platforms. Open-source technology, in fact, enables the designer (if capable) directly to design or personalize the tools necessary for his/her activity, or to use (share) the tools of other (similar or equivalent) actors, personalizing them for his/her own purposes. For example, these new actors are able to set up small-scale production places such as micro-manufacturing labs, makerspaces (Walter-Hermann and Büching, 2013), and micro-factories equipped with analogic/digital tools and machines to combine digital, interactive fabrication (Willis *et al.*, 2011) and bio-fabrication with handmade. Moreover, all these actors are today able to develop their own products by relying on a growing array of on-line and off-line tools (free, low cost, or pay-for-use) that support them in the following phases:

1. *Ideation and design*, through the services and resources furnished by applications for design and open design such as Open Structure and WikiHouse,[10] design communities like BubbleUs, and online repositories of sketches/models or design guidelines such as Thingiverse.

2. *Education and training*, through training and information services. The technical knowledge necessary for design and self-production is transferred by tools and tutorials that can be downloaded from platforms like Instructables and courses offered by "tinker and maker schools" (the MakersAcademy by MakerBot).[11]

3. *Financing and incubation*, through services supplied by crowdfunding platforms such as Kickstarter or IndieGoGo,[12] multidisciplinary research labs (e.g., academic design factories),[13] and the numerous venture capitalists, enterprise accelerators, and incubators.

4. *Production and distribution*, through the supply of products and services by the designers and producers of devices and technologies for digital fabrication [from the open-source digital fabricators linked to the RepRap Project[14] (Fig. 10.1) to commercial low-cost devices like Makerbot and Ultimaker, DIY centers, workshops, and makerspaces like TechShop and Fab Labs, local micro-manufacturing hubs such as Artisans Asylum, networks for distributed manufacturing such as 100kgarages?, 3D Hubs, and Maker Map,[15] aggregators and virtual services centers for production like Ponoko, to online distributive platforms or showrooms (e.g., Etsy), temporary shops and galleries, indie design festivals, and MakerFaire].

Figure 10.1
Computer-augmented craft machine. The map visualizes the evolution of RepRap ecosystem and its 3D printers over time (last accessed: August 8, 2014 on Wikipedia). Programming: Martin Schneider. Electronics: David Menting.
© *Christian Fiebig*

DESIGNER=ENTERPRISE: AN EMERGING PRODUCTION (SYSTEM) MODEL

The success of many products has been historically based on a virtuous relationship among design, business and territory (industrial districts), and personal relationships between designers and businesses. It is now being flanked by alternative arrangements and configurations that show that the changes that have taken place in the industrial system will be reflected by parallel changes in the design sector and market. Alongside this classic model in decline (where the relationship between design and business is codified), a phenomenon like D=E is emerging, where the traditional logics of design, production and distribution, and the traditional relationship between design and business become more complex. The latter phenomenon is the most interesting aspect of the analysis because it is closest to a possible new model of Italian design where the designer no longer offers his/her services to the company, but *becomes a company* in his/her own right, defining new types of relations with other firms and markets. This is a phenomenon manifest in a number of significant experiences but which is not yet consolidated. Adopting the definition D=E is not to assert that *designer and enterprise are one and the same thing*, but rather that, because there no longer exists a single entrepreneurial/manufacturing model of reference, the convergence D=E becomes an opportunity for designers and firms. It represents a new model of doing the design business and a new way to operate in the market.

THE NATURE OF THE DESIGNER=ENTERPRISE

But how can a D=E be defined? She/he is primarily a promoter of innovation, a maker possessing design, production, and distribution skills who activates a temporary process for the development of products and services, creating his/her own solution in the awareness that a niche for it exists (or can be created) on the market. A D=E concretely develops the project, but she/he also creates a product without being a design professional because she/he anyway acts as a designer by transforming a given situation into a desired one (Simon, 1969). D=Es are actors in a complex market characterized by ideative processes that use readily accessible services for production, and by forms of largely personalized distribution connected to configurable personal and community-markets.

In this transition phase, players like D=Es can also utilize the resources, the manufacturing capacity, and the technological expertise of existing companies,

connecting and combining them on the basis of their own design requirements. They thus distinguish themselves from the historical experience of Italian design because the designer also becomes an entrepreneur (that is, someone who also possesses the means of production) to complete his/her own project–product cycle.

The Production of Designer=Enterprises

D=Es are independent agents who work with various design, production, and distribution networks without being constrained by the fact that, even in the presence of a market success, they must automatically make scale changes or stabilize their activities or products (thus becoming outright enterprises). A D=E decides case by case:

- whether always to produce the same type of product;
- whether always to produce on the same scale;
- whether always to produce with the same network or types of actors;
- whether always to produce in the same place;
- whether only to produce or also to distribute.

For this reason, D=Es represent a heterogeneous set of design and production experiences realized by designers, architects, engineers, crafts persons, technologists, artists, entrepreneurs, and new makers whose genesis and growth (individual and collective) follow individual and idiosyncratic patterns. D=Es today operate mainly in production sectors with low-to-average technological complexity: textiles, clothing, furnishings, accessories for the home and the person, but also machine tools, bicycles, motorcycles, robots, even micro-architecture modules. The development of their activities is not automatic but proceeds through "trial and error" by mixing evolutionary processes that are sectorial (continuity of activity in the same sector), commercial (continuity of activity for the same categories of consumers), or technological (continuity of activity with the same technologies). This is the case of creative and recycling factories like Don't Run Beta (Fig. 10.2) and Polyfloss or Officine Arduino,[16] which work with additive manufacturing technologies and open hardware. A D=E may be an amateur whose passion induces him/her to create his/her own firm. Cases include D-Shape and WASP, who are developing a building system based on large-scale 3D printers. Other D=Es develop low-cost, self-constructed customized, or rebooted technologies. The set of these patterns, where design and production practices tend to coincide with the persons themselves, and with a production system that becomes personal, shows that transformation is taking place in the consolidated models of local systems. This has consequences for innovation processes, which also tend to be reconfigured.

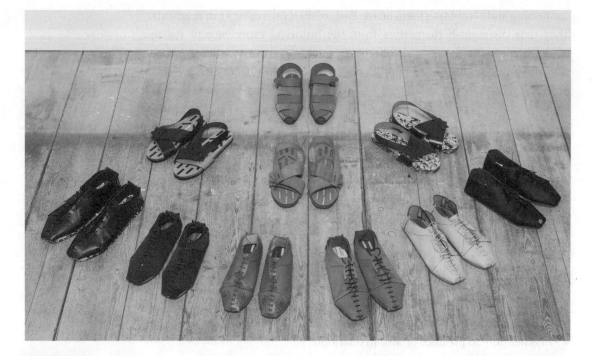

Figure 10.2
Don't Run (Beta) is a shoes micro-factory that explores the possibilities of small-scale manufacturing using digital fabrication technologies.
© *Eugenia Morpurgo and Juan Montero*

THE ORGANIZATIONAL AND BUSINESS MODELS OF THE DESIGNER=ENTERPRISE

The Integrated Personal Management of Designer=Enterprises

From the point of view of organizational models, in the case of the D=E the entrepreneur, designer, and manager come together in a single person whose leadership takes a personal form (Andersson *et al.*, 2010). None of the existing design management approaches and tools—highly structured and bureaucratic—can be applied *tout court* to the organizational processes of D=Es, which have a specific organizational identity. Unlike product designers and design managers who work for/within traditional companies (exercising the design leadership), D=Es do not have to relate to other professionals working in the company (e.g., marketing, technical office) to develop their design and innovation strategies (Turner and Topalian, 2002).

A permanent "tension" between the individual (the designer) and the organization (the enterprise) can instead be observed in many D=Es. These two dimensions need to be constantly balanced in order to organize and

manage the production and distribution activities. The "plasticity" of these micro and individual organizations is comparable with the logic of "lean start-up" (Ries, 2011). Hence, the D=E can be considered a "rapid prototyper of (design) business processes." D=Es are characterized by their "maker instinct"—that is, the ability to build and grow things, and to connect with others in the relative decision-making process (Johansen, 2007). This also means building a network of practice by developing a connective ability centered on "the strength of weak ties" (Granovetter, 1973), which is refined through the continuous search for new relationships and opportunities. In essence, a growing number of designers are becoming innovation curators or editors and configurators of micro-production networks (Shirky, 2010). In a historical phase of economic transformation, this attitude becomes a competitive weapon that enables designers to become the pivots of new peer-to-peer manufacturing communities co-managed with artisans and small enterprises.

The Design (of the) Business by Designer=Enterprises

In a design market largely consisting of well-known professional designers, there is an emergent population of anonymous D=Es operating in the area where value moves from tangible products to ideas. In this space, the D=E, rather than being the executor or interpreter of a third party's innovative project, may represent his/her own. The D=E leads the process of innovation because she/he is able to implement it in concrete and tangible terms. The D=E changes from a model in which the designer could live (even his/her whole life) on a few successful ideas (the "royalties" model) to one in which the designer takes a chance on an idea, investing his/her personal brand and money, to turn it into a product or business that she/he launches on the market, trying to reduce the risk as much as possible, also by involving other players or the users themselves. By analyzing a representative sample of 100 D=Es,[17] we can see how many of them follow a hands-on entrepreneurial development (first create the product, then create the enterprise) that deviates from the traditional business incubation process (first set up the enterprise that will later create the products). The overall purpose of many D=Es is not just to sell products. In some cases, digital files of the products are released for free (and *freemium*) and open source to increase the social and professional reputation of the designer ("likes" and "downloads" are becoming new kinds of currency). In other cases, the micro-production is used as a tool (design probe or demonstrator) to find on *crowdfunding* platforms the resources necessary to start up an entrepreneurial activity. Even the designers who continue to

work for the traditional market look to micro-production as a solution for supplementing, occasionally or permanently, their income or as an investment to develop the business.

The D=E starts by trialing one or more products in small numbers or unique pieces, sometimes developing a process, a technique, a tool, or an original technology. If the trial is successful, the manufacturing process is refined by organizing the resources necessary to meet the new market demand. At the same time, new versions or product lines can be designed. If the positive feedback from the market grows, the designer can turn into a D=E: the production activities may gradually replace or complement the pure design ones. Of course, this is not a regular and irreversible path; rather, it is a process that makes the designer a subject in constant evolution. Design and production thus become a *continuous* and *contiguous* activity modifying the traditional field of action of designers who once worked for industry and services primarily as suppliers and consultants. Also in their approach to the market, D=Es conceive the competition and competitive advantage in a different way. They do not use the traditional marketing strategies and tools (initially, at least), and they work to create their own "community-market" with which to establish a personal relationship both physical and virtual (through the strategic use of social media). On observing these dynamics as a whole, one witnesses the consolidation of a new model called "Design-to-consumer" (D2C),[18] where the D=E combines the potential offered by the production technologies with a renewed relationship with the world of craft; he/she connects e-commerce services with logistics to organize personally the delivery of products through the web. Starting from a general business model, one observes a diversification of the ways in which D=Es relate to the market:

- *Design to Order.* The D=E develops projects and promotes them on its web platform. The project is put into production only if it reaches a minimum quantity of orders (pre-order), ensuring economic sustainability in the production phase (which is undertaken by the D=E or by one or more contractors).
- *Zero Design Miles.* The product can only be purchased online, and production is carried out as close as possible to the customer. The D=E develops its projects, promotes them on its web platform, and coordinates a distributed network of local artisans and makers.
- *Design to download.* The D=E develops its projects and promotes them on its web platform, while the production phase may be entirely delegated to the customer. The customer accesses the online project, can customize and download it (for free or on payment) in order to (self) produce where it

wants without intermediaries or shipping charges. This business model also has connections with the logics of open design and open hardware.

- *Design your own.* The design phase is delegated to the customer through a software application often developed by the D=E itself. Through CAD software or an interactive fabrication process, design becomes "process-able," so that the customer can design its product by changing some mathematical parameters (e.g., generative design). When the customer has obtained the model desired, the product is manufactured and home delivered

- *Design to measure.* The design and production phases are carried out in the time and manner desired by the customer (*design-on-demand*), sometimes through a direct relationship based on co-design and co-production.

- *One-of-a-kind design.* The design and production phases are expressly and exclusively designed to produce and sell unique artifacts or limited editions.

FROM "PRODUCT SERVICE SYSTEM DESIGN" TO "PRODUCTION SERVICE SYSTEM DESIGN": A NEW FIELD OF PRACTICE FOR DESIGNER=ENTERPRISES

We conclude therefore that Designer=Enterprises will inhabit a world where the categories that have characterized how designers traditionally work will no longer exist, or will change radically. And the ways in which design activity deals with the manufacturing dimension and its most important structural components (crafts and industry) have changed as well. This radically transforms the creativity dimension. The advent of different forms of creativity that do not originate in industrial R&D and traditional markets (and which are thus linked, for instance, to technology-driven models or economies of scale), and which consequently use distinctive business models, will generate new forms of design-operational sharing that undermine the idea of the uniqueness of traditional, demiurgic intellectual property. The open and distributed micro-production developed by D=Es is creating new products for new community-markets, while also laying the foundations for the creation of a future "market of ideas." Moreover, D=Es are creating a corpus of techniques, technology, tools, and machines that (1) create an *augmented craftsmanship* so that it is possible to simulate, reproduce, and enhance craft techniques, and (2) recreate a *simplified industry* by reproducing entire industrial processes and plants in extremely miniaturized and manualized form. This is a radical and inclusive change that questions the way in which we produce goods and

services by trying to combine the "just in time" (fast) logic of globalized industry with the renewed "take your time" (slow) logic of crafts.

A social process of the re-appropriation of direct and personal control over the means of design and production has clearly begun. This change will facilitate the search for new forms of direct participation in and personal control over production, and it shifts the focus of innovation from design of the product service system to "design of the entire production-distribution system," so that production places, processes, techniques, and technologies must be designed for an increasing number of subjects. In short, micro-producers are crafting, equipping, fabbing, and making *social innovation*.

NOTES

1. In the period 2003–2011, the share of manufacturing output in the world held by Europe, the USA, and China was reversed (data source: UN). That of Europe (27 members) decreased from 31% to 21% and that of the USA from 27% to 17%, while China doubled its share (from 10% to 20%).

2. A recent interesting debate on insourcing has appeared in *The Atlantic* magazine with articles by C. Friedman, *The Insourcing Boom* (December, 2012) and A. Tonelson, *The Insourcing Boom that Is Not* (April, 2013). Another interesting indicator is represented by the growth of additive manufacturing. In 2013, $2.2 billion was spent on 3D printing products and services worldwide (in 2003, the sector represented only 3.9% of revenues). Wohlers Associates estimates that in four years' time the sale of 3D printing products and services will approach $6 billion worldwide.

3. These artifacts are produced through lean production models organized according to mass-customization platforms as well as made-to-order demand models.

4. Anderson, C. (2006) *The Long Tail: Why the Future of Business is Selling Less of More*, New York: Hyperion.

5. At present, there are 150 Fab Labs in the world (http://www.fabfoundation.org/). FabLabs have proliferated across the globe, so much so that their number roughly doubles every 18 months. The culture of fabbing and making is often based on open peer-to-peer design processes and on-site production.

6. Arduino (http://arduino.cc/) is an Italian company that produces an open-source physical computing platform based on a simple microcontroller board, and a development environment for writing software for the board. Arduino can be used to develop interactive objects, taking inputs from a variety of switches or sensors, and controlling a variety of lights, motors, and other physical outputs.

7. This term is related to the manufacturing of unique pieces and limited collections by individuals using single machine tools in small labs and micro-plants. It includes the concepts of fabbing, making, desktop fabrication, and self-production (self-made design and DIY activities).

8. The authors have defined self-production and self-made design as "a set of organised activities for the purpose of achieving new products/services through a process made up of strategic orientation/choice, design, construction, communication and distribution all implemented by the designer. These aspects may be carried out freely and in different ways. However, they must co-exist systematically in order to truly

classify as self-produced design. And this entire list of activities does not necessarily have to be performed in person by an individual or a group. Nevertheless, when these parties do not make the object directly, they must at least have organised/commissioned it." In Maffei, S. and Bianchini, M. (2013b) "Self-made Design: From Industrial to Industrious Design," *Ottagono*, 257 (February).

9. The authors coined the term "community-market" to explain two concepts. The first relates to the composition of the market, which consists of a highly diverse community of individuals and groups; not simple customers but also family members, friends, fans, followers, and funders. The second concept relates to the ability of many micro-producers to build their own market by developing personal and direct relationships with the customers.

10. Open Structure (www.openstructures.net/) is a project that explores the possibility of a modular construction model where everyone designs for everyone on the basis of one shared geometrical grid. WikiHouse (www.wikihouse.cc) is an open-source construction system. It makes it possible for anyone to design, download, adapt, share, and "print" high-performance, low-cost houses that they can assemble by hand.

11. Makers Academy is a project announced by MakerBot Industries (since 2013 it has been part of Stratasys). The aim of this project is to put a desktop 3D printer in every school in the USA.

12. The Crowdfunding Industry Report by Massolution evidences that Crowdfunding platforms raised $2.7 billion and successfully funded more than 1 million campaigns in 2012. Massolution forecast an 81% increase in global crowdfunding volumes in 2013, to $5.1 billion.

13. D-School – Institute for Design at Stanford, Aalto University (Finland), DuOC (Chile), and Swinburne University (Australia) have multidisciplinary research laboratories linked to maker facilities that work to incubate start-ups based on innovative products and services.

14. The RepRap is a research project developed by Andrew Bayer (University of Bath) in 2006 that has created an open-source low-cost 3D printer inspiring the growth of many 3D small manufacturers like MakerBot Industries (www.makerbot.com/), the first industrial producer of low-cost 3D printers.

15. www.100kgarages.com; http://themakermap.com/; www.3dhubs.com/.

16. High Street Factory Gent, http://www.dontrun-beta.com; http://www.fablabtorino.org/; www.thepolyflossfactory.com/.

17. This analysis is part of an ongoing PhD research project titled "Design for Microproduction: New Design Processes between Advanced Fabrication and Open Distributed Production" (PhD Candidate: Massimo Bianchini; Relator: Stefano Maffei).

18. This term was coined by the designer-researcher Johathan Olivares. An article by Olivares entirely devoted to D2C was published by the *Domus* online magazine in 2012 [https://www.domusweb.it/en/design/2012/12/17/d2c-generation.html; last accessed January 13, 2014].

REFERENCES

Anderson, C. (2006) *The Long Tail: Why the Future of Business is Selling Less of More*, New York: Hyperion.

Andersson, T., Formica, P. and Curley, M.G. (2010) *Knowledge-Driven Entrepreneurship: The Key to Social and Economic Transformation*, New York: Springer.

Arquilla, V., Bianchini, M. and Maffei, S. (2011) "Designer = Enterprise: A New Policy for the Next Generation of Italian Designers," in *Proceedings of the Tsinghua–DMI International Design Management Symposium*, Hong Kong, 3–5 December.

Bauwens, M. (2007) "Peer to Peer and Human Evolution," Foundation for P2P Alternatives [p2pfoundation.net; last accessed February 10, 2014].

Benkler, Y. (2006) *The Wealth of Networks: How Social Production Transforms Markets and Freedom*, New Haven, CT: Yale University Press.

Branzi, A. (2010) *Ritratti e autoritratti di design*, Venezia: Marsilio Editore

Gershenfeld, N. (2007) *Fab: The Coming Revolution on Your Desktop—from Personal Computers to Personal Fabrication*, New York: Basic Books.

Granovetter, M. (1973) "The Strength of Weak Ties," *American Journal of Sociology*, 78 (6), 1360–1380.

Himanen, P., Torvalds, L. and Castells, M. (2001) *The Hacker Ethic and the Spirit of the Information Age*, London: Viking.

Johansen, B. (2007) *Leaders Make the Future: Ten New Leadership Skills for an Uncertain World*, 2nd edn., San Francisco, CA: Berrett-Koehler.

Khanna, A. and Khanna, P. (2012) *Hybrid Reality: Thriving in the Emerging Human-Technology Civilizations*, New York: TED Books.

Kuznetsov, S. and Paulos, E. (2010) "The Rise of the Expert Amateur: DIY Projects, Communities, and Cultures," in *Proceedings of the 6th Nordic Conference on Human–Computer Interaction: Extending Boundaries*, 295–304.

Lipson, H. and Kurman, M. (2013) *Fabricated: The New World of 3D Printing*, New York: John Wiley.

Maffei, S. and Bianchini, M. (2013a) "Microproduction Everywhere: Defining the Boundaries of the Emerging New Distributed Microproduction Socio-technical Paradigm," *NESTA Social Frontiers Conference*, London, 4–6.

Maffei, S. and Bianchini, M. (2013b) "Self-made Design: From Industrial to Industrious Design," *Ottagono*, 257 (February).

Mistry, N. and Byron, J. (2011) *The Federal Role in Supporting Urban Manufacturing*, New York: Pratt Center for Community Development.

Nussbaum, B. (2012) "4 Reasons why the Future of Capitalism is Homegrown, Small-scale, and Independent," *FastCompany* [http://www.fastcodesign.com/1665567/4-reasons-why-the-future-of-capitalism-is-homegrown-small-scale-and-independent; last accessed February 10, 2014].

Olivares, J. (2012) "D2C Generation," *Domus*, 964 (December) [www.domusweb.it/en/design/2012/12/17/d2c-generation.html; last accessed January 18, 2014].

Piller, F. (2006) *Mass Customization*, Frankfurt: Gabler Verlag.

Radjou, N., Prabhu, J., Ahuja, S. and Roberts, K. (2012) *Jugaad Innovation: Think Frugal, Be Flexible, Generate Breakthrough Growth*, New York: John Wiley.

Reas, C. and McWilliams, C. (2010) *Form + Code in Design, Art, and Architecture*, Princeton, NJ: Princeton Architectural Press.

Ries, E. (2011) *The Lean Startup: How Today's Entrepreneurs Use Continuous Innovation to Create Radically Successful Businesses*, New York: Crown Business.

Schwarz, M. and Yair, K. (2010) *Making Value: Craft and the Economic and Social Contribution of Makers*, London: Crafts Council.

Shirky, C. (2010) *Cognitive Surplus: How Technology Makes Consumers into Collaborators*, London: Penguin Books.

Simon, H. (1969) *The Sciences of the Artificial*, Cambridge, MA: MIT Press.

Slade, G. (2006) *Made to Break: Technology and Obsolescence in America*, Cambridge, MA: Harvard University Press.

Tapscott, D. and Williams, A. D. (2010) *MacroWikinomics: Rebooting Business and the World*, London: Penguin Books.

Turner, R. and Topalian, A. (2002) "Core Responsibilities of Design Leaders in Commercially Demanding Environments," Inaugural presentation at the Design Leadership Forum, London, organized by Alto Design Management.

Van Abel, B., Evers, L., Klaassen, R. and Troxler, P. (2012) *Open Design Now: Why Design Cannot Remain Exclusive*, Amsterdam: BIS Publishers.

von Hippel, E. (2005) *Democratizing Innovation*, Cambridge, MA: MIT Press.

Walter-Hermann, J. and Büching, C. (eds.) (2013) *FabLab: Of Machines, Makers and Inventors*, Bielefeld, Germany: Transcript.

Willis, K. D. D., Xu, C., Wu, K. J., Levin, G. and Gross, M. D. (2011) "Interactive Fabrication: New Interfaces for Digital Fabrication," in *Proceedings of the Fifth International Conference on Tangible, Embedded, and Embodied Interaction*, Funchal, Portugal, 23–26 January, pp. 69–72.

CHAPTER 11

HANDMADE BY LOVE
Crochet work and social business design (or: it is not easy to be good)

Nadja Ruby, Elisa Steltner, and Wolfgang Jonas

"Social design" in its multiple forms is still very vague and unexplored. First, the chapter argues that the methodological, theoretical, and epistemological aspects of the concept of "the social" as used in social design, social business design, social transformation design, etc., ought to be examined more deeply (Jonas, 2011). A case study of a social business design project is then presented, which seems to support and approve the critical hypotheses. Finally, the chapter opens up the perspective and briefly elaborates on the concept of social transformation design in general, its rich origins, its deficits and blind spots, and its perspectives.

THE SOCIAL: SOME PRELIMINARY REFLECTIONS

"Social," as the designation of our stance towards design can be considered as *normative*, aimed at social balance, fairness, support, abstaining from inappropriate private profit, etc.; or, as *descriptive*, meaning communication and interaction patterns of different types. Depending on the preferred theory background, the latter notion of "social" may be characterized as the establishment of autopoietic communicative systems, or as the emergence of hybrid networks of human and non-human actors.

The evolution of modern society arose with the formation of specialized functional sub-systems, which led to a marked increase in internal complexity and efficiency, but also to rigid structures and autopoietic closure. Each of the systems works according to its own incompatible eigen-logic, making a universal logic, let alone value-system impossible. Design never became a fully developed social sub-system comparable to law or politics, or science or economy (Luhmann, 1987). According to Latour (1998), one might argue that it has never been modern. This non-disciplinarity is not a deficit but seems to be essential, related to design's character as an interface-creating agency between the artificial and the contextual systems (Simon, 1996). The interfaces depend on the specific purpose: aesthetic, functional, emotional, economic, ethical, etc., which is reflected in the various ideologies, notions, and histories of design.

This non-disciplinary position, orthogonal to the disciplinary differentiation, often misleads designers to regard their profession as a moral instance for "the whole." They mix what should be carefully separated: the process competence to conceive and organize change processes, and the competence to decide what is preferable or good. The former is design and research competence, the latter is a negotiation and decision process among stakeholders, including design. The situation is tightened further by the urge to "think bigger" (Brown, 2009), to redefine their role and shift activities toward more *normative* social subjects. The Kyoto Design Declaration (2008) is definitely a loud-mouthed appeal to save the world. What justifies this naïve hubris?

We cannot embrace the entire world with its apparent calamities and, at the same time, keep its perplexing complexity at a distance by "criticizing" it. Design is aiming at intervention strategies regarding desired outcomes, but it cannot define these purposes by itself. Design can be critical only inasmuch as it is unbiased and provides and illustrates different choices and offers them up for discussion among the stakeholders. It has no privileged criteria that enable decisions as to morally good or bad solutions. Designers are moral human beings, but they should clearly separate their personal preference system from the preference system of the inquiring system they are working with and for. Moral is first of all private and contingent. The naïve claim for morality as a constituent of design seems to be a symptom of immaturity and impedes recognition by other disciplines.

Ethics, as the reflection of morals, is essential but should be integrated into the process and the methods. Only by dropping rigorous concepts of humanism will we be able to work for real people in their individuality and real communities in their specificity. The humanistic attitude ignores and even destroys complexity. Design teams, companies, and individuals are definitely responsible for what they are doing. Responsibility is possible only if we do *not*

retreat to fixed moral positions. Responsibility means the duty to know the knowable facts of the situation and the willingness to facilitate perspectivity in a democratic and "designerly" process.

Normativity should be replaced by purpose orientation (teleology). Rosenblueth *et al.* (1943) re-introduced the concept of teleology into science. Moral, critical, and humanistic attitudes would better be transformed into irony (Rorty, 1989). Imagination, provocation, intervention, etc., are essential to design's role in increasing the variety of choices for people. Designers should rather conceive of themselves as scouts, sometimes as jesters, hopefully as respected partners in a network of disciplines and stakeholders. The creation of alternatives and variations is their unique area of expertise.

Transdisciplinarity (Nicolescu, 2008; Brown *et al.*, 2010) as epistemological and methodological paradigm can be considered as the operationalization of this ethical stance. Design as interface-building transdiscipline enables the transgression of disciplinary boundaries. Design does not have the task to guarantee a morally correct solution, but design facilitates the formulation of a systemic goal. Ethics remains implicit and therefore more powerful.

CASE STUDY: "ALTE LIEBE"

In old age in particular, social integration is an important issue. Since a significant proportion of the population cannot always rely on the resources of the family, a system of relations and networks outside the family is required in the neighborhood or the local community to minimize distress, to counteract the isolation of singles, and to encourage social solidarity between the generations. The family solidarity that remains is in no way sufficient to keep the community together. At this point "Alte Liebe" comes into play, which aims to provide communication, understanding, and sociability between the generations in order to prevent isolation and loneliness in old age and to generate quality of life. "Alte Liebe" aims at the commitment and vitality of the individual and thus contributes to the development of post-familial structures.

This case study describes the development of a social business by two product designers who have established a design consultancy, which—among other things—develops tenant loyalty concepts for public and private housing companies. It started as the non-profit social design project "Alte Liebe," which promotes relationships between old and young people in Kassel, Germany. The concept is based on old ladies in nursing homes who apply their skills in crocheting to produce fancy hats for a young target group. Moreover, the product enables a dialogue between the old ladies and their much younger customers, as every buyer can return an attached postcard with a personal

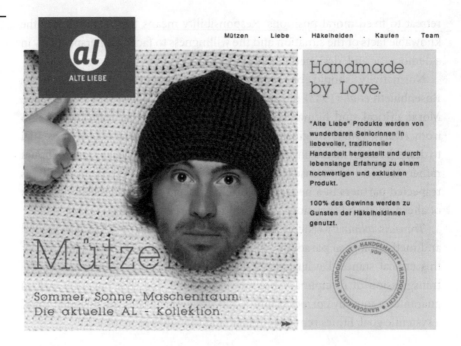

message. The following describes the scaling process of "Alte Liebe" and the design of a profitable social business model.

It took a year for the project to evolve into a viable model for starting a business. "Alte Liebe" was created as part of a student project that was developed and tested over four months. The positive responses of all concerned, public interest, and in particular the intense enquiry of the initiators of the project regarding new options for design were the decisive factors for the further development of the idea.

The award of the concept by the University of Kassel attracted the interest of entrepreneurs in the regional economy. Together with members of the Entrepreneurs' Council of Kassel, new financing channels for "Alte Liebe" were found. Through interviews with experts in management consulting, gerontology, the housing industry, and social welfare, knowledge about entrepreneurship and markets has been strengthened and the need for social concepts confirmed. The acquisition of this knowledge led to the business model of the *Ruby & Steltner GbR* (R & S GbR), which was sharpened by the detailed business plan (Fig. 11.1).

The Initial Project

"Alte Liebe" is intended primarily for supervised homes, retirement homes, municipalities, and real estate companies. In the project, senior citizens are

motivated and instructed to crochet hats together. The materials and instructions are provided by "Alte Liebe" (R & S GbR). The label "al" is attached to the finished caps, which are packed and sold through selected authorized partners for €39.99 a piece. In addition to material costs (wool, packaging, etc.) and project-support costs (lawyers, patent, website, personnel, sales, advertising, organization, etc.), activities and excursions for the benefit of the participants are financed through the sales. Participants decide together what is done with the profits (for example, a concert, trip to the theatre, creating a garden). In addition, participants are involved in the sale during selected cultural or social events. Through direct contact with the buyers, they experience others' appreciation and admiration of their abilities and personalities.

The three essential groups that make up the project are the participants, the customers, and the distributors. These three stakeholders influence each other and take different benefits from the project and the product. The participants create products that are sold under the label "Alte Liebe." They receive a meaningful job and experience the feeling of being needed as well as a sense of personal esteem and affection. Thus, they strongly identify with the product and develop a personal motivation. Participants are given responsibility and individual initiative is encouraged. The seniors set goals and celebrate successes. The end user receives a unique handmade artifact and communicates his/her appreciation of the project through the purchase of the product; social assets are created. The distributors provide the necessary sales platforms. They expand their range with a friendly, high-quality, and regionally produced product. Highlighting of the project in the media provides additional advertising for the dealers.

At this level "Alte Liebe" does not generate sufficient income for the initiators. But "Alte Liebe" is designed in such a way that it is adaptable to specific regional and economic conditions, which contributes to promoting customer and producer loyalty. The project is scalable due to the flexibility of its elements and its transferability to other cities and regions. This allows a higher social benefit and a higher profit at the same time.

The Scalable Business Concept

After the first months of implementing the project, a detailed analysis and research of various factors was performed. The goal was to create synergies, to recognize conditions, dynamics and connections, and to obtain a comprehensive understanding of the relevant issues. How can the need for social concepts in society be explained? What are the reasons? How do we define and understand the market of the real estate industry? What are the trends and future forecasts in this industry? Which strategies and possible entry points are available in

this market segment? From these insights, future visions were developed, which led to the formulation of a business plan and finally the starting of a business.

The clarified and newly defined business goal of R & S GbR is the development of intergenerational tenant loyalty concepts that are tailored to the urban district management of real estate companies. The service comprises the design of meaningful leisure concepts especially for seniors, the implementation and support of these projects, and the image-building communication of the clients' social engagement. The target customers are located in the housing industry. Housing providers are increasingly geared toward the objective of offering a comprehensive service for people of all ages, and especially of helping older people to experience the longest possible life in their own apartment. Today, nine in ten elderly people and two-thirds of those needing care live at home. The trend away from the familiar home for the elderly to various forms of life in old age continues (Haustein and Mischke, 2011). The conditions of the housing industry will be increasingly defined by the needs of tenants. Thus the housing industry must actively and increasingly address topics such as "tenant services" and "living for a long life," as well as the corporate social responsibility (CSR) issues of business in society.

The basic foundation of R & S GbR is social design, an integrated design approach, which aims to connect entrepreneurial efforts and social responsibility. The focus of social design is on the identification of social problems and their future-oriented solutions including corporate value. This means that the needs of the tenants in certain age segments are connected with the economic interests of the landlords. It is crucial for R & S GbR to strategically integrate these social businesses (tenant loyalty projects) into the economic structures of the target customers. In this way, controlled changes are initiated, with the aim of creating social and economic value.

This is not an easy task and the question remains: How is it possible to combine the legitimate business aim of generating profit with the clients' needs and an empathetic view of the people? The main requirement is to create a bridge between individual members of society and their needs and economic reality, so that companies or parts of companies can be profitable. Design is the key to providing access to customers' needs. Wasn't it always like this? Many have thought about these issues before.

SOCIAL TRANSFORMATION DESIGN?

What is new about the concept designing society? One of the most lucid deliberations of social transformation design with its characteristics and

constraints can be found in chapter 6 of Herbert Simon's *Sciences of the Artificial* (Simon, 1996): "Social Planning: Designing the Evolving Artifact." Crucial problems include determination of the boundaries of the design situation and the designer's position in the game. What are the goals? Planners must decide who the client is and what to include, what to exclude, and how to avoid unwanted side effects. One might argue that all ambiguities should be resolved by identifying the client with the whole of society. Churchman (1968, 1970) introduces the notion of the "ethics of the whole system," which would require a world without conflict of interest or uncertainty in professional, let alone personal, judgment. Therefore, according to Simon, the institutions of the society must share with the professional designer the redefinition of the goals of design. Simon's focus is on the institutional and professional stakeholders and decision-makers and not so much on the "end-users," which he does not seem to consider as legitimate participants but rather as selfish and tricky sources of irritation, unable to keep the common good in mind. He considers them as "designers who are seeking to use the system to further their own goals" (Simon, 1996, p. 153).

Today, there is the impression that (social) transformation design was "invented" by the British Design Council (2004): "Transformation design is a human-centred, interdisciplinary process that seeks to create desirable and sustainable changes in behaviour and form—of individuals, systems and organizations—often for socially progressive ends."

Is there any progress or clarification of Simon's (1996) prosaic notion that design means to "transfer an existing situation into a preferred one"? One of the crucial aspects in the Design Council definition is the—almost incidental— qualification: "often for socially progressive ends." Blyth and Kimbell (2011, p. 7) focus on design thinking (Brown, 2009) and criticize this approach as basing itself too much on the paradigm of user-centeredness, which treats the individual and personal symptoms of social problems rather than its causes. They call for design thinking to take seriously the "social" in social problems and develop its tools accordingly. And rather than claiming to solve social problems, they argue for design's competence in actively, critically, and reflectively contributing to their construction and representation. For that purpose, designers have to carefully consider their own role and values and perspectives in the process, they have to introduce double-loop learning and reflective conversations into the process, and they should aim to be actively involved rather than external consultants. Phills *et al.* (2008, p. 39) use the term "social innovation":

A novel solution to a social problem that is more effective, efficient, sustainable, or just than existing solutions and for which the

value created accrues primarily to society as a whole rather than private individuals.

There is "society as a whole" again. After all, the authors raise the question "What is social?" and arrive at a vague and tautological answer (p. 39):

> ... we define social value as the creation of benefits or reductions of costs for society—through efforts to address social needs and problems—in ways that go beyond the private gains and general benefits of market activity.

Finally (p. 40), they argue for new integrative cross-sector models, including non-profit, government, and business partners, which will allow the exchange of ideas and values and as a consequence fruitful shifts in roles and relationships. This promotes what some call the emergence of the "fourth sector" (http://www.fourthsector.net/).

It is amazing in this current debate on social design how little regard is given to the rich history of thinking about social transformation in design and planning. In particular, Critical Systems Thinking (CST; Ulrich, 1979, 1987), an operationalization of West Churchman's philosophical approach, seems to be a comprehensive and promising framework for social design. CST comprises the reflection and determination of system boundaries and driving forces as well as questions of legitimacy and power. It explicitly addresses the integration of the normative and the descriptive aspects of "the social." Although Ulrich mainly refers to Churchman, there are various other influences such as Issue-Based Information Systems as dialogic instruments (Rittel and Kunz, 1970), the notion of the Sciences of the Artificial and reflections on designing the evolving artifact (Simon, 1996), and dialogic approaches to systemic modeling, mixed causation problems, and sensitivity modeling (Vester, 2007). The diagram of the four "heroes" demonstrates the richness of seemingly controversial positions and attitudes. There is no "progress," just options for richer design considerations. It may be used as a map and navigation aid for reflecting our own positions.

Figure 11.2 provides an idea of the range of ethical and epistemological positions and provides abundant references to further theoretical roots. It contrasts the following systems thinkers: C. West Churchman (1913–2004), the thoughtful melancholic; Herbert A. Simon (1916–2001), the composed positivist; Frederic Vester (1925–2003), the friendly missionary; and Horst Rittel (1930–1990), the socratic ironist. All these stances are required and have to be integrated in social design.

Optimistic
Empirical
Analytical

VESTER Biokybernetik MISSIONARY	SIMON Science of the Artificial POSITIVISTIC
CHURCHMAN Philosophy of Social System Design MELANCHOLIC	RITTEL Second Generation Design Methods IRONIC

Strained
Prescriptive

Composed
Descriptive

Pessimistic
Philosophical
Reflective

Figure 11.2
Diagram of the "Four Heroes": Moods and attitudes to approaching social transformation design.
© *Wolfgang Jonas*

REFERENCES

Blyth, S. and Kimbell, L. (2011) 'Design Thinking and the Big Society: From Solving Personal Troubles to Designing Social Problems: An Essay Exploring what Design can Offer those Working on Social Problems and How it Needs to Change," Actant and Taylor Haig, June 2011 [http://www.taylorhaig.co.uk/assets/taylorhaig_designthinkingandthebigsociety.pdf; accessed March 1, 2012].

Brown, T. (2009) *Change by Design: How Design Thinking Transforms Organizations and Inspires Innovation*, New York: Harper Business.

Brown, V. A., Harris, J. A. and Russell, J. Y. (2010) *Tackling Wicked Problems through the Transdisciplinary Imagination*, London: Earthscan.

Churchman, C. W. (1968) *Challenge to Reason*, New York: McGraw Hill.

Churchman, C. W. (1970) "The Artificiality of Science," book review of Herbert A. Simon, *The Sciences of the Artificial, Contemporary Psychology*, 15 (6), 385–386.

Design Council (2004) *Red Paper 02: Transformation Design*, London: Design Council [http://www.designcouncil.info/mt/RED/transformationdesign/TransformationDesignFinalDraft.pdf; accessed February 18, 2012].

Haustein, T. and Mischke, J. (2011) *Ältere Menschen in Deutschland und der EU*, Wiesbaden: Statistisches Bundesamt.

Jonas, W. (2011) "Design | Business – 10 remarks regarding a delicate relation," Provocation statement, *Design Business Conference*, Barcelona, 16–18 November.

Kyoto Design Declaration (2008) Aalto, Finland: Cumulus [http://www.cumulusassociation.org/index.php?option=com_content&task=view&id=308&Itemid=109; accessed 07 April 2012].

Latour, B. (1998) *Wir sind nie modern gewesen. Versuch einer symmetrischen Anthropologie*, Frankfurt am Main: Fischer (original published in French 1991).

Luhmann, N. (1987) *Soziale Systeme*, Frankfurt am Main: Suhrkamp.

Nicolescu, B. (2008) *Transdisciplinarity: Theory and Practice*, New York: Hampton Press.

Phills Jr., J. A., Deiglmeier, K. and Miller, D. T. (2008) "Rediscovering Social Innovation," *Stanford Social Innovation Review*, Fall 2008, 34–43.

Rittel, H. W. J. and Kunz, W. (1970) *Issues as Elements of Information Systems*, Working Paper No. 131, Center for Planning and Development Research, University of California, Berkeley, July.

Rorty, R. (1989) *Contingency, Irony, and Solidarity*, Cambridge, MA: Cambridge University Press.

Rosenblueth, A., Wiener, N. and Bigelow, J. (1943) "Behavior, Purpose and Teleology," *Philosophy of Science*, 10 (1), 18–24.

Simon, H. A. (1996) *The Sciences of the Artificial*, 3rd edn., Cambridge, MA: MIT Press.

Ulrich, W. (1979) "Zur Metaphysik der Planung. Eine Debatte zwischen Herbert A. Simon und C. West Churchman," *Die Unternehmung*, 33 (3), 201–211.

Ulrich, W. (1987) "Critical Heuristics of Social Systems Design," reprinted in R. L. Flood and M. C. Jackson (eds.) (1991) *Critical Systems Thinking: Directed Readings*, Chichester: John Wiley.

Vester, F. (2007) *The Art of Interconnected Thinking*, Munich: MCB Verlag.

EDUCATIONAL CHALLENGES

CHAPTER 12

A STUDIO AT A BUSINESS SCHOOL?

Stefan Meisiek

This chapter takes a look at the recent appearance of design-inspired studio spaces at business schools. While they resemble somewhat their cousins in design and architecture schools, their purpose is less clear. Tracing the origins and inspiration back to design thinking, I discuss how far this is an adequate framework for studio work at a business school, and what other sources and resources there might be. The challenges and opportunities of bringing design pedagogy into management classrooms become apparent when considering needs to address systemic issues, and to bring scientific knowledge on board.

Historically, business schools had more in common with art and design schools than with the natural and social sciences. Managing was seen as a craft, organizing as a design task, and leadership as an art form. Trade associations were the founders of business schools, and they saw themselves as guardians of a vocation. They wanted to educate young men to join the management ranks in their ever-growing organizations. In the 1950s, the Carnegie and Ford reports changed this profoundly. To gain broader legitimacy, management had to become a science, and the natural sciences were the role model. Rigorous data gathering and timeless analysis were to be the basis for decision-making, moving management closer to economics. Business schools heeded the call. They "scientized" their activities and curricula, educated PhDs, and made publications and their impact the criteria for faculty members' careers.

Over the past decade, however, criticism has been mounting that the scientific agenda with its focus on analysis is too removed from practice to prepare students for what awaits them at work (Colby *et al.*, 2011). To counteract this criticism, business schools have started to look for the vocational roots of the management profession, and the main place for inspiration has been design.

At first, the lure might have been to learn about making new or improved products and services (Kelley and Littman, 2001; Brown, 2008). Then, a broader interest in the processes and principles of designing as analogous to managing took root (Sarasvathy, 2001; Boland and Collopy, 2004; Liedka and Mintzberg, 2006; Yoo *et al.*, 2006). This was followed by reflections on how designers and managers might work together in creative endeavors, understand each other's fields of practice, and generatively complement each other's abilities (Austin and Nolan, 2007; Verganti, 2009). And most recently, some business schools took the additional step of creating design studios, and started adapting design pedagogies for management learning.

The studios are an experimental ground for how design and management can come together, and they point toward working on systemic problems of business in society. This in turn might change what design is known for in society. Management and design might meet on the ground of human organization, rather than in new product and service development. Having said this, it seems still a long way off until business schools can teach design as key to a new craft of management.

This chapter takes into account the hitherto codified and popularized design processes in business schools, looking at their relevance for addressing systemic problems, and raises the following additional questions: How can design and science coexist in business schools? What should studio pedagogy for management education be like? And what alternative sources for studio work are there? The purpose is to open up a discussion on the future of design in business schools, and its impact on management education.

DESIGN IN BUSINESS

Without doubt, the Stanford D-School (Doorley and Witthoft, 2012), the School of Design Thinking, and Case Western's Managing as Designing (Boland and Collopy 2004; Buchanan, 1992) have played a significant role in popularizing design among business school faculty. And since their beginnings, design thinking has been a vividly discussed concept and practice. In spite of the controversy around the term, it has become a part of management curricula in many business schools around the world. Its promise is that if managers become designers, then they can solve wicked problems, especially those pertaining to creating new or improved products and services.

To the proponents of design thinking, it is equal to what design can do for management education. They praise it for its powerful simplicity and clarity of codification, which allows design novices to learn and apply it quickly. They point out that heterogeneous groups, brainstorming, and prototyping enable technology brokering and quick gains (Brown, 2008). To the skeptics it is but

one, albeit well-codified, process among many others, with lots left to explore. They deride it for just the same reasons that proponents praise it, saying that it over-simplifies design, and takes it out of the hands of the classical design professions (Verganti, 2009).

The skeptics also point beyond process to the affordances of studio spaces, and the relevance of academic content for legitimizing design in management schools. They note that a number of companies, non-profits, and government organizations have created studio spaces for a variety of uses, many of which have gone beyond design thinking. To mention a few, at P&G's Clay Street Project designers and employees work on issues pertaining to organizational identity, in the Danish tax ministry's New Room employees attempt to span legal and administrative fields of practice, and at the Helsinki Design Lab a group of Harvard-trained architects work against "dark matter" of administrative interests and habits surrounding public policy changes. These organizations are investing in studio spaces to help executives develop wider repertoires of thought and action, and to solve systemic problems.

The starting point is that organizations are created to solve some problems (i.e., those of production and distribution) and that organizations in turn create new, systemic problems (i.e., those of power and politics, work–life balance, sustainability, or inertia). Since organizations are good at solving the problems they were created for, but bad at solving the problems they create, design processes stand out as a way of addressing such problems.

Inspired by the pioneers of design thinking, their skeptics, and organizations that developed studios to deal with systemic issues, some business schools began creating dedicated studio spaces for management education. Rotman Business School, Sauder Business School, and Copenhagen Business School are notable in this respect. Sauder converted one of their classrooms into the D-Studio (dstudio.ubc.ca), and hired faculty with design backgrounds to develop MBA classes. Rotman's Design Works recently moved from an art gallery, where it worked somewhat in the fashion of a design consultancy, to a custom-built room on campus and hence closer to the core of the school's activities (Martin, 2009). Copenhagen Business School created a studio environment in an art nouveau villa (www.cbs.dk/studio), developed a design strategy minor, and seeks to inspire diverse faculty to explore studio work. The schools experiment with a variety of studio-based topics, formats, and processes to make design a part of management curricula and research across their spectrum of disciplines. The aim is to go beyond designing products and services, since this is not a management discipline *per se*.

Accounting, strategy, marketing, finance, organization, and operations are concerned with outfitting, staffing, and setting innovation and processes into motion, and to secure profit from the activity. These management disciplines

are providing a language to speak about innovation and change that is broadly familiar to managers. It anchors innovation and change in the purpose of the organization. This concern with providing the context of innovation more than with developing the content is the reason why business schools treat design thinking like an extracurricular activity, and many managers "don't get it" (Nussbaum, 2011).

A studio space, a number of principles, and design expertise are all that is needed for developing original, idiosyncratic approaches to systemic problems. Or, so it is assumed. It seems that the processes have to be different each time, because social systems have a memory and apprehend intervention patterns quickly. The exact same process is very unlikely to work twice. All of the above-mentioned studios at business schools are still experimenting to find the right formula of making design and management meet in the service of business and society.

A conversation about design and management among stakeholders is needed, if the design studios at business schools are to be more than a passing fad; a conversation that asks how studio work can benefit or bridge the scientific management disciplines, and move management learning towards activity and process.

DESIGN AND SCIENCE

Design thinking has often been portrayed in contrast to science. Its lively action-orientation was to replace the dustiness of academic thought. It seemed for a while as if a new language was arising to replace the old one of analysis, critical reflection, and theory building. While the use of science as a straw man might have been helpful for PR reasons, it blocks the view onto an attractive alternative for today's business schools—design and science as complementary processes for working on the systemic problems at the heart of management. It also means to accept that business schools won't perform a 180 degrees turn and become vocational training centers again, they will preserve the legitimacy they gained through "scientizing" their activities.

Philosophy might give us a hand to avoid thinking in terms of either-or. Cassirer (1944), a German philosopher, wrote about science, art, myth, and technology as symbolic forms of knowing. Each symbolic form is a world in itself, seeking consistency in thought and practices. Science and design are thus not in conflict with one another, but move on completely different planes. Each has idiosyncratic standards of quality, which are incommensurable to the other. For a discipline like management, this means that is doesn't make sense to argue for one symbolic form or the other: science or design. Rather, and to paraphrase Cassirer, practitioners are better off developing binocular vision;

meaning the ability to see and apply more than one symbolic form for any particular problem (Irgens, 2014). And the studio, in contrast to the lecture hall or laboratory, is the place that accommodates and thrives on plurality in epistemological approaches.

Taking a symbolic view on knowledge, management, and practice should be easy for design, and it seems the most promising platform from which design can bring its power into business school education. It would also lead the much-required conversation away from an obsession with objects and environments, and toward social systems, organizational processes, representation of firms, and sustainable business. These and other conceptual demarcations of the "social sculpture" of human activity are difficult to deal with through factual accuracy, but they are open to playfulness, imagination, and renegotiation on the symbolic level (Meisiek and Hatch, 2008)—something that designing can deliver.

Business schools have invested the last 60 years into learning everything they could about business relationships, management practices, organizational entities, work processes, governance, and so forth. There is hardly an aspect of organizational life that hasn't received attention. Epistemological and ontological disputes aside, this knowledge could not be used in studio-based work in business schools for the benefit of the students and external partners. Bringing academic content and design process together in a meaningful way is the challenge for every studio at a business school.

CONSEQUENCES FOR DESIGN AND MANAGEMENT

From Cassirer's binocular view we can begin to speculate about the future role of design studios in business schools, and how they might change management education. It begins with seeing more in business than buying and selling stuff for a profit. Business depends on societal approval, requires a legal framework, and happens in an organized or organizing fashion. Questions of ethics and sustainability are enriching the debate and call for curricular and pedagogical changes in business schools. Further, the very notion of what organizations are and do is changing. It seems that they are disappearing from our sight, dissolving into habits, practices, institutions, and similar concepts. Managers find it difficult to make any use of these concepts. The studio might well be a way to mitigate.

Unfortunately, the present interest in studio work at business schools seems to favor a realist perspective on organizations. For example, studio classes on tangible business modeling seldom ask questions about power, politics, culture, and identity in organizations. This is strange, since design works between the functional and symbolic level by its very definition. "De signare" describes the

act of giving meaning to something. Management scholars have been working for decades to theorize the social activity of doing business and managing businesses. Over the years, a plethora of different perspectives on organizations and organizing have developed, and educational frameworks for design studios at business schools will have to take positivist, interpretivist, and critical perspectives into account when working on systemic issues.

Seeing designing as managing, and managing as working with organizational processes means to abandon the idea that a designer could be working unconstrained, and from the outside on an organizational problem. The designers/managers are a part of the organization (and also a part of the problem), working in a social context that dynamically enables and constraints choices and actions. They can't stand apart or above these, but in their design practices they act from within this context. As little as it is possible to engineer an organizational culture and identity, it is possible to design it from outside the context. Seeing the design studio as a closed space, where problems could be neatly identified and separated is of little benefit to the effort. Just as architects had to open their studios to account for the "dark matter" of administrative interests and habits, business schools will have to have open studios. Studios can bring the living organization in to the room, a social arena with its power differences, political games, (ante-) narratives, cultural sensitivities, organizational identities, paradoxes, and ambiguities.

In this way, education at business schools can benefit from having dedicated studio space. Along with studio pedagogies, it promotes experiential, problem-based learning around business issues and techniques. It is a place where teachers and students can work with processes like tangible business modeling, dramaturgic approaches to organizational behavior, visual and haptic design of organizations, strategies, and creative explorations of innovation and change. Much of the studio work circles around live business cases where company stakeholders interact with students.

It will make studios the place where resourcefulness and versatility are developed, and where young people and experienced managers can learn what it means to manage in today's world. While it is the steeper climb, and it is a burden to take management science on board, I believe that it will lead to finer views.

FURTHER RESOURCES

Studios are not exclusive to design. There are many arts and crafts that use studios to teach their apprentices, or to experiment with new techniques and processes. Historically, the fine arts, the decorative arts, and the crafts were indistinguishable and all subsumed under the arts title. During the nineteenth century they developed into particular branches, which ever since have been

disputing their territories. Design is a relative latecomer on the stage. When it comes to developing an educational framework for studios in business schools, its seems counterproductive to uphold these divisions, and to say that only design practice as we see it today could contribute to a studio pedagogy for management.

The arts are already there, offering their studio processes to organizations to, well, redesign the way they do business. Theatre, music, dance, visual art, and conceptual art, all have found their place as interventions in organizations; seeking organizational change through the ways of their functioning, or as we would say for the present concern: by bringing their studio mindset to the workplace (Barry and Meisiek, 2010).

Design can learn from the arts how to take account of and attempt to influence social systems. This becomes necessary where design is attempting to go beyond its historical confines, and starts to work with systemic problems. The issue will be, however, to learn with a view to the functional requirements that are being placed on design wherever it is effective. This will be the starting point for any design studio at a business school.

CONCLUSION

This chapter, this small provocation if you permit, has the purpose to give the business studio some freedom to become. Like a number of other skeptics, I have argued for going beyond design thinking. Design thinking has a place in the business school studio, but it shouldn't demand exclusivity. We need new and different approaches to deal with the systemic problems that are the subject of management as it is taught in business schools.

The understanding of what design is and how it works in our societies is changing rapidly these days, and with strategic design, experience design, or business modeling, it moves into areas where new demands arise. This has brought design into business schools. Only some 10 years ago management faculty would only have thought of taking management to design, and to call it design management. Now, and maybe not as unexpectedly as it may seem, it is coming the other way around: design is taken to management. And the studio will play a key role in making it work.

REFERENCES

Austin, R. and Nolan, R. (2007) "Bridging the Gap Between Stewards and Creators," *MIT Sloan Management Review*, 48 (2), 29–36.

Barry, D. and Meisiek, S. (2010) "Seeing More and Seeing Differently: Sensemaking, Mindfulness and the Workarts," *Organization Studies*, 31 (11), 1505–1530.

Boland Jr., R. & Collopy, F. (eds.) (2004) *Managing as Designing*, Stanford, CA: Stanford Business Books.

Brown, T. (2008) "Design Thinking," *Harvard Business Review*, 86 (6), 84–92.

Buchanan, R. (1992) "Wicked Problems in Design Thinking," *Design Issues*, 8 (2), 5–21.

Cassirer, E. (1944) *An Essay on Man: An Introduction to a Philosophy of Human Culture*, New Haven, CT: Yale University Press.

Colby, A., Ehrlich, T., Sullivan, W. M. and Dolle, J. R. (2011) *Rethinking Undergraduate Business Education: Liberal Learning for the Profession*, San Francisco, CA: Jossey-Bass.

Doorley, S. and Witthoft, S. (2012) *Make Space: How to Set the Stage for Creative Collaboration*, New York: John Wiley.

Irgens, E. (2014) "Art, Science and the Challenge of Management Education," *Scandinavian Journal of Management*, 30, 86–94.

Kelley, T. and Littman, J. (2001) *The Art of Innovation: Lessons in Creativity from IDEO, America's Leading Design Firm*, New York: Crown Business.

Liedtka, J. and Mintzberg, H. (2006) "Time for Design," *Design Management Review*, 17 (2), 10–18.

Martin. R. (2009) *The Design of Business: Why Design Thinking is the Next Competitive Advantage*, Cambridge, MA: Harvard Business School Press.

Meisiek, S. and Hatch, M. J. (2008) "This is Work, This is Play," in D. Barry and H. Hansen (eds.) *Handbook of New and Emerging Approaches to Management and Organization*, London: Sage.

Nussbaum, B. (2011) "Design Thinking is a Failed Experiment: So What's Next?," *Co-Design* [http://www.fastcodesign.com/1663558/design-thinking-is-a-failed-experiment-so-whats-next].

Sarasvathy, S. (2001) "Causation and Effectuation: Toward a Theoretical Shift from Economic Inevitability to Entrepreneurial Contingency," *Academy of Management Review*, 26 (2), 243–263.

Verganti, R. (2009) *Design-Driven Innovation: Changing the Rules of Competition by Radically Innovating what Things Mean*, Cambridge, MA: Harvard Business Press.

Youngjin, Y., Boland Jr., R. J. and Lyytinen, K. (2006) "From Organization Design to Organization Designing," *Organization Science*, 17 (2), 215–229.

CHAPTER 13

DESIGNING EDUCATION FOR BUSINESS

Teal Triggs

I have been involved in graphic design education for longer than I can remember both as a student and as a teacher, and have witnessed many changes in the ways design curricula have been developed and delivered. Over the last decade, a distinct paradigm shift has taken place in terms of what and how students learn in UK higher education. This has been driven by economic necessity in response to government demands as well as a response to the specific needs of industry. In 2006, the Leitch Review of Skills commissioned by the government concluded that: "skills [are] the most important lever within our control to create wealth and to reduce social deprivation"; "skills" meaning "capabilities and expertise in a particular occupation or activity" (Leitch, 2006: 2).

Previously, education was about knowledge for its own sake, with a sideline involving feeding our graduates into the UK creative industries, which were perceived as prime movers behind economic growth. Recently, government has emphasized STEM subjects (made up of Science, Technology, Engineering, and Mathematics) as the focus of their strategic economic plan. As the broader social, political, and economic context alters, how might educators meet these new challenges head-on, especially those initiated by shifting government policies, funding cutbacks, tuition increases, and staff reductions?

One answer lies in the malleable nature of graphic design. The discipline may still be at the core of what we do, but over the years it has formed part of new subject hybrids where design is increasingly informed by other subjects and partnered with, for example, service design, design management, design writing, and design for social business. Thus it has been noticeable that key business programs have absorbed design thinking over the last few years, for

instance at Case Western Reserve University in the United States. However, some have argued that graphic design is in danger of losing its core principles and practices. Are we at risk of diluting the very knowledge base to which other disciplines have been attracted? The British design critic Rick Poynor wrote in *Print* magazine that he had concerns about "many graphic designers' apparent lack of interest in visual form ... that design without a concern for the 'graphic' is cutting off its nose to spite its face, and risks ending up with not much of an identity at all" (Poynor, 2011, p. 32). But is it really so much about "identity," or what we actually name the subject? Isn't our search more about finding the best ways for designers to be flexible, responsive but also pro-active in contributing to changing social, political, and economic conditions, production/technology processes, and end-user needs? How might we ensure the skills and knowledge that are already inherent to graphic design practice (e.g. craft, design thinking, making complex information accessible, behavior and human factors, visualization and communication) are employed effectively in their crossover to other disciplines? What does a graphic design toolbox look like for this next generation of business innovators and designer entrepreneurs?

Increasingly, we are asked to articulate what establishes our courses' distinctiveness by defining what is at the core of our offering. At the same time we are under pressure by university management to develop courses that are economically viable. This is achieved in most circumstances by setting higher targets and reaching out to international fee-payers (i.e., foreign students). In others, it is a change in the course content that broadens the scope in order to attract interest from a wider range of applicants. We also have to consider industry's needs and student demand for employment upon graduation. New models for design curricula also require staff that have an understanding of, if not practice within, these new forms of inquiry. Thus, "essentialist" definitions of graphic design are constantly under review.

KNOWLEDGE EXCHANGE

Historically in the UK, there has been little or no consensus in defining the term "knowledge transfer," now more commonly referred to as "knowledge exchange" (House of Commons, 2006, p. 17). Research Councils UK has attempted to encapsulate a definition that includes both "exchange" as "the two way flow of people and ideas between the research environment and the wider economy" and "transfer," which "encompasses the systems and processes" between the academic and the public and private sectors (Research Councils UK, 2007, pp. 2–3). For the purposes of this paper, "knowledge exchange" is

defined simply as a mutually beneficial collaboration in "the transfer of tangible and intellectual property, expertise, learning and skills between academia and the non-academic community" (Chubb, undated). In recent years, this concept has been at the center of redefining notions of what graphic design research can be.

In 2011, the UK's Arts and Humanities Research Council (AHRC) published findings from their commissioned report that evidenced the "high degree of connectivity between academics from the Arts and Humanities and the rest of society" (Hughes *et al.*, 2011, p. 8). The report showed that UK academics are engaged in a variety of knowledge exchange processes with businesses, and in turn, evidenced how these partnerships resulted in "impact" not only for economic gain, but in the pursuit of knowledge (ibid., p. 54). The report also concluded that "improved connectivity would both support academic pursuits and wider social and economic objectives" (ibid., p. 58). Although the way in which knowledge exchange might inform curricula and partnerships between art, design, and business was not within the scope of the Council's study, it is useful nonetheless to explore this teaching context more fully. The case study below describes the development of one possible model within a UK art school context where postgraduate students in graphic design have engaged effectively in knowledge exchange through international corporate partnership.

DESIGNING FOR BUSINESS: THE HYUNDAI MOTOR COMPANY AND THE ROYAL COLLEGE OF ART

While a number of questions emerge as to what role design might play more broadly, it is worth exploring one possible model for an academic and business partnership where graphic design for social need is its primary focus. What follows is a brief overview of the challenges and successes of developing knowledge exchange partnerships, which form part of postgraduate curricula in order to inform innovative thinking; and by doing so, instigating a process of "change." In this case, change took place not only in relationship to rethinking brand value but also within an academic context: our learning experiences. For this nine-month project, undertaken between October 2013 and June 2014, staff and students from the School of Communication, Royal College of Art were involved as equal participants with Hyundai Motor Company. This process signaled a new approach for the School. It resulted in staff learning as much about how to facilitate and manage corporate partnerships, as it did for the students engaging in what were often difficult conversations. These

were notably focused on the car and consumer culture, as well as corporations and branding as they played out within a context of broader social and environmental concerns.

In 2012, the School of Communication at the Royal College of Art (RCA) was approached by Seokhoon Kang, Youth Marketing Director at Hyundai Motor Company, to consider innovative ways of improving their brand image, especially in relation to an emerging European youth market. The company had recently launched its global brand campaign "Live Brilliant" (*Hyundai Motor News*, 2012) and was seeking to reinforce its intentions "by collecting fresh and interesting ideas from students at world class design/ art schools" (Kang, 2012). Hyundai wanted to move beyond conventional approaches to branding while also recognizing the importance of working with students in pushing forward their own professional practice as well as social, political, and cultural agendas. Such an approach is certainly in keeping with Hyundai's (2014) history of "encompassing cultural sponsorship," as witnessed most recently in the UK, where Hyundai entered into an eleven-year corporate partnership with the premier national art gallery, Tate Modern (Brown, 2014).

Hyundai's concept behind the "Live Brilliant" campaign aimed to express how its "Modern Premium" value "is expressed and delivered in customers' everyday lives" (*Hyundai Motor News*, 2012). In an effort to deliver the same message to all prominent global markets, a series of television commercials played to the idea of Hyundai as the "most beloved automaker of the world," with such themes as "memorable emotions," including "Family & Friendships," "Self & Love," and so forth. The campaign is based on the "experiential" reflected in a stylized sense of reality as each driver lives out his or her aspirations by driving a Hyundai car. In an accompanying press release, Hyundai remarks that car buyers today "want a car that is not only used as a means of transportation, but as a 'Life Space'." This concept of "life space" provided a platform for this project in order to move beyond an exercise in "branding" to that where students might begin to address some of the significant and timely issues found within the area of transportation, design, and future cities. As Kang later remarked, "the students made an unexpected suggestion: to shift the focus of the project toward a broader perception or notion of the car from that of merely developing new marketing messages" (Kang, 2013).

The project began with an overview presentation by Hyundai Motor Company, of its history and plans for achieving their goal of becoming "a favorite automotive brand, desired by consumers" (Kang, 2013). The presentation focused on Hyundai's "Modern Premium" and the company's strategy "to deliver new experiences and values that bypass customer

expectations in Hyundai's unique way" (Kang, 2013). The intent was for students and staff to explore new ways of thinking about the car in the future; and to consider ways in which a European youth market might be addressed. The project was focused on "blue sky" thinking, free from any formal constraints in terms of media, approach, and pre-determined outcome.

Hyundai was incorporated in 1967 and, compared with other automotive companies, is a relatively young business. In 1976, the company launched the "'Hyundai Pony," Korea's first passenger car. The absence of an inherent heritage has meant the company has had to find other ways of establishing brand value to its consumers. One way has been a consistent awareness of environmental issues through Hyundai's emphasis on "Global Environmental Management." This led to the development in 2003 of the first ultra high-pressure hydrogen storage system for fuel cell electric vehicles and a decade later, Hyundai launched the ix35 Fuel Cell electric car, as but one solution to reducing greenhouse gas emissions (Green Car Congress, 2014).

One ethical question immediately became apparent. Despite Hyundai's proven environmental track record, some students still questioned their involvement in the project, citing that it compromised their own belief systems and values. This led to a series of seminars where the issues were debated. One student suggested that overall her contemporaries, dubbed "Gen Y," were driving far less than previous generations and, as a result, she felt that marketing cars to them would result in a "bumpy road" (Kim, 2014, p. 79). This was echoed consistently throughout the project, leading students to reflect on sharing where mobility in future cities might actually reside: car sharing, electric cars, mass transportation, increased cycling and pedestrian areas, etc. Ed Gillespie, co-founder of a specialist sustainability communications agency Futerra, and guest lecturer on the project, proposed that the wrong question was being asked. He observed: "If instead, we asked how can we create clean, efficient, safe and sustainable urban transport access for all? Then the answer would be very different. And it almost certainly wouldn't be a car" (Gillespie, 2014, p. 195).

The car, however, was seen in a different light in the proposal offered by doctoral students Bethany Shepherd and Cerys Wilson. They proposed "a new educational model" in which a speculative Hyundai Driving School aims "to bring together the brightest minds in the fields of urban culture and design criticism to research, create and implement strategies that strive for a brighter future for our cities." The proposed school is contained in a mobile research and writing residency program created as a vehicle to critically examine "the cities whose economic survival has been (or continues to be) dependent on a single commercial or manufacturing industry" (Shepherd and Wilson, 2014). Here the creation of a knowledge exchange network facilitates innovative

design thinking in order to find solutions to challenges faced by cities impacted by the current economic downturn.

The international dimension to the project was also considered significant, especially the link inherent in the project with different geographic locations: London and South Korea. The idea of "connections" captured one student's imagination where she explored the notion of the journey—a Korean cultural exchange—from one destination to another: from A to B. For Suhee Kim, the car became a metaphor for freedom, but also one of movement—a shift from a physical to a mental space.

The project was divided into three stages: discuss, decide, and design. Graphic design came into play more explicitly again in the last stage "design" as a way of giving form to the findings offered by the research. There is no doubt that the project overall represented a set of complex relationships between industry and the art school, between branding and anti-branding, local and global, craft and manufacturing, the ethical and the unprincipled. While the details of these relationships are beyond the scope of this chapter, suffice it to say that the experience overall was successfully captured in *The Horse is Dead, Long Live the Horse*—a reference to the mythological Trojan horse and a nod to Hyundai's first car, The Pony. The book is designed as a curated selection of twenty-two commissioned text-based and visual essays addressing wide-ranging issues and views about the car and mobility. In order to complete "the two way flow of people and ideas between the research environment and the wider economy," the publication has gone back to Hyundai Motor Company to act as a catalyst for thinking differently and considering "new possibilities."

It was clear from the outset that this was not a conventional client-brief and student project; rather, it represented an opportunity to fully engage in a collaborative learning process between two seemingly different organizations. Art schools have historically been seen as a free space, where an emphasis is normally placed on individuality, experimentation, and "thinking outside the box." In contrast, business is generally understood to be a more rigid space with specific rules and economic parameters. The shared space in which this project took place allowed both organizations to engage with a fresh approach and utilize the experiences of those external to each organization to bring new perspectives and critical thinking to each other. In the closing essay of the book, staff researcher Tom Simmons observes:

> Through the generation of design ideas and the development of individual practice and knowledge, these in turn opened up deeper questions associated with the ethical parameters of design, social and environmental design responsibilities, and local and international economic contexts in which contemporary design, and designers, operate.

The project represents one model of how graphic design education may inform and shape the ways in which both the academy and global business might provide new perspectives on "contemporary challenges associated with learning, research, and innovation" (Simmons, in RCA, 2014, p. 202). In so doing, essentialist definitions of graphic design never seemed more questionable.

ACKNOWLEDGMENTS

My thanks to Seokhoon Kang and Hyundai Motor Company for their support in the development of this project and to the RCA students and staff who participated.

REFERENCES

Brown, M. (2014) "Tate Modern Announces Huge Sponsorship Deal with Huyndai," *The Guardian*, Monday, January 20 [http://www.theguardian.com/artanddesign/2014/jan/20/tate-modern-sponsorship-deal-hyundai; accessed June 2014].

Chubb, J. (undated) "Presentation on Knowledge Exchange and Impact," PowerPoint presentation, University of York [www.heacademy.ac.uk/assets/. . ./Knowledge_exchange_and_impact.pdf; accessed June 2014].

Green Car Congress (2014) "Hyundai to Offer Tucson Fuel Cell Vehicle to LA-area Retail Customers in Spring 2014," in Green Car Congress: Energy, Technologies, Issues and Policies for Sustainable Mobility" [http://www.greencarcongress.com/2013/11/20131121-fcvs.html; accessed June 2014].

House of Commons Science and Technology Committee (2006) "Research Council Support for Knowledge Transfer," Third Report of Session 2005–06, Volume 1, London: The Stationery Office.

Hughes, A., Kitson, M. and Probert, J. with Bullock, A. and Milner, I. (2011) *Hidden Connections: Knowledge Exchange between the Arts and Humanities and the Private, Public and Third Sectors*, Swindon: AHRC and Centre for Business Research.

Hyundai Motor Company (2014) "Corporate Information: History" [http://worldwide.hyundai.com/WW/Corporate/CorporateInformation/History/index.html; accessed June 2014].

Hyundai Motor News (2012) "Hyundai Motor Launches New Global Brand Campaign 'Live Brillant'," *Hyundai Motor News*, April 3 [http://globalpr.hyundai.com/prCenter/news/newsView.do?dID=267; accessed June 2014].

Kang, S. (2012) Email to the Author, "Hyundai Motor Partnership Inquiry." 12 June.

Kang, S. (2013) "Presentation: Hyundai Motor Company," October 14, Royal College of Art, London.

Kim, M. (2014) "A Car Named Desirable: The Bumpy Road Ahead in Marketing Cars to Gen Y," in RCA (ed.), *The Horse is Dead, Long Live the Horse*, London: Royal College of Art, 79–94.

Leitch, S., Lord (2006) *Leitch Review: Prosperity for all in the Global Economy—World Class Skills*, London: The Stationery Office.

Poynor, R. (2011) "A Report from the Place Formerly Known as Graphic Design," *Print Magazine*, 65 (5), 30–32.

Research Councils UK (2007) *Knowledge Transfer Categorisation and Harmonisation Project Final Report*. Swindon: Research Councils UK.

Simmons, T. (2014) "Hyundai/RCA: Design Process and Knowledge Exchange," in RCA (ed.), *The Horse is Dead, Long Live the Horse*, London: Royal College of Art, 199–203.

CHAPTER 14

COLLABORATION REQUIRES DESIGN THINKING

Matthew Hollern

In 2002, I participated in the working conference, *Managing as Designing*, hosted by Weatherhead School of Management, Case Western Reserve University. Educators, managers, and designers were invited into a discourse to provoke and challenge ideas of design in management. As the inaugural event in the Gehry-designed building, the working conference format and the architecture were models and manifestations of design thinking. In his keynote, Frank Gehry expressed design as a ubiquitous force that could be kept alive throughout the most complex decision-making processes. He encouraged the practice of maintaining a design "flux-state" late into the process, to lengthen the life of the design conceptualization, and decision-making activity. Participants in the two-day workshop provided wide-ranging perspectives that helped recognize common challenges across disciplines, and brought a shared purpose to rethink design education. The working conference format and the presentation of provocations are an interesting model of design thinking, a synergy from a diverse collaborative.

The take on *Designing Business* at the heart of this book and at the core of this chapter has continued this effort to consider design horizons or the design meta-text (or meta-design), and to consider new models in education to create more collaboration and "thinking models." The province of design cannot be substantively extended without meta-design, design thinking, and designing. In the challenge of *Designing Business*, and in the best models of design education, the advancement of all three practices is critical. Toward such advancement, we have applied the strategies and values of collaboration: provocation, discourse, and shared inquiry, the working conference model. In

our varied commitments to designing, implementing, and sustaining design for change in education, design thinking models and collaboration promise valuable insights and ultimately sustainable practices for design curricula and our programs. The "working conference" is a model of collaboration and design thinking of great potential, a model of *collaborative design thinking*: provocation–discourse–reflection (repeat). It is inclusive and suggests that "thinking" may be the province of one, but "design thinking" potentially is the product of many.

DESIGN THINKING IN HIGHER EDUCATION

In the late 1980s and into the 1990s, higher education was in the midst of a long and unfortunate period of "team efforts" (retreats and task forces) to make decisions and rework education at the level of the institution. Teams often included facilitators working with faculty, administration, and board members, but did not constitute design thinking teams. These were fundamentally constituent groups. "Forward planning" took place early and was dominated by budgets and business plans. "Strategic planning" and "strategic plans" changed the methodology, but often remained trapped by history and tradition. The product, "the plan," could die on the vine, or sit retired on a shelf after being publicly presented. Failure to commit and connect the plan with operations and budgets demonstrated the greater complexity of the problem and the need for design thinking and design. As the problem persisted, the training and expectations for participants and the planning evolved. "Strategic thinking" called for ongoing application of the strategic planning process, but again would suffer if not connected and operationalized. "Scenario planning" was perhaps the first collaboration that engaged in a form of "thinking-in-action" and some level of designing. This idea has carried forward and more recently we see the application of scenario planning as a part of the discourse around "sustainability" and "sustainable planning." At this level, there is a great potential for collaboration by design thinking. But what can we predict for this newest of all planning processes? If it is not a process of design thinking, if it is not pursued to the level of operationalization, if it is not afforded early and continuously influences in the design and planning of resources, a new generation of "vision statements" will fill office shelves where they will fade away waiting for the next round.

At its best, higher education must continue to model itself as a laboratory of design thinking, a "collaborator," a working conference. It should afford provocation, discourse, reflection, theory, exercise, critique, iteration,

innovation, and renewal. Unlike strategic planning, design thinking can be holistic and self-reflective, on both the process model and the product model. A school of art and design should be a laboratory where new thinking models are developed and exercised. In this laboratory, curriculum is catalytic to experiences, strategic to achieving objectives, and ultimately active in designing, thinking, and learning. In a model where "knowledge" has long been the "text" of education, design thinking and learning can be the meta-text. In this model, the education of designers is a process of cultivation of sustainable attributes, a "green education." It is a process akin to farming, not manufacturing. It benefits from cross-pollination and symbiosis. It is not assembled, dispensed, or completed by the institution. It requires provision of space, light, time, and synthesis. It is collaborative. The elements of a climate of learning must be carefully and deliberately nurtured and sustained. In my experience at the Cleveland Institute of Art, I have been able to establish and extend the metaphor of a green education through a climate of thinking and learning to cultivate three important areas of sustainable growth in our graduates: skills, knowledge, and character. All three represent unlimited potential in both concrete and abstract matters. All three are cultivated with an emphasis on research and continuous learning. In this model, I suggest we are focusing on "sustainability of intellectual matter" or green education by teaching research, learning, and synthesis as the fundamental and sustainable value proposition. At its best it allows for self-selection, individuation, and culmination in projects that reflect complex synthesis. It is the foundation for substantive innovation, the contribution to knowledge, and the advancement of culture. As Richard Buchanan has reminded us so aptly, design can be a "new liberal arts education" in a technological culture.

A NEW MODEL CURRICULUM FOR ART AND DESIGN EDUCATION

Collaboration requires design thinking. In a new model curriculum, thinking is privileged over knowledge. *Curriculum* transcends medium or discipline to achieve a complex of experiences, collaborations, and integration beyond a respective discipline. In order to achieve a meaningful and promising *integrative* learning model, collaboration is essential. In order for the collaboration to be effective, participants must engage as a design thinking team: converge–diverge–assimilate–accommodate. Unlike the role of chance in an informal collaboration, design thinking can afford process and essential dichotomies: concrete and abstract, analysis and synthesis. In a former model, proprietary knowledge is an end goal, a high-order "learning outcome." In an

TABLE 14.1

A NEW MODEL CURRICULUM FOR ART AND DESIGN EDUCATION

New curriclum		Old curriculum
Curriculum	vs.	Medium
Integrative	vs.	Proprietary
Hybrid	vs.	Purebred
Transdisciplinary	vs.	Medium-specific
Collaboration	vs.	Individuation
Cohorts	vs.	Majors

integrative learning model, design thinking is a high-order goal, and the acquisition of proprietary knowledge is repositioned as a strategy or vehicle toward that end. It is a paradigm shift that effectively repositions former goals as strategies, and former strategies as goals. It is the displacement of the "master of medium" and the placement of design thinking as part of the thinking and learning spectrum (Table 14.1).

In this model, *hybridity* is privileged as a product of synthesis (thinking), and the purebred is simply an archetype among others, which can be referenced or applied. The rationale for medium-specific study is no longer mastery of the specific, but rather a strategy to reach competencies that also support *transdisciplinary* experiences. The new model affords team-based research, design, charrettes, and presentations. Collaboration still recognizes the value of the individual directly as part of a whole, a unique contributor to the collective design thinking

In this new curriculum model, "cohort" is also redefined and transcends the former notion of a "college major." A cohort may be defined as a group of students whose program curricula have shared objectives, exclusive of individual practices, mediums, disciplines, or majors. Meaningful cohorts may exist across programs through the establishment of shared objectives, and may be identified across curricula by the common objectives adopted or practiced in varied disciplines, a collaborative. The spirit of cohort-based design and the substantive effect is addressed in the creation of transdisciplinary experiences, and a form of symbiosis, collaboration. Cohorts may combine different types of groups and vary in makeup of constituents; larger cohorts may also produce subsets that also achieve design objectives:

- To achieve cross-curricular and interdisciplinary objectives
- To increase dynamism

- To establish new and novel cores of skills and knowledge
- To establish non-medium-specific research and practice
- To define "comprehensive" by strategies of inquiry, rather than mediums or disciplines
- To increase the breadth of applied knowledge
- To decrease proprietary emphasis on mediums or disciplines.

Beyond respective collaborations, a sustainable collaboration model requires design thinking. It is clear that the most valuable outcome of a design thinking action may not be the product, but rather the process that may be sustained for future problems: a "designerly way," a "thinking-in-action," an "art of experimental thinking," a "culture of designing." As such, design thinking is a meta-process that produces processes, which in turn may produce products. It can be the goose that laid the golden egg. The golden egg may be a brilliant product, an important outcome, but the goose is invaluable, the persistence of design thinking. A collaboration model requires design thinking and must address and shape a series of institutional challenges:

- To develop a sustainable change-process model
- To facilitate and privilege change and improvement
- To review strategic curricular relationships
- To inventory program assets
- To identify overlaps and share resources
- To create cross-disciplinary courses and programs
- To inventory and prioritize initiatives vs. reductions
- To recognize internal strengths and weaknesses: curricular and operational
- To recognize internal and external partnership potential
- To prioritize goals and objectives
- To create architecture for sustainable change in process and form
- To reduce waste and strengthen programs
- To increase equity and affect positive revenue
- To design and manage processes
- To achieve inclusiveness of content and process experts.

INFLUENCE OF THE DIGITAL

The power of collaboration has been profoundly enhanced by digital technologies. At this moment, it is critical to participate in shaping the influence of the digital on the process and product of design, collaboration, and more recently the definition of meta-design and design thinking. Rapidly advancing digital technologies and requisite collaborations continue to expand our

horizons. In my own work with three colleagues, we conceived and founded CadLaboration (Cadlaboration.com), an organization dedicated to the exploration of the influence of collaboration and digital technology. We raise the fundamental question of collaboration in design and design education. Through collaboration we are able to expand the connectedness of our communities, affect new curricula, and share our technological resources for the benefit of our students. Toward the application of 3D printing and RP (rapid prototyping) technologies, we have been able to maintain a simple "fair trade" agreement without the need for any complex policies. Almost immediately the organization included twelve schools, and has been the catalyst for three symposia and several exhibitions. Again almost immediately we realized that the value in the collaboration was not in the technology of hardware, but rather in technology facilitating collaboration. Here we are reminded of the better definition of technology offered by Buchanan (1992, p. 8) in his interpretation of Dewey:

> Instead of meaning knowledge of how to make and use artifacts or the artifacts themselves, technology for Dewey is an art of experimental thinking. It is, in fact, the intentional operations themselves carried out in the sciences, the arts of production, or social and political action. We mistakenly identify technology with one particular type of product—hardware—that may result from experimental thinking, but overlook the art that lies behind and provides the basis for creating other types of products.

Such an "art of experimental thinking" suggests that design thinking, technology, and collaboration create symbiotic values for other types of products, new and novel ideas. Moreover, where we have sought to change design and the design "workflow," we have accessed a new kind of medium, a meta-medium, a digital medium. We have moved from practices based in fixed matter (tangibles of the artificial) to those based in a digital realm (virtuals of the artificial), digital models. It is a profound instance of synchronicity between art, design, science, and technology that demonstrates the power and potential of working with the stuff that ultimately describes everything: *information*.

We have moved from limited and static manifestations to limitless and dynamic experimentation. Modeling is no longer the proof at the end of the process. It can be the early visualization that spurs further experimental thinking, the model that reveals opportunity. In a design studio or in design across other disciplines, information is extraordinary, unlike any other medium or substance, a meta-medium. It is elastic, infinitely deformable, affordable, easy to share, an extraordinary source and matter of subject. It is not bound by

discipline, industry, or scale. Digital information suggests a meta-medium where generative design affords authorship of meta-forms, the forms that offer, describe, or generate other forms, the data that generates other data; it offers design parameters as algorithms. At this level, the algorithm is the meta-form, a kind of "find-forming," as opposed to "form-finding" (a modernist expression often used to describe work in sculpture). The designer engaged in exploration and digital modeling is analogous to the geneticist engaged in research and genetic code, essentially working with the DNA (information) behind the product. It is an extraordinary manifestation of "technology as the art of experimental thinking" in the form of digital modeling, algorithm design, and generative design. At this level, the value of collaboration and the interdisciplinary team is most evident and requires design thinking. Technology-enhanced connectivity further facilitates collaboration, and has helped to generate new attitudes toward research, creative processes, and authorship. The Human Genome Project is perhaps the greatest example of this idea that collaboration requires design thinking.

ONWARD

To assess the state of design in higher education, consider our enduring objectives and abstract principles, and then see them as reflected in the specific strategies and practices of our time. A primary and enduring objective of higher education itself is the generation of new knowledge or advancement of knowledge, and its contribution to community, society, humanity, and the planet. A school of art and design has a unique opportunity to lead change and positively affect communities, both immediate and global. While such missions have long been achieved, the strategies have changed. The cultivation of artists and designers to be innovative thinkers and leaders, and to define meaningful problems has replaced the emphasis on familiar products and process. In the new model, the product is "evidence" of education, not the education itself. The definition of "product" has also expanded exponentially. The challenge to change curricula is great and is a worthy subject of design thinking. As per the idiom "in order to design innovation, we must innovate design," new educational models are the challenge. New curricula must afford even greater transparency, to question and expand the common definition of design itself, and assume greater roles and responsibilities in practicum.

Artists, designers, and scholars serve as pioneers and creators of more than culture, and contribute new knowledge and modes of thinking far beyond traditional boundaries. The most valuable and sustainable attributes of art and design education are not best expressed in examples of a current program design or particular objectives, but rather in the ability of certain programs

and institutions to continually change and grow within a constantly changing scenario. We cannot identify the best current and specific practices and see them as the competition or archetype. They are already being replaced by new questions and opportunities. We can identify the most agile programs and institutions and seek to redesign the architecture of our own academic programs committed to faculty development, research, and new horizons. We can seek to continue our work to guide and support institutional change on an ongoing basis. On this order leading models can be understood by examining the sustainable and essential attributes of the architectures that continue to change and prosper. One of the most important contributors to vitality in academic programs is the development of the faculty and an environment committed to research, collaboration, and contemporary pedagogy. It is the principal value that ultimately must guide design and innovation in order to sustain a climate for healthy ongoing change.

Our collective, collaborative work together to redesign and affect new educational models, design, design thinking, and ultimately *design business* requires that we refine our abilities for design thinking, and find shared objectives and sustainable values expressed first in abstract terms. We should continue the emphasis on communities of shared inquiry and research, and continue to engage beyond our walls to collaborate with other programs and institutions, and contribute to our fields and communities, both immediate and global. As we further the process and refine the design of individual programs, questions of shared pedagogical design principles and curricular objectives can be addressed. The best work should be revisited, reanimated, revised, reengaged. The working conference, collaboration, and design thinking remain transparent, agile, and a sustainable part of a vital culture for higher education and business. A new model or design of education will always be temporal, but renewable within a sustained climate of research and design thinking. The future of education is an extraordinary problem, but education is the goose that laid the golden egg.

FOUR METAPHORS

Beyond its etymology, "design" metaphors may suggest more complex values for design thinking. I will end by presenting four metaphors:

1. Design is a wave carried by our collective experience, a cultural phenomenon, a force transmitted and revealed by culture.
2. Design is a particle, a common element in the periodic table of human experience, powerful and ubiquitous, compoundable, complex, and essential.

3. Design, like inspiration, is only truly complete upon causation of action, thinking, or experience.
4. Design is conscience, a force to transcend boundaries of material and technology, and to address substantive and meaningful needs of community, society, humanity, and the planet.

REFERENCE

Buchanan, R. (1992) "Wicked Problems in Design Thinking," *Design Issues*, 8 (2), 5–21.

TRANSLATIONAL DESIGN
The Evolution of Design Management for the Twenty-first Century
Michele Rusk

All changed, changed utterly: A terrible beauty is born.

<div align="right">W.B. YEATS</div>

It is a truism to say times have changed and that old models no longer fit our time; indeed, it could be said that our old ways of thinking are positively obstructive and certainly will not serve us well for navigating the future. We live in an age of quantum physics, yet we still largely employ approaches to management that were formulated in the 1950s for the 1950s. It may no longer be possible to plan future strategies effectively, given the changing nature of the economy, the political landscape, and the speed at which these changes occur in cities and urban areas of the world (Friedmann, 1973). As traditional organizations begin to fail in the face of twenty-first-century complexity, strategic design has come center stage with leaders and indeed governments searching for new approaches to recognizing, anticipating, and tackling some of our most pressing predicaments.

With the pursuit of happiness, meanings, and wellbeing—a constant human imperative—new ways of connecting with our creative selves to unlock potential need to be found. In a world that is so unpredictable and complex, we no longer have a choice but to improvise, evolve, and innovate. Consequently

collaborative approaches are becoming critical to addressing current and future big problems such as regional development, city regeneration, poverty alleviation, and sustainability. These entail the ability to assemble, manage, and lead interdisciplinary teams in different ways, as well as actively mining the tacit knowledge residing in communities of practice. Many of these skills are the common currency of design practice (Rusk, 2003), with design thinking being the discipline that uses design to match people's needs with what is technologically feasible—design is thus a principal source of innovation in its broadest sense (Brown, 2008).

Changing circumstances beget innovation and this is fairly well understood in business and science where there has long been valuable research activity in this regard. Findings are often counterintuitive, innovation is often serendipitous; where the law of unintended consequences prevails, so that we get solutions that are not the answers to the questions that were first posed but are often transforming in unexpected ways. What is implicit is that disaggregated industries are better suited to volatility, while big organizations better serve stable conditions.

Social innovation, on the other hand, is much less understood, yet social innovation is very much linked to broader patterns of technological change. More reliable research into how social organizations create civic value is needed. We need a wider understanding and better insight into how social change takes place and how it interfaces with new developments in economics, politics, and technology. New models must to be designed if policy-makers, funders, and universities are to more ably support and become integral to the process of social innovation (Mulgan, 2006).

LEADERSHIP AND MANAGEMENT

The roots of leadership and management theory are grounded in military strategy (see, for example, Sun Tzu, sixth century BC; Butler-Bowdon, 2010) and leading through fear (Machiavelli, 1513 [1961]), over time evolving to specialism of labor, resource allocation, and production maximization (Smith, 1776 [1999]; J.S. Mill [Colini, 1989])—all theories fit for their time. By the twentieth century, preoccupations with Scientific Management (Taylor, 1911 [2006]) evolved into a focus on Total Quality and Japanese style management (Deming, 1982). Thus management was a rational and analytical science based on what was measurable, with Harvard having launched the first MBA degree in 1921.

No wonder the word innovation became synonymous only with technology given the scientific context of the time, with the fuzzy logic of the arts being relegated to a "softer" discipline of only peripheral value. Even so, management

gurus still attested that the essence of management was really marketing and innovation (Drucker, 2001) and throughout the 1970s, 1980s, and 1990s business thinkers were considering how to get better ideas through "conceptual blockbusting" (Adams, 1974), looking into the nature of creativity in business and business as an art (Ray and Mayer, 1989), or wondering how to engage in creative management and manage innovation (Henry and Walker, 1991). And with this, the importance of situational management came to the fore and specifically a loose–tight, iterative approach that built in contingency and allowed for creative experimentation.

MBA degrees, so long the gold standard of management, stand for Master of Business ADMINISTRATION, but as time passed what were actually needed were Masters of INNOVATION. Because, in the quest for competitive advantage, old hierarchical ways of working had to become more flexible and in response matrix organizational design, which focused on bespoke team-building around specific projects, became the norm. But today, the old command and control systems and even matrices are not adequate for the task, particularly when it comes to governance, public administration, and education management—not to mention the need for democratic processes in the not-for-profit sector.

Flexibility itself takes the form of evolution and adaptation; in fact, the name of the game is now metamorphosis and we have to look at chaos theory, systems dynamics, and open systems networks for inspiration. All this requires a deep understanding of the nature of creativity and how it is made manifest through design processes.

For this reason, leaders in different spheres are currently interested in harnessing design sensibility, to go beyond the conventional sense of design thinking and practice; to encompass change and synthesize new knowledge from different domains so as to better tackle multifaceted socio-economic issues. While there is undoubtedly widespread recognition of the importance of creativity and innovation for organizational agility and strategy formation, the fundamental challenge is how to enable the imagination to innovate, the professionalism to perform, and the openness to collaborate: leading to change-adept organizations and systems (Moss Kanter, 1997).

The real imperative for leaders, in whatever context, and strategists across all disciplines, is to articulate and draw on a philosophy of global relevance—fit for our time and beyond. This must entail a breath of scope that embraces plasticity and recognizes the dynamic nature of the forces at play in shaping the future. Based on the premise that traditional business models may no longer adequately serve in today's landscape, there is a need to explore and engage in experimental journeys into ways of discovering and articulating new route maps for creative venturing and organic development.

The first steps require a reexamination of our modes of thinking; how knowledge is created and disseminated; the character of creative education and practice; and their role in socio-economic problem-solving and value creation.

SEEING THROUGH DESIGN

Design Thinking

What designers do in practice has been the subject of much inquiry since the 1960s, with particular reference to designerly thinking. Design has been described as the creation of artifacts (Simon, 1996), a reflexive practice (Schön, 1983), a problem-solving activity (Buchanan, 1992), a way of reasoning/making sense of things (Cross, 2006; Lawson, 2006), and the creation of meaning (Krippendorff, 2006; Verganti, 2009).

At the core of this inquiry has been the pursuit of new ways of thinking to generate new ideas, release new energies and new possibilities. Writers have argued that creativity comes from "displacement concepts"—taking concepts from one field of life and applying them to another in order to bring fresh insights (Schön, 1983)—or that creative "upside down" thinking is a way to open the imagination (Handy, 1989). Still others have described thinking in holistic, visual terms as "kaleidoscope thinking"—going beyond conventional wisdom to find a creative new approach that can produce dramatic, transforming change (Moss Kanter, 1989)

Changing the way we think changes everything. Creative thinking is an essential step on a journey of innovation, change, and transformation toward higher achievement, and sometimes that means thinking unreasonably to find new patterns, for discontinuous change requires discontinuous thinking (Handy, 1989).

Managerial approaches to design thinking have focused on "managing as designing"—that is, the intersection of design, organizations, and managing (Boland and Collopy, 2004); integrative thinking for leadership success (Martin, 2007); a thinking style to open up innovative practice (Brown, 2008); and as the next competitive advantage (Martin, 2009).

Design, previously linked to business only through multidisciplinary brand and innovation teams, is now being taken up in direct relation to strategy and organization design (Borja De Mozota, 2011). So not only does design give form to products, processes, and systems, it also gives form to decision-making itself (Steinberg, 2010) through networked design processes (Manzini, 2011). Taken in this context, the word design becomes synonymous with intent or

strategy. Consequently, design plays a central role as the switch between creativity (i.e., the thinking) and innovation (i.e., the doing) (Rusk, 2003). At bottom, the renaissance view still prevails: "Design is the Animating Principle of all Creative Processes" according to Vasari.

So is design thinking essentially a new term for creative thinking? But if creativity *is* the thinking and design the animator, it is incumbent upon design to articulate how this thinking style uniquely vitalizes innovation. Consequently, the real question becomes: "What is the relationship between creativity, design, and innovation and what is the unique role of design thinking in making manifest entrepreneurial leadership within the contemporary cultural milieu?"

Design Management

Although the Design Management Institute has been in existence for over 30 years, the debate as to whether the discipline is the province of Business Schools or Design Schools, or indeed whether Design Schools are the new Business Schools (*Business Week*, 2005) has raged for almost as long. Undoubtedly changing contexts necessitate metamorphosis that invariably leads to tensions between theory and practice; core and responsive concepts and design and management practice.

But design is nothing if not integrative and synergetic, so surely it is time for design management to be reflexive and move past the recurrent concerns connected to an old paradigm. Preoccupations with board-level representation or how to justify impact of investment may be better supplanted by questions prompted by today's rapidly changing context of digital communication, globalization, and austerity. More appropriate issues might be:

- How to demonstrate the value of creativity and ingenuity in many situations—the political, social, economic, and environmental?
- How to make explicate the function of design as the animator that makes possible innovation in its broadest sense?
- What is the cost of not innovating?

Some of the prevailing discourse in design management circles is frankly myopic and even reactionary, centering on design's relationship to management and vice versa. Is it the term design management itself that gives rise to this quandary? In the quest for clarity, a plethora of different terms are being coined, including business design, design for social business, service design, strategic design, meta-design, and design direction. Would not an umbrella term like *translational design* more aptly describe developments in the domain? Translational design would encompass equality, good governance, policy-making, and ethics.

If design management is to have a transcendent effect, it must itself transcend its genesis so that a radical new school of thought, that addresses human affairs, can emerge. Design management needs to ask bigger questions, such as: What is design management's unique way of seeing? What are its core principles? And what is the distinctive philosophy? The domain needs to make explicit:

- The role of design as central to setting directions that result in original strategies in evolving ecosystems.
- Critical factors that facilitate design-led leadership skills, including the ability to appreciate the "big picture" and articulate the architecture of multifaceted problems from the outset.
- How design generates alternatives and provides integrated solutions in different circumstances.

So the real puzzle is, what is design management's role in defining and creating new social and technical infrastructures that enable a collective approach to change management, economic development, regeneration, and sustainability? In fact, what is its role in wellbeing *per se*, both physical and metaphorical?

From this new perspective, design can be viewed as a meta-skill, the enabler that makes tangible the possible, while differentiating design thinking as the cognitive aid to dealing with the flux of events and adapting accordingly—in essence, a source of new insights, new knowledge, and new understanding. Thus design factors in the notion of the emergent, espousing it and making it an opportunity for more creative and more adequate solutions to problems, particularly those of sustainability and socio-economic value creation.

Translational design is aimed at arranging new forms of social engagement to make possible collaboration design. It encourages users to become co-designers by employing design attitudes of improvisation and evolution to approach innovation in its broadest sense. Consequently, it initiates collaborative leadership by stimulating partnerships that combine academic, economic, social, and industrial and professional groups into communities of inquiry, learning, and practice, for social action.

This meta-skill approach brings to the fore notions of continuous innovation through metamorphosis and adaptability. It is necessarily contingent on unknown contexts because it embraces uncertainty; assuming that future problem cannot be fully anticipated. Thus it is an iterative approach comfortable with the concept of emergence.

In essence, translational design methodology enables transformation; focusing as it does on directional thinking to create smart specialization platforms and strategies that stimulate regional creative economic development and help cope with future difficulties.

KNOWLEDGE AND ITS TRANSFER

Knowledge Generation

To equip people for living as well as prepare managers for emerging leadership roles, we need to go beyond coping mechanisms to better ways of cultivating wisdom. This requires a holistic approach to individual, organizational, and indeed societal learning. It means developing a climate that fosters learning by valuing understanding and conflict resolution over winning and self-interest. It means arranging the conditions that support valid information, free and informed choice, and internal commitment (Argyris and Schön, 1996).

The route to expanding minds is education through inquiry, learning, and practice; for knowing is everything, especially when life is full of paradoxes that need to be balanced. But the acquisition of knowledge also requires incubation, reflection and contemplation, and so at times of disintegration and fragmentation we look for integrative processes. Integrative learning is holistic, addressing the whole person or system—physically, mentally, and metaphorically. It focuses on learning from differences in content, points of view and learning styles, and is best achieved in circumstances where diversity is welcomed as a stimulant and where different approaches and perspectives are espoused as complementary. Further, integrated learning is about learning how to learn, from and with others. When everyone shares the same experiences, learning occurs through dialogue, among participants who share observations, feelings and thoughts, and arrive together at conclusions (Kolb *et al.*, 1991). Thus the generation of knowledge and its dissemination occur concurrently.

Experiential learning theory and practice provide scaffolds to facilitate integrative learning that occurs best when the learning process is integrated with work in the real world through action learning (Revans, 1982). For organizational or societal learning, this concept can best be translated into learning by focusing on and tackling real complex issues or multifaceted problems. At the same time, communities of practice have been described as the new organizational frontier. How, then, to enable the formation of communities of practice? They can be recognized, supported, encouraged, and nurtured, but they are not designable reified units. Practice itself is not amenable to design (Wenger, 1998).

Design thinking and innovative educational methodologies, such as design direction forums, action learning sets, creative team-building workshops, consensus-building meetings, and design labs, as well as innovative mapping and model-generating techniques, will be central to enabling and supporting the evolution of healthy communities of practice, so that design practices can be used to create tangible outcomes for the sustainable benefit of society and

the economy. Consequently, new organizational frameworks are emerging that rely on open source and connected, collaborative processes (Mulgan, 1997). Design Schools represent a distinctive resource not only as generators of knowledge but also as powerful players that have a direct bearing on the transition to sustainability through stimulating connections (Manzini, 2011).

Design Education: Studio as Community

Design studios are quintessentially communities of practice, and traditional learning activities in design take place through studio practice, a social context where strategic design (giving form to decision-making) is a key principle. But the studio is also a community of inquiry and learning that can be viewed as a microcosm with distinct advantages in term of scale; small enough and sufficiently networked to be, in effect, a living lab; able to extend its reach to encompass other disciplines, stakeholders, and jurisdictions.

The preferred pedagogical approach of design educators is constructive and consequently the studio exemplifies an interactive environment of knowledge building, experimentation, and discovery of principles. Design studio practice encourages the exploration of new concepts, enabling practitioners to create and innovate, present and discuss, critically review and evaluate one's own and others' work (JISC, 2010). Thus studio practice encourages collaboration and shared experience of ideas as well as encouraging reflection, peer review, and evaluation (Cross, 1982, 2006).

But the studio also provides a physical learning context that enables learners to develop their identities through participation in a design community. It allows student designers to engage in social inquiry and learning to hone design skills and to develop learning relationships through dialogue. In design education, the studio provides the environment for the development of university graduate core qualities of relevance to other disciplines too, specifically:

- subject-specific knowledge and skills informed by current research and professional/vocational practice;
- effective collaborative working, communication skills, and the capacity for reflective practice, including the ability to give and receive feedback.

With the ubiquity of networked technologies and the popularity of personal mobile devices (HEFCE, 2009), the studio has benefited from its boundaries becoming more porous. This changing situation enables education practitioners to focus on pedagogic skills as facilitator and animator of self-directed collaborative learning processes. It also presents an unprecedented opportunity to broaden learning activities beyond a purely institutional-based, narrowly defined set of activities—giving credence to Sir Ken Robinson's assertion on

the subject of unlocking creativity that "schools are not the sole provider of education" (Robinson, 2009).

However, with information proliferating rapidly through ever increasing channels, the need for learners to acquire critical and evaluative skills to make sense of an ever more complex world has never been greater (Browne *et al.*, 2010). Creative education has a unique position in enabling integrative learning by providing the space for creative experimentation, contemplation, and search for meaning. Thus Design Schools have a key role in equipping learners with the faculties to effectively deal with the potential confusion offered by unlimited information access.

Technology is a powerful enhancer of studio practice because it expands the physical to the virtual and strengthens the bonds within a design community as learners collectively become active makers and shapers of their own learning (Butcher, 2008). Technology also adds value to learning by providing the means for reflection, planning, and knowledge sharing. It enables more active learning through access to an abundance of knowledge and paves the way for the establishment of diverse multidiscipline global communities of practice. Given that communities of practice are rarely planned entities but rather emerge (Wenger and Snyder, 2000), technology can be a catalyst in their creation. In this context, technology provides the opportunity for active collaborative learning; flexible access to self-paced, self-managed learning; as well as exploration of the digital self through learner-generated content—a natural extension of the core competencies of designers.

A NEW SCHOOL OF THOUGHT

Twenty-first-century Curriculum

> If we change our attitudes, our habits and the ways of some of our organizations it can be an age of new discovery, new enlightenment and new freedom, an age of true learning.
>
> (Handy, 1989, p. 10)

True learning is predicated on advances in knowledge and its transfer, which relies on insightful pedagogy and curriculum development, based on the integration and convergence of the three pillars of academia, namely:

- *Research*: inquiry, reflection, and thinking.
- *Teaching and Learning*: promulgation, dissemination, and drawing forth inner potential.
- *Academic Enterprise*: practice, doing, and mastery.

In this context, therefore, educational development *per se* can be viewed as a whole system of knowledge creation, exchange, and application. The importance of problem-based, technology-enhanced, and collaborative learning are well understood, but for design management, specifically, we first need to know how knowledge is generated and learning occurs in this domain. The notion of threshold concepts as learning outcomes of "seeing things in a new way" may be central in this regard.

Threshold concepts have been described, not as clearly defined elements of curricular content, but as part of the evolving repertoire of a legitimate peripheral participant, gradually developing their "identity as" by increasingly taking part in the practices of a learning or disciplinary community (Lave and Wenger, 1991; Wenger, 1998). Consequently, threshold concepts are seen as: "being akin to a portal, opening up a new and previously inaccessible way of thinking about something . . . represents a transformed way of understanding, or interpreting or viewing something, without which the learner cannot progress," and being generally characterized as "transformative, probably irreversible, integrative, often troublesome and probably bounded" (Meyer and Land, 2003). Threshold concepts may represent *troublesome knowledge*— knowledge that is conceptually difficult, counterintuitive, or "alien" (Perkins, 1999). In addition, threshold concepts are conceived of as "webs" of concepts that have a role in the integration of new ideas into existing individual belief systems (Meyer and Land, 2006).

In essence, to begin to construct a twenty-first-century creative curriculum that builds and disseminates design management knowledge, the domain needs to:

- articulate design management's unique way of seeing;
- identify design management threshold concepts and begin to make sense of how they represent troublesome knowledge; and
- map out the web of concepts and how they relate one to the other to describe design management's altered kaleidoscope.

Translational design should inform new teaching and learning approaches that are based on design sensibility yet go beyond the conventional sense of design thinking and practice, to encompass change and synthesize new knowledge from many different disciplines so as to better tackle complex socio-economic issues. So that the leaders of tomorrow can gain sufficient insight to engage authenticity with difficult live issues; then marshal their thoughts into new ways of knowing. In this way, studio practice and design methods could be the catalyst to create new dynamic strategic models and avenues for creative venturing—or should that be adventuring?

REFERENCES

Adams, J. (1974) *Conceptual Blockbusting: A Guide to Better Ideas*, New York: Penguin Books.

Argyris, C. and Schön, D. (1996) *Organizational Learning II: Theory, Method, and Practice*, Reading, MA: Addison Wesley.

Boland Jr., R. & Collopy, F. (eds.) (2004) *Managing as Designing*, Stanford, CA: Stanford Business Books.

Borja De Mozota, B. (2011) "Design Economics—Microeconomics and Macroeconomics: Exploring the Value of Designers' Skills in Our 21st Century Economy," paper presented at the 1st International Symposium CUMULUS // DRS for Design Education Researchers, Paris, May 18–19 [http://www.designresearchsociety.org/docs-procs/paris11].

Brown, T. (2008) "Design Thinking," *Harvard Business Review*, 86 (6), 84–92.

Browne, T., Hewitt, R., Jenkins, M., Voce, J., Walker, R. and Yip, H. (2010) *2010 Survey of Technology Enhanced Learning for Higher Education in the UK*, Oxford: UCISA [http://www.ucisa.ac.uk/~/media/groups/ssg/surveys/TEL%20survey%202010_FINAL.ashx].

Buchanan, R. (1992) "Wicked Problems in Design Thinking," *Design Issues*, 8 (2), 5–21.

Business Week (2005) "Tomorrow's B-School? It Might Be a D-School," Special Report [http://www.businessweek.com/magazine/content/05_31/b3945418.htm].

Butcher, J. (2008) "Off-Campus Learning and Employability in Undergraduate Design: The Sorrell Young Design Project as an Innovative Partnership," *Art, Design & Communication in Higher Education*, 7 (3), 171–184.

Butler-Bowdon, T. (2010) *The Art of War by Sun Tzu*, New York: John Wiley.

Colini, S. (ed.) (1989) *J.S. Mill: On Liberty and Other Writings*, Cambridge: Cambridge University Press.

Cross, N. (1982) "Designerly Ways of Knowing", *Design Studies*, 3 (4), 221–227.

Cross, N. (2006) *Designerly Ways of Knowing*, New York: Springer.

Deming, W. (1982) *Out of Crisis*, Cambridge, MA: MIT Centre for Advanced Educational Services.

Drucker, P. (2001) *Essential Drucker*, Oxford: Butterworth-Heinemann.

Friedmann, J. (1973) "The Public Interest and Community Interest," *Journal of the American Institute of Planners*, 39 (1), 2–7.

Handy, C. (1989) *The Age of Unreason: New Thinking for a New World*, London: Random House.

HEFCE (2009) "Effective Practice in a Digital Age: A Guide to Technology-enhanced Learning and Teaching," London: HEFCE [http://www.webarchive.org.uk/wayback/archive/20140615094835/http://www.jisc.ac.uk/media/documents/publications/effectivepracticedigitalage.pdf].

Henry, J. and Walker, D. (1991) *Managing Innovation*, London: Sage.

JISC (2010) "In Their Own Words: Exploring the Learner's Perspective on e-Learning" [www.jisc.ac.uk/elearning].

Kolb, D. A., Lublin, S., Spoth, J. and Baker, R. (1991) "Strategic Management Development: Experiential Learning and Managerial Competencies," in J. Henry and D. Walker (eds.), *Creative Management*. London: Sage/The Open University, 221–231.

Krippendorff, K. (2006) *The Semantic Turn: A New Foundation for Design*, New York: CRC Press.

Lave, J. and Wenger, E. (1991) *Situated Learning: Legitimate Peripheral Participation*, Cambridge: Cambridge University Press.

Lawson, B. (2006) *How Designers Think: The Design Process Demystified*, 4th edn., Oxford: Architectural Press.

Machiavelli, N. (1513 [1961]) *The Prince*, New York: Penguin Classics.

Manzini, E. (2011) "Design Schools as Agents of (Sustainable) Change," paper presented at the 1st International Symposium CUMULUS // DRS for Design Education Researchers, Paris, May 18–19 [http://www.designresearchsociety.org/docs-procs/paris11].

Martin, R. (2007) *The Opposable Mind: How Successful Leaders Win Through Integrative Thinking*, Boston, MA: Harvard Business Press.

Martin, R. (2009) *The Design of Business*, Boston, MA: Harvard Business Press.

Meyer, J. and Land, R. (2003) "Threshold Concepts and Troublesome Knowledge: Linkages to Ways of Thinking and Practising within the Disciplines," Occasional Report 4: Enhancing Teaching-Learning Environments in Undergraduate Courses [http://www.leeds.ac.uk/educol/documents/142206.pdf].

Meyer, J. and Land, R. (2006) "Threshold Concepts and Troublesome Knowledge: An Introduction," in J. Meyer and R. Land (eds.), *Overcoming Barriers to Student Understanding: Threshold Concepts and Troublesome Knowledge*, London: Routledge, 19–32.

Moss Kanter, R. (1989) *When Giants Learn to Dance: The Definitive Guide to Corporate Success*, New York: Touchstone Simon & Schuster.

Moss Kanter, R. (1997) *Frontiers of Management*, Boston, MA: Harvard Business Review.

Mulgan, G. (1997) *Connexity: How to Live in a Connected World*, Boston, MA: Harvard Business School Press.

Mulgan, G. (2006) *Social Silicon Valleys: A Manifesto for Social Innovation*, London: The Young Foundation.

Perkins, D. (1999) "The Many Faces of Constructivism," *Educational Leadership*, 57 (3), 6–11.

Ray, M. and Mayer, R. (1989) *Creativity in Business*, New York: Doubleday.

Revans, R. W. (1982) *The Origin and Growth of Action Learning*, London: Blond & Briggs.

Robinson, K. (2009) *The Element: How Finding Your Passion Changes Everything*, New York: Viking Penguin.

Rusk, M. (2003) "Meeting the Challenges of a Changing World," paper presented at the 5th Association for Business Communication European Convention, Lugano.

Schön, D. (1983) *The Reflective Practitioner: How Professionals Think in Action*, New York: Basic Books.

Simon, H. (1996) *The Sciences of the Artificial*, 3rd edn., Cambridge, MA: MIT Press.

Smith, A. (1776 [1999]) *The Wealth of Nations*, Harmondsworth: Penguin Classics.

Steinberg, M. (2010) *Design Policy: A Perspective from Finland. Conference Presentation*. Helsinki Global Design Lab.

Taylor, F. W. (1911[2006]) *The Principles of Scientific Management*, New York: Cosimo.

Verganti, R. (2009) *Design Driven Innovation*, Boston, MA: Harvard Business Press.

Wenger, E. (1998) *Communities of Practice: Learning, Meaning and Identity*, Cambridge: Cambridge University Press.

Wenger, E. and Snyder, W. M. (2000) "Communities of Practice: The Organizational Frontier," *Harvard Business Review*, 78 (1), 139–145.

WEAVING TOGETHER CREATIVE PROBLEM-SOLVING AND DESIGN THINKING IN AN MBA CLASS

Amy Zidulka

When, in 2010, a colleague and I were asked to design a new course that would introduce creativity and innovation-related content into our school's MBA program, I suggested a design thinking focus. Although I have taught in a business school since 2001, I have a first degree in architecture and had been experimenting with design thinking ideas ever since I first heard about the concept a few years earlier. Design thinking intuitively made sense to me, and I was excited by its potential to open our students to new ways of navigating challenges. My colleague, however, was skeptical.

With three degrees in business and extensive practitioner experience as a partner in an international consulting firm, he perceived his background in traditional analytical approaches to serve him well. Indeed, he credited the skills he had gained in his MBA training as being foundational to his own ability to innovate. He bristled at a methodology that, in its rhetoric at least, appeared both to devalue these skills and to overinflate its own value. "Design thinkers act like they invented empathy and prototyping," he wrote me in one email. He also questioned the fuzziness of the design thinking discourse, pointing out that, given how difficult it was to define it or to identify its theoretical foundations, perhaps it was not yet mature or credible enough to serve as the basis for our class.

What followed was a year of conversations, in which time we debated the merits of design thinking for our demographic of working professional MBA

students and ultimately decided to use Creative Problem Solving (CPS), not design thinking, as the foundational model for our class. Now that the class has run six times, CPS seems to have shown itself to be an effective foundational model. That said, as the class has evolved, I, as the class instructor, have woven design thinking concepts into the curriculum, in order to complement the CPS framework. Design thinking thus has re-emerged as a core curricular concept, and the class can be understood to be using a hybrid CPS-design thinking approach.

This chapter tells the story of our class's evolution, from 2010 until the present day. It begins by providing context about our student demographic. It then explores the doubts my colleague and I had about design thinking, explains why we came to choose CPS as our class's foundational model, and tells of how design thinking concepts were integrated. We hope this chapter will be of use to others who want to adopt design thinking, but are grappling with some of the issues we grappled with, namely the fact that (1) design thinking can seem confusing to a business audience, and (2) it can be difficult to transfer design thinking concepts into a non-design environment.

It is necessary for the coherence of this chapter to mention that my colleague, Dr. Steven Glover, passed away shortly after the course launched and that I have taught all intakes on my own. I therefore refer to Dr. Glover when discussing the course design process but only to myself when discussing the subsequent integration of design thinking. Dr. Glover, to whom I owe an enormous debt for helping me develop my thinking and move past my initial assumptions, reviewed an early draft of this paper. I have made every effort not to misrepresent my late colleague's position here.

CONTEXT: STUDENT DEMOGRAPHIC

Students on the MBA program in which my colleague's and my innovation class is situated are on average forty years old and most already occupy mid-level management jobs. They come from a wide range of sectors and industries, and a given class might have students from, for example, government, banking, oil and gas, marketing, health care, and the military. Our course design therefore needed to accommodate students from a wide range of professional backgrounds. Our class is an elective, but students have the choice of two out of only three electives. Therefore, in designing the course, we could not assume that students had a strong pre-existing interest in creative methods; the course design had to accommodate the "average" MBA student.

This final point became particularly relevant to us, since our review of existing design thinking courses suggested that almost all were offered either

as electives or as part of design-thinking-focused programs. We therefore assumed that our students might exhibit more resistance to being asked to adopt new work habits or cope with significant ambiguity than those featured in stories about successful design thinking classes. Our experience of our MBA students told us that they were motivated and open to learning, but that they were also extremely busy, balancing professional, domestic, and academic responsibilities. We perceived the challenge we faced in fostering creativity in students who might not be entirely open to our efforts as analogous to that which our mid-level manager students themselves might face in attempting to foster creativity in those they managed. We thus embraced the challenge of designing a creativity-focused class for students who had not actively sought out creativity education, because it seemed to us to be a worthy cause.

QUESTIONING DESIGN THINKING

In the months in which we discussed design thinking, my colleague and I repeatedly returned to two concerns. The first, which was primarily his, revolved around the ambiguity concerning the definition and roots of design thinking, as well as the lack of research affirming its effectiveness. The second, which emerged as a concern for me, revolved around the gap between the culture from which design thinking emerged and that of the business school in which we were operating and the organizational cultures in which most of our students would be called upon to innovate. In this section, I examine each of these concerns.

While my colleague and I were engaged in conversation, I found myself frustrated by my own inability to explain a concept, which I believed I understood. When he asked for definitions, I pointed toward that provided by Brown in the *Harvard Business Review* (2008, p. 86):

> A discipline that uses the designer's sensibility and methods to match people's needs with what is technologically feasible and what a viable business strategy can convert into customer value and market opportunity.

And that provided by Dunne and Martin in *Academy of Management Learning and Education* (2006, p. 512): "approaching management problems as designers approach design problems." But these only led us into circular conversations. Moreover, we struggled to connect the dots between thinkers such as Simon (1996), Boland and Collopy (2004), and Martin (2004).

From my perspective, our inability to achieve clarity was of secondary importance. After all, I argued, if we could provide our students with a meaningful experience of the creative process, to what degree did this

underlying ambiguity matter? For him, it mattered a great deal. He believed we should bring to our students an untested concept like design thinking, only if we felt confident there was no other, more credible way to achieve the goal of fostering creativity and innovation—and he was not certain that no other way existed. Also, he saw his own confusion as foreshadowing what our students would likely feel, which I had to acknowledge was likely.

Moreover, I was developing doubts of my own. When I thought back to my own time as an architecture student, it struck me that the creative magic of the studio did not result from the adoption of a particular way of thinking; rather, it emerged from a whole culture of openness and innovation. The issue of grades stood out for me as symptomatic of the cultural difference between design and business. When I was an architecture student, it would have been laughable to begin a new project and say, "I'm going to work really hard and get an A." It was accepted that we would be embarking on an unpredictable creative journey. In contrast, business students commonly assume there is a path they can follow to A-level work, thinking that can be understood as analogous to the type that occurs in the workplace, where employees often seek clarity around pay scales and opportunities for advancement. Given that design school is a very different place than business school—and given that most design thinking classes featured in the literature seemed to make use of multiple features, such as specialized studio spaces and high instructor–student ratios, which communicated to students that they were involved in a "special" experience—I questioned whether, in the context of a regular MBA class with no additional resourcing, we would struggle to recreate a design environment.

More significantly, even if my colleague and I, as educators, succeeded in creating a design-conducive environment for our students, I questioned whether our students, as managers, would be able to recreate these conditions in their workplaces. Most of our students are mid-level managers, and thus possess limited influence over the overall culture and design of their organization. Most would likely use the skills gained in our class to impact intrapreneurial change: to make things better within their own sphere of influence within their organizations. Proponents of design thinking have acknowledged the challenges of introducing it into the organizational environment and even have provided strategies for how they might be overcome (Martin, 2006). However, while it seemed plausible that these strategies would be effective, they also seemed arduous. We therefore, once again, questioned whether a gentler way to foster creativity and innovation existed, one that showed greater alignment with business practices and thus potentially would be easier for our manager-students to transfer into their own contexts.

After a few months of dialogue, my colleague and I had come to two realizations. First, we were seeking "optimal strangeness." We recognized that,

if our class was not different enough from the regular analytically focused MBA curriculum—if it wasn't strange enough—it would serve no purpose. Students would leave it thinking in the same ways they always had, and thus not advance their ability to innovate. On the other hand, if the class was too different—if it pushed students too far outside their established approaches— we risked both alienating all but the most adventurous among them and inhibiting their ability to transfer their learning into their professional contexts. We were concerned that design thinking would be too strange, a concern that was supported by constructivist learning theory, which suggests that adults learn best when they can link new to existing knowledge (Merriam *et al.*, 2007).

Our second realization was that we, as course designers, needed to focus on the outcome of helping our students become innovators, and not, as we had been doing, on that of designing a successful design thinking course. Due to my advocacy, we had begun our conversations by focusing on design thinking and had even agreed that we would put the words "design thinking" in the course title. We now agreed to remove them and title the course "Leading Innovation," concurring that its goal was to help our manager-students lead innovation in their professional contexts. We agreed to remain open both to design thinking and to other options that might allow us to achieve our goal. As my colleague put it, "If design thinking is the best way to achieve the goal of leading innovation, we will adopt it. If it's not, we won't."

At about this time, I introduced my colleague to Puccio and colleagues' *Creative Leadership: Skills that Drive Change* (2011), a book which draws on Creative Problem Solving (CPS) as its foundational model, and which I had used in my own facilitation and in teaching undergraduate classes. Perhaps because I felt so excited about the potential of adopting a design thinking approach, I had not considered it as a textbook for our MBA class. However, my colleague immediately saw it as offering a way forward because, as explored in the next section, it responded both to his desire to employ an approach that possessed greater grounding in research and to my desire to employ an approach that more closely aligned with existing modes of problem-solving within business schools and organizations.

CREATIVE PROBLEM-SOLVING

Like design thinking, CPS is a structured process for navigating complex, open-ended problems. It was originally conceived in 1942 by Alex Osborn, a founding partner in an advertising agency, who, shortly after, also founded a CPS-focused research and educational center. This affiliation with a research center has meant that the process continually has been adapted in response

both to new research findings from those academics studying it and to new external academic research in the field of creativity. Since its inception, CPS has since evolved so that multiple versions currently exist (Isaksen and Treffinger, 2004; Puccio *et al.*, 2005), but all possess two basic characteristics: First, they are comprised of discrete steps associated with the need to define problems, generate ideas, transform ideas into solutions, and construct action plans. Second, each step of the CPS process calls for practitioners to partake in a phase of divergent then convergent thinking, where divergent thinking involves "generating a diverse set of alternatives" and convergent thinking focuses on "screening, selecting and evaluating alternatives" (Puccio *et al.*, 2006, p. 20).

The version of CPS featured in Creative Leadership is called the Thinking Skills Model and is comprised of four steps, Assessing the Situation, Clarification, Transformation, and Implementation. The model further breaks down each of these broad steps into two sub-steps, each of which consists of a divergent and convergent step. The problem solving process is thus laid out, step-by-step, at a fairly granular level and becomes characterized by repeated cycles of divergent and convergent thinking.

For my colleague, CPS's maturity was a draw. He viewed a clear, thorough textbook as a priority and perceived *Creative Leadership* as ideal, because it offered both a strong theoretical grounding in the disciplines of creativity and leadership and a practical toolkit, which our manager-students could draw on to practice CPS. Moreover, the fact that CPS has been shown to be effective by multiple empirical studies and had a history of use within the organizational context gave him comfort that we were passing on a credible approach to our students (Parnes, 1987; Thompson, 2001; Isaksen and Treffinger, 2004; Puccio *et al.*, 2006).

I was drawn to the similarities between CPS and my students' default approaches to problem-solving. The stages of CPS, which guide problem-solvers in gathering information, clarifying the problem, generating solutions, and then implementing them, are commonplace and do not represent a radical departure from analytical approaches. Indeed, as has been observed by others (Hughes, 2003; Newman, 2004), CPS maps cleanly onto standard approaches to business analysis. CPS's value thus lies primarily in the way it shifts the emphasis—as opposed to the underlying structure—of problem-solving. Specifically, it asks problem-solvers to diverge more frequently and rigorously than they typically would, and at points in the process—for example, in the clarification stage—when they might not usually think to do so. The emphasis on transforming ideas into solutions, which is highlighted in the version of CPS featured in *Creative Leadership*, is also significant, since it accentuates that new ideas require iterative development before they can be considered

potential solutions. In other words, CPS seemed to offer optimal strangeness, being different enough to push students in new directions, but similar enough to enable them to build on their strengths.

Now that the class has run six times, I feel satisfied that CPS is the right foundational model. In retrospect, I am grateful that my colleague foresaw the importance of a thorough, clear textbook. Given that the creative process can be disorienting, students seem to appreciate being able to turn to *Creative Leadership* as a touch point, and the book has consistently been well reviewed in course evaluations. CPS's repeated divergent–convergent cycles acknowledge what MBA thinkers typically do well (converge), allowing them to begin from a place of competence, but then push them to move beyond their comfort zone. Moreover, the pattern of returning repeatedly to convergent thinking seems to contribute to foundational feelings of comfort and safety that enable creative risk. Students who typically are not comfortable with the ambiguity of delving into the creative process seem to enter into it more willingly, because they know that convergence will follow. As comfort grows, problem-solvers can be guided through longer, less structured periods of divergence.

The CPS model seems to have proven particularly effective in the latter part of the class, when students are asked to complete a practicum exercise, in which they facilitate a CPS session in their own professional context. Students from a wide range of industries—from creative industries like video-game development to non-creative ones like the fire service or utilities—have reported its effectiveness.

INTEGRATING DESIGN THINKING

While CPS has proven to be a strong foundational model, I have found that students have benefited by also drawing on design thinking approaches, which have been woven into the CPS curriculum. Although multiple models of design thinking exist, a focus on "human-centricity," which suggests beginning the problem-solving process through achieving empathy with users, and on prototyping seems to persist as dominant features of most models (Efeoglu *et al.*, 2013). These design thinking concepts have proven to be useful additions to the CPS framework.

Drawing on the design thinking literature to explicitly address the concept of user empathy appears to have helped students come to more grounded and creative solutions. The concept of user empathy is compatible with the CPS model, since CPS emphasizes the importance of beginning the problem process by "assessing the situation," and empathic approaches such as observational research, journey mapping, and interviewing are ways of doing

so. I am therefore able to integrate this concept, by highlighting it as a particular effective approach to assessing the situation, when the goal is innovation. Focusing on attaining user empathy has seemed particularly effective in the first part of the course, when students practice CPS using a live case, a real-life challenge presented to them by an organizational leader. Because I try to choose challenges from outside most students' sphere of expertise (recent challenges have included those presented by an opera company and an astronomical observatory), emphasizing the importance of beginning with attaining deep understanding of users has seemed effective in opening students to more nuanced possibilities, as opposed to defaulting to stock business solutions.

The idea of prototyping has also become central to the class experience. Again, this is compatible with the CPS model, since CPS emphasizes the importance of transforming ideas into viable solutions, and prototyping is a way to achieve transformation. In my context, asking students to prototype has meant asking them to publically put forward multiple drafts of ideas for feedback. For example, after two weeks of working on the live case, students present their draft recommendations, using a format adapted from Liedtka and Ogilvie's (2011) "Napkin Pitch" template, to the organizational leader for feedback. They then reflect on any feedback in groups and as individuals before proposing a new, revised recommendation. This public process of putting forward an idea with the explicit purpose of learning from the feedback seems to represent a significant departure from business students' default approach to problem-solving. For example, it runs counter to much of what they learn through the practice of case analysis, which asks them to decisively defend their recommendation as being the best possible solution. Significant learning seems to emerge from the experience of prototyping.

As stated above, the design thinking concepts of user empathy and prototyping are compatible with the CPS framework. This does not mean, however, that the addition of design thinking is innocuous or benign. For example, by adopting prototyping, the class immerses students in a fundamentally different experience than they would have if they adhered only to the textbook's suggested approaches. I therefore believe that the addition of design thinking concepts alters the CPS experience, and that the approach adopted in Leading Innovation represents a hybrid of CPS and design thinking.

CONCLUSION

The design thinking conversation has matured since 2010, when my colleague and I began our discussions. Clearer analyses of the discourse exist (for

example, Hassi and Laakso, 2011; Efeoglu *et al.*, 2013; Johansson-Sköldberg *et al.*, 2013) and more resources for students are available (for example, Liedtka and Ogilvie, 2011). Had we been tasked to design an innovation class in 2014 rather than 2010, it is possible that my colleague's skepticism would have been more easily assuaged, and we never would have explored alternative pathways. I believe that would have been a loss, since CPS has proven itself to be a flexible and useful foundational model, which has successfully guided student-managers from a broad diversity of industries in facilitating creative process. Moreover, because it is more generic than design thinking—it lays out the steps required to engage in the creative process, but is less directive on how those steps might be executed—it has the capacity to integrate design thinking approaches, leading to a hybrid approach.

In short, a hybrid CPS-design thinking model may be of interest to educators and managers who recognize the value of design thinking approaches, such as beginning with user empathy and prototyping, but are concerned that adopting design thinking wholesale may lead to confusion for a business audience, as well as to challenges in transferring design approaches to non-design contexts. CPS offers the advantage of being more closely aligned with existing managerial approaches to problem-solving.

REFERENCES

Boland Jr., R. and Collopy, F. (2004) "Design Matters for Management," in R. Boland Jr. and F. Collopy (eds.), *Managing as Designing,* Stanford, CA: Stanford Business Books, 3–18.

Brown, T. (2008) "Design Thinking," *Harvard Business Review*, 86 (6), 84–92.

Dunne, D. and Martin, R. (2006) "Design Thinking and How it will Change Management Education: An Interview and Discussion," *Academy of Management Learning and Education*, 5 (4), 512–523.

Efeoglu, A., Møller, C., Sérié, M. and Boer, H. (2013) "Design Thinking: Characteristics and Promises," paper presented at the 14th International CINet Conference on Business Development and Co-Creation, 241–256 [http://vbn.aau.dk/ws/files/176789431/cinet_2013_nijmegen_efeoglu_et_al_cinet_version.pdf].

Hassi, L. and Laakso, M. (2011) "Conceptions of Design Thinking in the Management Discourse," in *Proceedings of the 9th European Academy of Design (EAD)*, Lisbon [http://www.mindspace.fi/wp-content/uploads/2013/12/HassiLaakso_IASDR_FINAL.pdf].

Hughes, G. D. (2003) "Add Creativity to Your Decision Processes," *Journal for Quality and Participation*, 26 (2), 4–13.

Isaksen, S. G. and Treffinger, D. J. (2004) "Celebrating 50 Years of Reflective Practice: Versions of Creative Problem Solving," *Journal of Creative Behavior*, 38 (2), 75–101.

Johansson-Sköldberg, U., Woodilla, J. and Çetinkaya, M. (2013) "Design Thinking: Past, Present and Possible Futures," *Creativity and Innovation Management*, 22 (2), 121–146.

Liedtka, J. and Ogilvie, T. (2011) *Designing for Growth: A Design Thinking Tool Kit for Managers*, New York: Columbia University Press.

Martin, R. (2004) "The Design of Business," *Rotman Magazine*, Winter, 7–11.

Martin, R. (2006) "Designing in Hostile Territory," *Rotman Magazine*, Spring/Summer, 4–9.

Merriam, S. B., Caffarella, R. S. and Baumgartner, L. M. (2007) *Learning in Adulthood: A Comprehensive Review*, Thousand Oaks, CA: Sage.

Newman, C. (2004) "Enhancing Creative Thinking in a Case-Based MBA Course," *Journal of College Teaching and Learning*, 1 (3), 27–30.

Parnes, S. J. (1987) "The Creative Studies Project," in S. G. Isaksen (ed.) *Frontiers of Creativity Research: Beyond the Basics*. Buffalo, NY: Bearly Ltd., 156–188.

Puccio, G. J., Murdock, M. C. and Mance, M. (2005) "Current Developments in Creative Problem Solving for Organizations: A Focus on Thinking Skills and Styles," *Korean Journal of Thinking and Problem Solving*, 15 (2), 43–76.

Puccio, G. J., Firestien, R. L., Coyle, C. and Masucci, C. (2006) "A Review of the Effectiveness of CPS Training: A Focus on Workplace Issues," *Creativity and Innovation Management*, 15 (1), 19–33.

Puccio, G. J., Mance, M. and Murdock, M. C. (2011) *Creative Leadership: Skills that Drive Change*, 2nd edn., Thousand Oaks, CA: Sage.

Simon, H. A. (1996) *The Sciences of the Artificial*, 3rd edn., Cambridge, MA: MIT Press.

Thompson, G. (2001) "The Reduction in Plant Maintenance Costs Using Creative Problem-solving Principles," *Proceedings of the Institution of Mechanical Engineers, Part E: Journal of Process Mechanical Engineering*, 215 (3), 185–195.

INDEX

collaborative approaches 186
collaborative computational frameworks, for distributed design computing 103–4
collaborative leadership 190
communication
 and business design 35
 in organizing 62–4
 technological advances in 106, 109
communicative aspects, of design 25
communities of practice 191, 192, 193
community-market
 designer = enterprises 139–41
 term 143n.9
 of users-clients-designers-businesses 132
community, studios as 192–3
complexity
 crisis 106
 dealing with 122, 124
 in design 131
 growth in 109, 110, 113
computational systems, purposeful thought 102–3
computer-augmented craft machine 135
construction industry, and management control 59–60
construction projects, organizing features on 58–9
consultancies, strategy 19
convergent thinking 202
coordination, of design activities 45
Copenhagen Business School 161
corporate management, and design 71–2
corporate social responsibility (CSR) 152
craft
 augmented craftsmanship 141
 and business models 32–3
 to design 106–9
 studios 164
Crafts, N.F.R. 107

creative class, and innovation 118–19, 125–6n.2
creative design thinking 96, 100–1
creative education 193
creative leadership 202
Creative Leadership: Skills that Drive Change 201, 202, 203
Creative Problem Solving (CPS) 13, 197–205
creative thinking, and design thinking 188–90
creativity 188, 189
crises, global 110
crisis, term 106
Critical Systems Thinking (CST) 154
crowdfunding 139, 143n.12
culture
 and design thinking 22
 technological 112
 two cultures 119–20
curriculum
 21st century 193–4
 art education 177–9
customizers 132
cybernetics 121–2

D

decision-making 60, 74, 75
Deming, W. Edwards 77
design
 and art 37–8, 45–7
 and business 136, 160–3, 188
 business and art 45–7
 and business schools 163, 165
 cohort-based 178
 communicative/social aspects of 25
 communities 192
 as a corporate resource 71–2
 craft to 106–9
 and design thinking 109–11
 education 47, 65, 112, 192–3
 and enterprise 131
 and ethics 148, 149
 flux-state 175
 Four Orders of Design 34, 71, 77
 fourth order 25

fundamental relations of 23
goals of 73, 153
graphic design 168–9, 173
and industry 130
and innovation 189
interaction 35
management 71–3, 185–94
and management 2, 6, 20–1, 23, 160, 163–4, 165
in management schools 161
managing as 64–5
as a mass profession 131
metaphors 182–3
as a meta-skill 190
methods/techniques 38, 39–45
and morality 148
as a non-discipline 148
object of 24
organizational 34–5, 67–75, 81–90
practice 110, 111–12, 113
process 72, 131–2
and production 140
re-appropriation of direct/personal control over 142
research 48
and responsibility 148–9
rhetoric and dialectic in 25
and science 162–3
seeing through 188–90
self-made 142n.8
and social problems 153
stakeholders in 153
strategic 35, 72, 86–7, 185
as strategic art 7, 39, 43, 45, 47–9
and systems theory 121–2
as a technique and method 42–5
thinking. *See* design thinking
traditional 110, 111, 113
transformation 152–5
translational 12–13, 185–94
designer = enterprises 133, 136–42
Designerly Organization Design (DOD) 87, 89

Fish Sculpture Project 59–60
Flaxmann, John 108
flexibility 187
Florida, R. 118
flux-state, design 175
Follett, Mary Parker 70, 71
formative thought 97, 120
Four Orders of Design 34, 71, 77
fourth order, design 25
fourth sector 154
Frankl, Viktor 77
Fraser, H. 46

G

garbage can model 74, 75
Gehry, Frank O. 54–6, 57, 59,
 61, 175
Gift of Good Land, The 76
Gillespie, Ed 171
Glanville, R. 121, 122
global crises 110
global logic 63
Glover, Steven 198
Glymph, Jim 59–60
goals, of design 73, 153
Good Grips kitchen utensils
 99–100
governance, of human systems 121
grammar, art of 25
graphic design 168–9, 173
green education 177
Guan Zhong 68
Guan Zi 68
guilt, existential 77

H

hackers 133
Halberstam, David 73–4
Hasso Plattner Institute 86
Helsinki Design Lab 25, 72, 87, 161
Hesiod 68
higher education, design thinking in
 176–7
Hobday *et al.* 123
Hoffman Construction 60
Horse is Dead, Long Live the Horse,
 The 172

house books 69
housing, Alte Liebe project 152
HPI School of Design Thinking 110
human-centricity, and problem-
 solving 203
Human Genome Project 181
humanism 148
hybridity 178
Hyundai Motor Company, and Royal
 College of Art 169–73

I

Ibn Khaldun 69
IDEO 86, 119
imagination, and design thinking 22
Imagination Lab, Serious Play
 system 86
incubation, of micro-production 135
Industrial Revolution 106, 107–8,
 113
industry, and design 130
information
 critical evaluation of 193
 digital 181
 society 109
innovation
 and creative class 118–19,
 125–6n.2
 and Creative Problem Solving
 (CPS) 204
 and creativity and design 189
 and design thinking 121, 123,
 125, 186
 and invention 123
 as a joint challenge 122–4
 leading 201
 management 118, 119
 and management 187
 and meta-skill approach 190
 and organizational survival/
 success 85–6
 process 123, 124
 social 142, 153–4, 186
 and user's needs 117–18
Innovation and Entrepreneurship 22
insourcing 142n.2
institutional change 182

Instructions of Amenemopet, The 68
integrative learning 178, 191
intentional thought 97, 120
interaction design 35
invention
 and innovation 123
 managers as source of 188

J

Jobs, Steve 100
Johnson *et al.* 31
Journal of Organizational Design 85
Junginger, Sabine 98
justice, as fairness 76
just in time 142

K

Kang, Seokhoon 170
Kassel, Germany 149–52
Keller, Scott and Price, Colin 85
Kiechell, Walter III 19
Kimbell, Lucy 86
Kim, Suhee 172
knowledge
 generation of 191–2
 symbolic view on 162–3
 transfer/exchange 168–9, 171–2,
 191–3
 troublesome 194
Kotter, John P. 21
Krippendorff, K. 27, 29, 34, 112, 121,
 124–5
Kuhn, Thomas S. 105
Kyoto Design Declaration
 (2008) 148

L

Lagrimas corporation 89
language, in organizing 62–4
language teaching 40–1
Latour, B. 148
leadership
 collaborative 190
 creative 202
 designer = enterprises 138–9
 for innovation 201
 and management 186–8

strategy consultancies 19
struggles
 of the designer 54–7
 involved in designing 8
 of managers 57–9
 in organizing 62–4, 65
studios. *See also* design studios
 art 164–5
 business 11
 as community 192–3
 studio approach 11–12
 studio practice and technology
 193
Sun Tzu 68
sustainable planning 176
Sutton, R. 118
symbolic view, on knowledge/
 management/practice
 162–3
system designing, and business
 model design 30
systems theory, and design/
 cybernetics 121–2

T

Taylor, Frederick Winslow
 70, 71
teaching innovation, design
 thinking in 117–25
technical engineering oversight
 61–2
techniques, design 38
technological culture 112
technology
 and communities of practice
 193

and designers 112
facilitating collaboration 180,
 192
and studio practice 193
teleology 149
Terrey, N. 110, 111
Theory of Design Thinking, A 96
thinking
 divergent/convergent 202
 experimental 180
 modes of 96–9, 120
 purposeful thought 96–101,
 102–3
 strategic 176
thinking-in-action 176
Thinking Skills Model 202
thought 96–101, 102–3, 120
threshold concepts 194
time
 as organizing principle 98
 and space 64
traditional design 110, 111, 113
training, for micro-production
 135
transdisciplinarity 149
transdisciplinary experiences, in
 education 178
transformation design 152–5
translational design 12–13, 185–94
two cultures 119–20

U

Ulrich, W. 154
uncertainty, and circularity 122
Universal Design 99
Ure, A. 108

user-centeredness 153
users, needs of and innovation
 117–18
utility, as organizing
 principle 98

V

value creation 113
Van Gogh, Vincent 56–7
veil of ignorance 76
Verganti, Roberto 86
Vester, Frederic 154–5
Viable System Model 122
Vision in Motion 25

W

Wang, James 42
WASP 137
wealth creation 5
Wealth of Nations, The 70
Weatherhead School of
 Management 20, 54, 175
Weick, K. 125
Western, Case 160
wicked problems 74–5, 110, 114,
 160
Works and Days 68
World Wide Web, and design
 practice 110

X

Xenophon 68

Y

Yagyu Munenori 69
Yunus, Mohammed 5